FaeMaker

Making Fantasy Characters in Polymer Clay

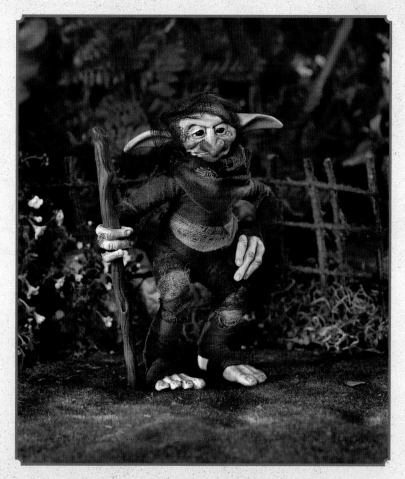

Dawn M. Schiller

IMPACT
CINCINNATI, OHIO
www.impact-books.com

CONTENTS

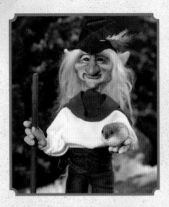

Chrainn the Elf
30

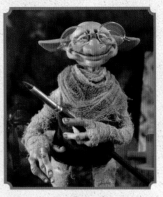

Fetch the Troll
42

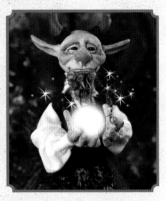

Teigh the Satyr
52

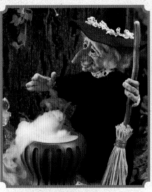

Zylphia the Witch
60

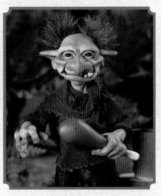

Ithe the Ogre
70

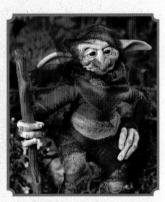

Crimbil the Goblin
78

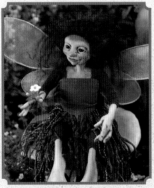

Ceolann the Fairy
86

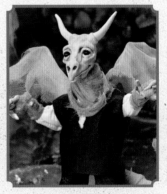

Dain the Dragon
94

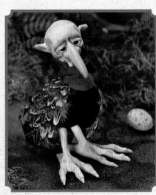

Milse the Bird
104

Finding Your Way to the Fae

Up the airy mountain, down the rushy glen
We daren't go a-hunting for fear of little men;
Wee folk, good folk, trooping all together;
Green jacket, red cap, and white owl's feather!
— "The Fairies" by William Allingham

Don't you just love the smell of a new book? It's one of the best things in the World! A cup of tea, a new book and an old cat are a perfect day. Especially if there's fairies involved! For as long as I can remember, I've been drawn to fairy tales and fantasy … and the only thing better than reading about fairies is making them!

I first came to love the fae, an old English word for fairies, short for "faerie," reading the Brothers Grimm. I had a book illustrated by a marvelous artist, Arthur Rackham, and I read it to pieces, poring over the pictures. The gnarled trees, equally gnarled old witches and odd little men fascinated me. Growing up in the Midwest, I was fortunate enough to live next to a small woods, and I would always look for the creatures from my book under leaves and old fallen logs. And I found them, at least in my imagination. At night before bed I would draw paper dolls or make pipe-cleaner dolls of the Little Folk I "saw" in the Woods.

In picking up this book, you've taken your first step in finding your way to the fae.

They're hard to see these days, what with all the cold iron that's everywhere, but they are there if you know how to look. Turn your head sideways and tilt it a little and by the light of the first star to left … there! See that Shadow? The fae are coming to watch you create.

I'll help you learn to sculpt fae that are a little quirky, occasionally cranky and definitely fun. You'll learn about making faces, hands and feet in polymer clay, making bodies that pose, and building a whole world of characters who are sure to make you smile. After you've gotten the hang of faemaking by creating the figures in this book, you can go off and explore faeries on your own, making even more fae friends.

Grab your sculpting stuff, crank up your imagination, and you'll be a faemaker in no time!

Cheers!

D/Oddfae

Meet Fetch

My assistant Fetch is coming along on this adventure to give you little hints and bits of information that I may forget to mention. My studio has a whole tribe of these li'l trolls—they hold my tools and keep me company. I don't know how I'd get anything done without them!

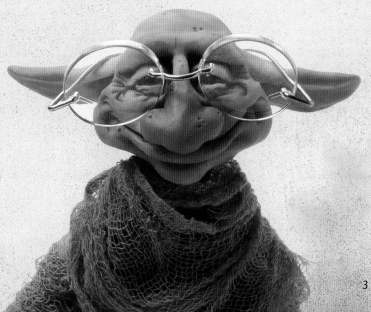

Materials for Makers

An excuse to add to your stash! It seems like you need a lot to get started, but most items are really inexpensive and available at local stores. Many of the materials needed are probably already around your house or studio. And you may discover some new tools that no one ever considered before!

Keep in mind, anything you borrow from the kitchen or bathroom to use with polymer clay should not be put back, but kept to use only with clay. This is a "dedicated" tool.

To start, you'll need a smooth work surface. You could use marble, Lucite, granite, ceramic tile, parchment paper, a plain sheet of glass (cover sharp edges with masking tape) or a glass cutting board. You can also tape a sheet of waxed paper to a table and work the clay on the waxed paper, changing the paper when it gets dirty. Raw clays will actually fuse with some types of plastic and can stain or damage wood; keep unbaked clay off of furniture.

Any handyman's tools you can "borrow" from the garage, workshop or toolshed will come in handy. Complaints regarding purloined tools can be answered with the statement, "One must suffer for one's art." It's just you're not the "one" doing the suffering!

Pretty much any fabric you find can be used to make fae; if you like it, your oddfae probably will, too. Dig through the remnant bin at the fabric shop, look in the closet for old clothes or check out thrift shops.

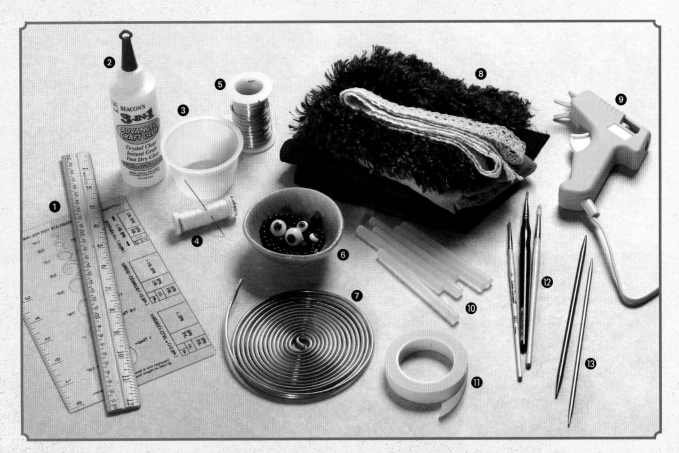

Build Your Stash

The really fun part about making fae is seeing something in a shop or in your stash and having that little lightbulb come on—"I know exactly who can use that!"—and you're off to make a new character.

Here's a selection of materials you'll need for faemaking: (1) rulers, (2) craft glue, (3) water cup, (4) needle and thread, (5) 20-gauge wire, (6) glass beads and eyes, (7) armature wire, (8) fabric, (9) glue gun, (10) glue sticks, (11) floral tape, (12) paint brushes and (13) knitting needles.

What You Need

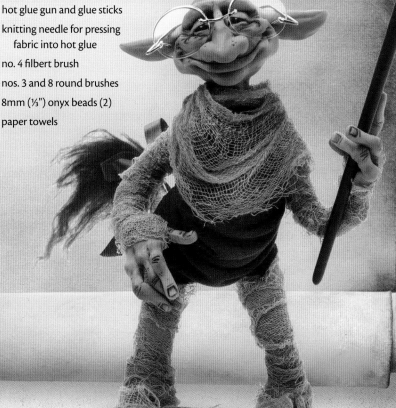

Basic

rolling pin or pasta machine

smooth work surface

Polymer Clay Colors

black

brown

flesh tone of your choice

gray

green

off-white

white

yellow

Acrylic paint

Burnt Umber

Terra Coral

Fabric

variety of fabrics in different colors
and textures

Sculpting Tools

craft knife

manicure stick

needle tool

needle-nose pliers

sculpting tool (with square
end and pointed end)

texture tool (homemade)

Other Supplies

aluminum foil

⅛" (3mm) armature wire
(approximately 12 gauge)

art fiber

artificial sinew

baby oil

baby wipes

beads, buttons, charms, feathers,
glass ball or marble, ribbons,
sticks, trims, etc.

boxwood dowel

cotton balls

fabric glue

feather pads (2)

½" (12mm) floral tape or masking
tape

floral wire (32 gauge)

hot glue gun and glue sticks

knitting needle for pressing
fabric into hot glue

no. 4 filbert brush

nos. 3 and 8 round brushes

8mm (⅓") onyx beads (2)

paper towels

polyfill for baking

quilt batting

raffia

sanding stick

scissors

small container of water
for burnt fingers

2" × 3" (51mm × 76mm)
Styrofoam egg

super glue

white craft glue

wire (20 gauge)

Optional Supplies

food processor

heat gun

Choose Your Clay

Several companies manufacture polymer clay. The brands differ in plasticity, strength, translucence, curing temperature, and flexibility after baking, and each company has its own selection of colors. The clays described here, in no particular order, are the ones I am personally familiar with.

ProSculpt requires very little kneading and blends without showing seams. When cured, it becomes extremely hard and durable, with a translucent, fleshlike color.

Super Sculpey is available in a semi-opaque beige that is easy to condition right out of the package and holds detail extremely well. It is shatter- and chip-resistant after curing. Super Sculpey is also available in a firm gray color used in the movie industry.

Super Sculpey Living Doll is specifically formulated for dollmaking. It blends easily and is strong and durable after baking with a slightly matte, fleshlike color.

Premo! Sculpey is soft enough to blend easily but firm enough to hold fine detail. Premo! retains flexibility after curing and is very strong.

Kato Polyclay conditions easily and is flexible and durable after baking. The flesh color cures to a translucent finish.

Cernit is a soft clay with a porcelain-like finish when cured. Strong and sturdy, it is available in several excellent flesh tones.

Staedler FIMO Puppen (German for doll) or *PuppenFIMO* is especially suitable for dollmaking. It holds detail well and is pliable after baking. It is available in several flesh tones with semimatte porcelain finish.

Staedler also offers several different formulas of clay besides Puppen–FIMO that can be used for sculpting but are more often used for other applications.

Clay Options
Polymer clay is available in many brands and colors, in individual packages, multipacks and sampler sets.

Fetch's Fact: Experimenting

Which clay is the best? Whichever one works for you. Each clay moves differently and has a different feel; some you'll love and some you won't. I recommend getting a small quantity of each and experimenting until you find your fave before you invest a lot of cash.

Clay Safety and Recipes

Polymer clay is a nontoxic man-made clay consisting of PVC (polyvinyl chloride) and a liquid plasticizer. Pigments added to the base formula create a wide range of colors, including fluorescent, metallic and glow-in-the-dark. You can mix different brands and/or colors of polymer clay together to make custom shades.

Keep polymer clay away from direct sunlight and heat, and it will remain pliable and workable for years. Store your clay in a cool, dry place, and it will not dry out like organic clay does.

Play It Safe

The Art & Creative Materials Institute, Inc. (ACMI) has certified that polymer clay is not hazardous when used as directed, but it never hurts to be cautious. In particular, don't eat it and don't burn it! Here are a few other precautions to keep in mind:

- Wash your hands after sculpting.
- If using eating utensils or cooking tools for sculpting tools, do not use them for eating or cooking again.
- The fumes from burnt clay are toxic. An oven thermometer and a timer are your best friends. Follow the package directions for baking time and temperature. If you blend different clays with differing baking instructions, bake at the longest time recommended and the lowest temperature.
- Cure clay in an area with good ventilation.
- Don't bake in a microwave.

Should you decide you like sculpting with polymer clay, you will probably want to get a dedicated (used only for baking clay) toaster oven or convection oven to cure your sculpts. While polymer clay is nontoxic, it is plastic, and I really don't want plastic in my food!

Mixing Clay

Different brands of clay can be blended to get the best properties of the various clays included in the mixture: for example, sculptors sometimes mix Super Sculpey with FIMO, resulting in a clay easier to work than FIMO, but stronger than Super Sculpey.

Clay can be used straight from the package, but if you don't find a flesh color that you really like, make your own. I've included some of my favorite recipes here.

Mix clay by twisting, rolling and kneading it in your hands. If you have a pasta machine, simply roll it through the machine as many times as needed to blend the colors. The clay is completely mixed when you can no longer make out individual colors. If you stop mixing before you reach this point, you'll get streaky color.

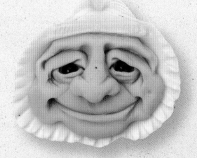

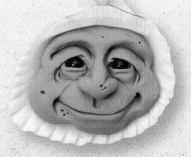

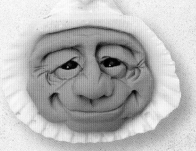

Light Skin Recipe

This makes a light skin tone that has a nice glow after baking. Keep a careful eye on your sculpt when you bake, as translucent clays burn easily. Mix:

- 8 parts Living Doll or Super Sculpey
- 3 parts Translucent Premo!
- 1 part White Premo!

Dark Skin Recipe

This is a great dark skin tone. Mix:

- 2 parts Raw Sienna Premo!
- 3 parts White Premo!
- 5 parts Living Doll or Super Sculpey

Green (Dragon) Skin Recipe

Your dragons will look great with this color. Mix:

- 2 parts Green Premo!
- 3 parts White Premo!
- 5 parts Living Doll or Super Sculpey

Conditioning and Curing Clay

No matter which brand of clay you use, it must be conditioned before you sculpt. If you try to work with clay straight out of the package, you will be an Unhappy Faemaker and probably use Bad Words because your clay will be crumbly and impossible to blend.

Conditioning

Conditioning is the warming and softening of polymer clay to ready it for use. Knead, roll and twist the clay with your hands, or crank it through the rollers of a clay-dedicated pasta machine, folding and rolling several times before beginning to sculpt. (Put the clay through the machine folded edge first to reduce air bubbles.) You can also use an acrylic roller, a clay-dedicated rolling pin, or a dedicated food processor to chop the clay into small pieces with a clay blade. (Run the machine in short bursts to avoid overheating.)

When conditioned, polymer clay is soft to the touch and slightly warm. The amount of conditioning required depends on the brand and age of the clay, on how hard the clay is and how soft a clay you prefer to work with. My friends think I sculpt with mush!

Leaching is the process of removing excess plasticizer from the clay in order to make it firmer. Roll the clay into a sheet and place it between two sheets of paper. *Do not* use printed paper, as the print will transfer to the clay. Rub the paper with your hands to adhere it to the clay, and leave it for a couple of hours. When the paper looks oily, peel it away from the clay, and it's done. Work with the clay a little after every leaching. If you take too much plasticizer out, the clay will crumble.

If your clay is hard or crumbly, you can soften it by mixing it with Sculpey Clay Softener, liquid clay or FIMO Mix Quick. Add a small amount at a time until the clay achieves the desired consistency.

Baking or Curing

Polymer clay stays soft until baked (cured) and doesn't require high heat from a kiln. Depending on the brand, 230–300° F (110–149° C) is sufficient for curing. It does not shrink or change color, though the colors may darken slightly. Raw clay can be added to cured clay and the item baked again any number of times without any damage.

Always keep the polymer clay packaging and check the time and temperature recommended before putting your work in the oven. Figure out the curing time based on the thickest part of the sculpt.

Though it is nontoxic, polymer clay has a slight odor while baking. After baking polymer clay you may notice the smell the next time you use the oven, so a dedicated (reserved only for clay) oven is the way to go if you do a lot of sculpting. Never bake polymer clay and food in the same oven at the same time.

Get a thermometer. Many ovens "spike" or have temperature fluctuations. Keep your sculpt in the middle of the oven and away from the heating elements. If your sculpt is brown or otherwise discolored when you remove it from the oven, check the thermometer. Lower the temperature if it is too high. If the temperature is correct, try covering your sculpt with a damp (not wet) paper towel or polyester batting.

Sculpts can be baked with polyfill stuffing or batting on cookie sheets, cardboard, a piece of glass or ceramic tile. If using glass or ceramic, place a sheet of paper or batting under your sculpt. (Any place the clay touches the tile or glass will develop a shiny spot.)

Polymer clay will slump a bit during baking, so prop fingers and ears in the desired position with polyfill batting or crumpled aluminum foil.

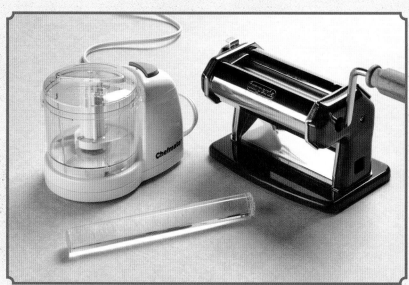

Conditioning Tools
Here are some of the tools you can use to condition your clay.

Clay Tools

All you really need for sculpting polymer clay is your hands and an oven, but tools make things much easier. I recommend a basic tool set to start. You can (and will) collect more equipment as you need it.

The Basic Tool Kit
- *Cutting tool:* A sharp blade, like a craft knife or kitchen knife.
- *Rolling tool:* A rolling pin, acrylic roller, heavy drinking glass or a pasta machine, anything that will make sheets of clay. Remember, don't use kitchen utensils for food after using them with clay.
- *Needle tool:* Useful for scribing lines in clay.
- *A place for your stuff:* Keep tools organized and in one place. I keep my tools in an old wooden box; it doesn't take up much room on my workspace, and I can easily see the tool I'm looking for.
- *Sculpting tool:* Get a wood or metal tool. They work better than plastic and will last longer.

Buying and Making Tools
You can purchase wood or metal tools online, in art stores and in most craft stores. I have an affinity for wood, and that's what works best for me.

You can easily make your own tools. The advantage is having the exact shapes you need to make the clay move as you want it to.

Other Tools
Most tools used by traditional sculptors can also be used for polymer clay. You can also improvise tools from things used in sewing, woodworking and papercrafts. Household items and kitchen utensils can be used, but don't use the items for food after using them with polymer clay.

Here are some other tools that you may find useful: Sharp tissue blades or craft knives can be used to cut up large chunks of clay. A clay gun or extruder with interchangeable disks makes lengths of clay in a variety of shapes. Knitting needles can be used for shaping clay. Brushes can be used to smooth clay. Ball styluses are good for making smooth lines and fitting in small spaces.

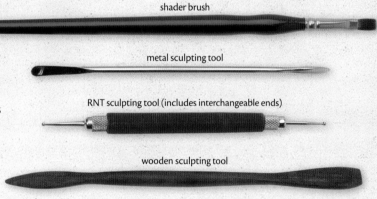

shader brush

metal sculpting tool

RNT sculpting tool (includes interchangeable ends)

wooden sculpting tool

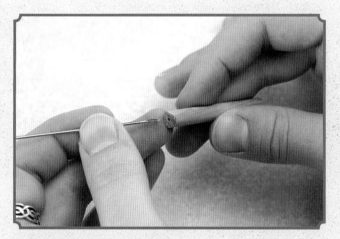

Homemade Needle Tool
Make your own needle tool with a small dowel and a tapestry or doll needle. Cut the dowel to length, drill a small hole in one end, and super glue the needle in the hole.

Altered Manicure Stick
Make a customized tool by altering a manicure stick. Use the coarse side of a nail file to fashion the end of the stick into the desired shape, then polish it off with the fine side of the file. That's it!

Costume Materials

Fabrics will say something about your character's personality. Velvets and brocades are associated with the upper class or good fae, and more raggedy fabrics suggest wild fae, monsters or bad fae. These are not rules but stereotypes. If your goblin is a dandy who wants some fancy clothes, go for it.

It's best to use natural fabrics such as cotton, leather and silk as much as possible. Natural materials drape better and are easier to manipulate when making smaller characters.

If you like to sew, use an all-purpose thread and common sewing needles. If you've never sewn in your life, you can still make wonderful characters. Fabric glue that holds instantly works just as well as needle and thread, and white craft glue can be used for some applications.

Costuming your fae will give you a chance to indulge yourself in fantastic, expensive fabrics, because you only need small pieces, usually only a quarter or half yard (23–46cm) of any one fabric. Get into the habit of checking out the remnant bin whenever you are in a fabric store. The treasures you sometimes find there for very little money are unbelievable.

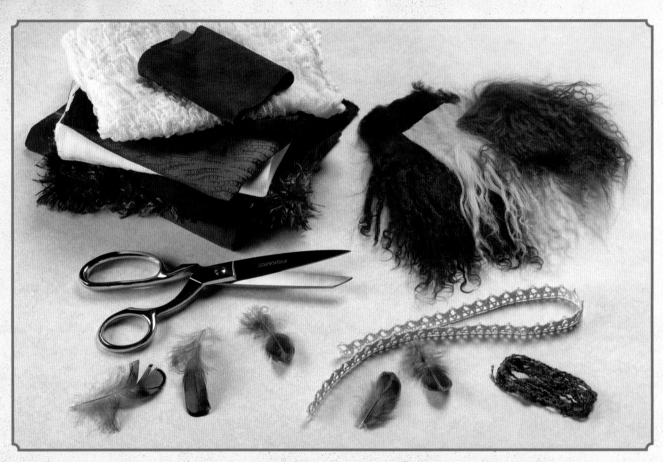

Costume Stash
Collecting fabrics, bits and bobs for your characters is big fun!

Fetch's Fact: Cheesecloth

The characters in this book have a lot of cheesecloth in their costuming. It's inexpensive and easy to find, and looks great on fantasy characters. It's also easy to dye! Grab some powdered dye, drop a teaspoonful in some water, and dip your cheesecloth in. Rinse until the water runs clear and let it dry.

CREATING CHARACTERS

The characters in this book are the most common types of fae—I just make them a little more odd than is considered usual. The pretty winged fairy that we're all familiar with didn't actually become popular until the Victorian era. Before that, fairies were pretty strange and sometimes downright scary. This is where I look for my inspiration.

There are so many types of fae I could list page after page of them; every country has its own kind. When you're ready to make characters other than the ones in *FaeMaker*, do some research—it's a lot of fun! Read fairy tales. Search the metaphysical section of your local bookshop for books about fairies, and of course there are all sorts of sites dedicated to faerie on the Internet.

Develop Your Style

We all have our way of seeing things. Your sculpts won't look exactly like mine, and that's OK. Don't be afraid to let your own style show. Here are some important elements that will help you develop unique characters of your own:

- **Proportion:** Understanding proportion will help make your characters believable, but, because they're not humans, proportions don't have to be perfect. Bigger hands and feet can help your fae look awkward. Big ears may suggest a not-so-smart goblin. Thin arms and legs make an elegant elf.
- **Extremities:** Hands and feet, noses and ears all contribute to the perception of your character. If your goblin is old, his hands will be more gnarly than a goblin pup's hands. Your ogre may have big droopy ears to indicate he's not a happy bunny! Try to vary the way you sculpt the extremities on each character, and remember it's OK to exaggerate.
- **Shapes and Personality:** Your characters are not all the same type of fae, so they will have different shapes. In addition, each has a stereotypical shape: thin, elegant elves; stumpy, sloppy ogres; cute, childlike fairies, and so on. Get the idea? Think about what body shapes you associate with which personality traits, and work up your fae's shape accordingly.

Develop Your Process

My process for making a doll includes sculpting, making the armature, building the body, costuming, and adding the hair and accessories. There will be exceptions to this order, but for the most part, that's the procedure I follow. As you work and experiment, you will develop the process that works best for you.

Practice

Sculpting is for everyone! How well you sculpt is dependent on the time and effort you put into study and practice, and on your own creativity.

If you don't like it, start again! It's only clay and fabric. There won't be a test at the end of the day. If you're *really* frustrated, put the sculpt down and come back to it later. There's not a rule that says you have to finish your character all in one go.

Fetch's Fact: Sketch

Keep a sketchbook for all your ideas and scribbles (or a folder for your "napkin sketches"). You'll be glad you did!

Making an Armature

Everybody needs strong bones, character figures included. An armature allows your oddfae to stand unsupported and makes it a poseable figure. They are fairly simple to make and go together quick. My oddfae range from 6 inches (15cm) to 3½ feet (107cm) tall (so far!). If you can build an armature to support it, there's no limit to the size characters you can make.

MATERIALS

⅛" (3mm) armature wire (approximately 12 gauge), floral wire, glue sticks, hot glue gun, needle-nose pliers

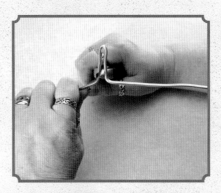

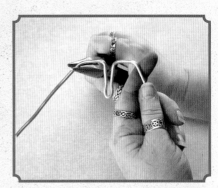

1 Cut Wires and Bend the Legs
Cut a 12-inch (30cm) piece of wire for the legs and a 10-inch (25cm) piece for the arms. Bend both wires in half with the needle-nose pliers. (See the armature map in the pattern appendix.)

Bend the leg wires out at an approximately 50-degree angle for the hips, then bend the wires straight down.

2 Bend the Arms
Bend the arm at a 90-degree angle 1½" (38mm) from the center bend, and then bend another 90-degree angle 1" (25mm) out from the first bend.

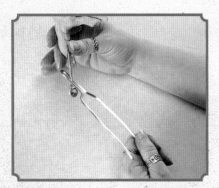

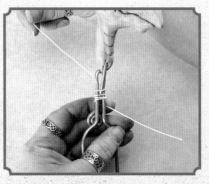

3 Attach the Legs to the Head Wire
Slip the coil from the head wire (see step 1 of the Chrainn the Elf demonstration) into the middle bend of the leg wire and wrap with floral wire.

4 Attach the Arms and Glue
Lay the arm wire over the other two wires and continue wrapping with floral wire.

Secure the armature with hot glue. Trim the arm and leg wires if needed, using the armature map in the patterns section for guidance.

Sculpting Basics

Sculpting an entire face may seem overwhelming, so look at it as a collection of shapes that flow one into the other, rather than as a whole face. First you will lay in basic shapes, then go back and refine the features. This method of modeling is known as *additive sculpting*.

Not baking the face until it's completely sculpted allows more room for experimentation. If you don't like something, you don't have to start over—just push it somewhere else!

When measuring clay, roll it into a ball and hold it alongside a ruler, then press with your fingers to flatten it into the shape desired. You can also use a set of clay cutters in simple shapes, or commercially available rulers specifically designed for measuring clay.

Smoothing or blending two pieces of clay together is a motion rather like putting peanut butter on toast or icing a cake. Don't peck or poke at the clay, or you'll have lots of tiny marks to smooth out later.

Sculpting With Tools

Anything can be a sculpting tool, from manicure sticks to the end of a ballpoint pen to your hands. If it makes the mark you want to make, it's a sculpting tool!

Unless there is a large volume of clay to be moved, use delicate pressure when sculpting.

Don't be afraid! It's only clay with a little character inside who can't wait to meet you.

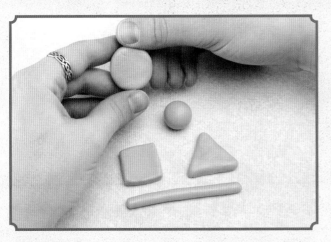

Simple Shapes
The basic shapes you'll be using are square, circle, triangle and rod or snake. Start each with a ball of clay and use your fingers or a tool to form the desired shape.

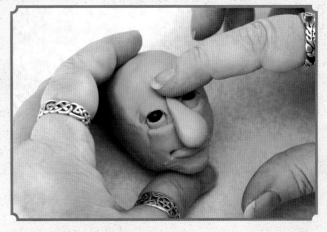

Blending With Your Fingers
You can use your fingers for blending and smoothing some of the facial features.

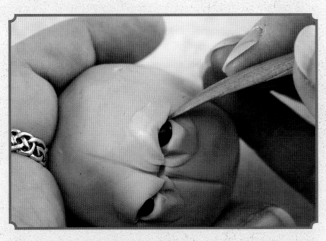

Wooden Sculpting Tool
The rounded end of a wooden sculpting tool works well for shaping the eyes.

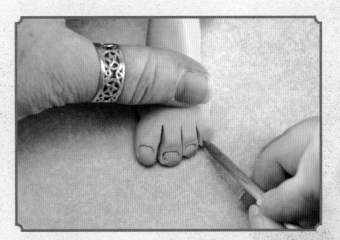

Manicure Stick
Use a small wooden tool such as a manicure stick to add tiny details.

Making hands

Your characters' hands will differ from figure to figure, dependent on the age or weight of the character. The basic sculpting is the same.

MATERIALS

Burnt Umber acrylic paint, craft knife, nos. 3 and 8 round brushes, paper towels, polymer clay (flesh tone of your choice), sculpting tool, Terra Coral acrylic paint

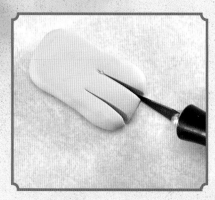

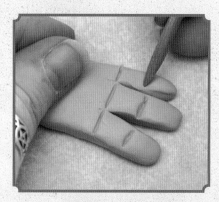

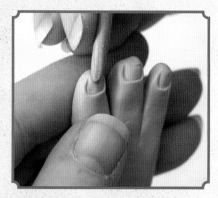

1 Make the Basic Shape and Divide the Fingers

Start with a flattened rectangle of clay half as wide as your character's face, and measuring from the chin to the eyebrows. Divide the hand into fingers using a craft knife, making the middle finger the longest. In my World, characters have only three fingers and a thumb.

2 Round Fingers and Make Bend Marks

Round the edges and ends of the fingers, leaving the top surface of the fingers slightly flattened. Turn the hand over and score lines at the base of the fingers where they meet the palm, and make another line halfway up each finger. When the hand is posed, this is where the fingers will bend.

3 Sculpt the Fingernails

Holding the end of a manicure stick at an angle, draw a line on either side of each finger to mark the sides of the nail. Turn the stick so the flat side is resting on the nail, and gently press in the lines for cuticles.

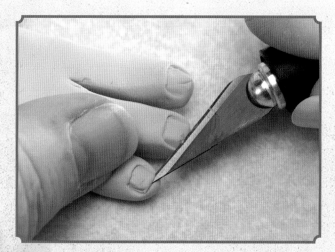

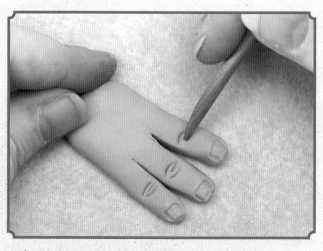

4 Lift the Fingernails

Slide the blade of a craft knife under the end of the nail and lift slightly.

5 Add the Knuckle Lines

Find the place on the top of each finger that is opposite the line on the palm side, and make small lines to represent knuckles.

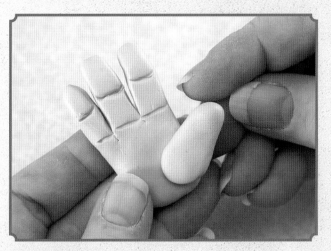
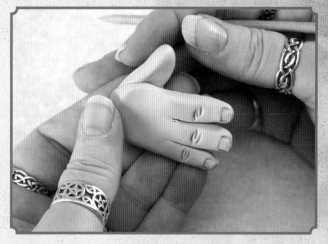

6 Add the Thumb Shape

Roll a teardrop slightly larger than the other fingers. Turn the hand over and add the teardrop to the base of the hand, smoothing the larger end into the palm to make the pad of the thumb.

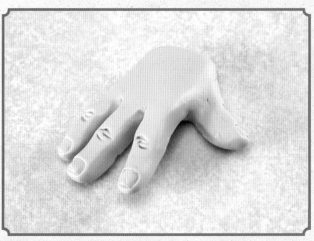

7 Shape the Thumb and Bake

Use the manicure stick to add a thumbnail. Remember, hands aren't flat—look at your own hand to see how thumbs work and where to place the lines of the palm. And don't forget to make a right and a left hand!

Continue smoothing and shaping. Bake at 275º F (135º C) for 20 minutes, or according to the clay package directions.

8 Add Color

Use no. 8 round to paint a thin diluted wash of Burnt Umber acrylic paint over the hands. Then, gently wipe off most of the paint with a paper towel. Repeat as needed or use water to remove excess paint. Paint a bit of Terra Coral over the knuckles with a no. 3 round. Pat the edges of the paint with your fingertip to blend.

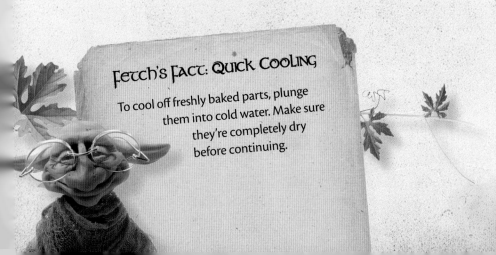

Fetch's Fact: Quick Cooling

To cool off freshly baked parts, plunge them into cold water. Make sure they're completely dry before continuing.

Making Feet

Your characters' feet will differ from figure to figure, mainly in the width of the foot and length and shape of the toes. The basic sculpting is the same.

MATERIALS

Burnt Umber acrylic paint, craft knife, nos. 3 and 8 round brushes, paper towels, polymer clay (flesh tone of your choice), sculpting tool, Terra Coral acrylic paint

1 Make Basic Foot Shape
Roll a 1½-inch (38mm) ball of flesh clay into a long rectangle. Squeeze one end so it is thinner than the other (this is the heel), then flatten the other end so it slopes from the heel.

2 Refine the Shape
Flip the foot over and use a thumb to hollow out the side of the instep. Turning the foot right-side up, push the little toe side backward so the front of the foot is angled.

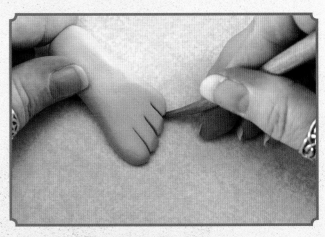

3 Divide the Toes
Use a craft knife to cut the lines for the toes. Make the first toe wider than the others, the third and fourth equal, and the little toe the smallest. Trim the corners of the toes so the shape is more rounded. Use a sculpting tool to smooth all lines and cuts, rounding the toes.

Fetch's Fact: Flat Feet
I usually leave the bottom of the foot unsculpted to provide balance and a more stable base. It's also a great place to sign your work!

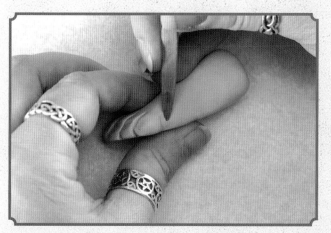

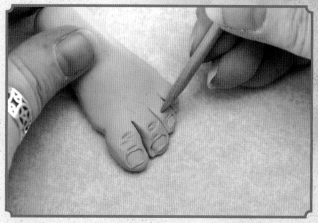

4 Shape the Toes
Flatten the area just behind the toes, but don't squash it too much. Push down on the front of the toes to flatten them as well. The final result should be a gradual stair-step effect. Use a craft knife to cut a notch for the big toe. Smooth the notch so there is separation between the big toe and the ball of the foot. Do the same on the little toe side.

5 Shape the Toenails
Holding the end of the manicure stick at an angle, draw a line on either side of each toe to mark the sides of the nail. Make the front of the nail a little wider than the cuticle end. Turn the manicure stick so the flat side is resting on the nail, and gently press in the lines for the cuticles. Slide the blade of a craft knife under the end of each nail and lift ever so slightly. Mark knuckle lines with the side of the manicure stick.

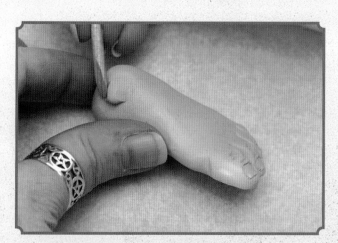

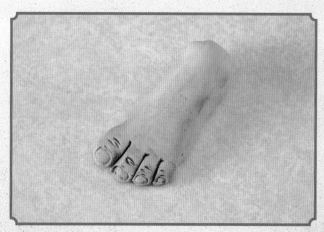

6 Shape the Anklebones and Bake
Put a small pancake of clay on either side of the foot, then smooth and blend to make the anklebones. Bake at 275º F (135º C) for 20 minutes, or according to the clay package directions.

7 Add Color
Use a no. 8 round to paint a thin diluted wash of Burnt Umber acrylic paint over the feet. Then, gently wipe off most of the paint with a paper towel. Repeat as needed or use water to remove excess paint. Paint a bit of Terra Coral over the knuckles with a no. 3 round. Pat the color at the edges to blend.

making heads

Meet Alouicious! Well, actually, you're going to sculpt him. Alouicious is a basic character, so sculpting him will help familiarize you with the techniques used to sculpt any face. You can refer back to this more detailed demonstration if you get stuck when working on other figures.

MATERIALS

aluminum foil, baby oil, Burnt Umber acrylic paint, craft knife, cookie sheet, ½" (12mm) floral tape, needle tool, no. 2 or 3 filbert brush, nos. 3 and 8 round brushes, ⅓" (8mm) onyx beads (2), paper towels, polyfill batting, polymer clay (flesh tone of your choice), sculpting tool, Terra Coral acrylic paint

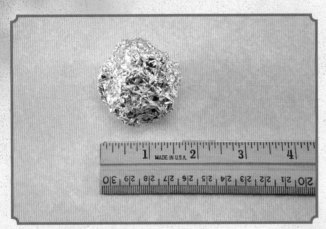

1 Make a Foil Ball
Tear off a 12-inch (30cm) square of foil. Crumple it up into a 1½ to 2-inch (38mm to 51mm) ball. Wash your hands to remove any black marks and residue from the foil so it doesn't come off into the clay (I use a baby wipe).

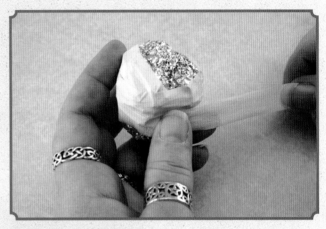

2 Cover the Foil With Tape
Wrap the foil ball with floral tape. When you take the tape out of the package, stretch it to activate the sticky gum. Just twist it around and cover the ball. Make sure all the foil is covered.

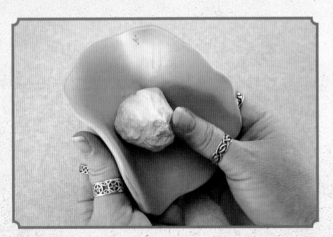

3 Cover the Ball With Clay
Flatten a 3-inch (8cm) chunk of flesh-colored clay into a ⅛-inch (3mm) thick sheet. I use a pasta machine, but a rolling pin, an acrylic roller or a brayer (anything that's smooth and won't leave texture in the clay) would also work. Cut out a 5½-inch (14cm) circle. Start wrapping the clay around the foil ball, covering it completely. Overlap the seams and smooth them out using a wooden sculpting tool. Trim off the excess with a craft knife. Then smooth it out, rolling it on the table or in your hands. Make it head shaped, slightly oblong. The foil is still shapeable, so you can squeeze and shape it.

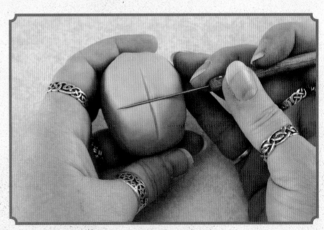

4 Position the Features
Use a needle tool to make a line exactly down the middle from top to bottom. This is the center line of the face. Make a line that crosses it at exactly halfway.

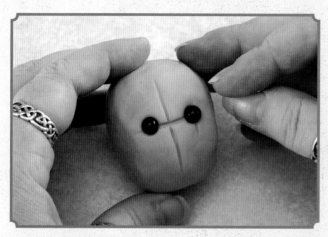

5 Add the Eyeballs

I use ⅓" (8mm) onyx beads for eyes, but you can also use pre-baked balls of clay. The eyes go exactly on the horizontal line. Just press them in about halfway so half the bead is sticking out.

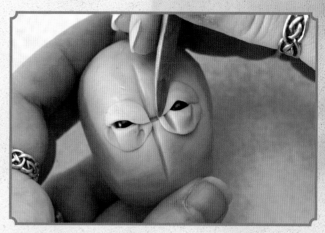

6 Add the Eyelids

Using leftover clay, roll two ⅜-inch (10mm) balls. Use your fingers to flatten each ball into a ½-inch (12mm) circle and cut each in half. Put one half circle under each eye, covering about half the bead (the flat part goes over the bead). Place the remaining halves over the top part of each eye. Use the pointed end of a sculpting tool to press in the clay on the lower lid and upper lid to make the corners of the eyes.

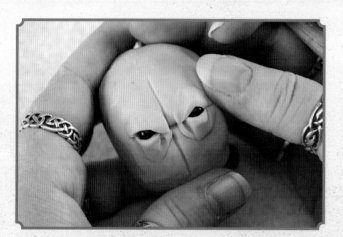

7 Continue Shaping the Eyelids

Blend the eyelid clay into the face using your thumb or the sculpting tool. Using the pointed end of the tool, move the clay off the eyeball, opening up the eyes.

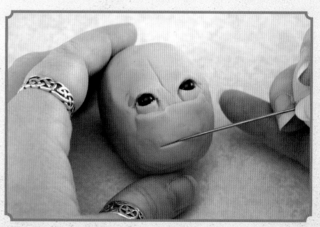

8 Add the Lower Face and Mouth Line

Using a craft knife, cut out a rectangle of flesh clay that fits over the lower part of the face (about 1" × 1½" [25mm × 38mm]). Place the clay right under the lower eyelids. Use the needle tool to draw a horizontal line across the rectangle, halfway between the eyes and the bottom of the face.

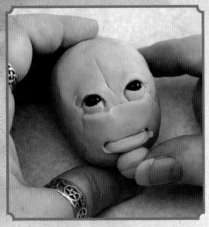

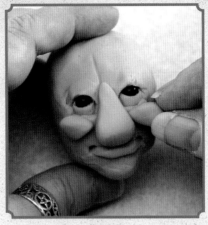

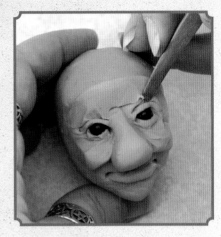

9 Add the Lower Lip and Chin
Roll a small piece of clay into a ¾-inch (19mm) snake. Use the pointed end of the sculpting tool to tuck the corners of the lower lip under the corners of the upper lip. Make a ½-inch (12mm) ball of clay for the chin and place it under the lower lip. Blend it with the end of a tool or with your fingers.

10 Add the Nose and Cheeks
Use your fingers to form a ½-inch (12mm) ball of clay into a teardrop shape and flatten out the end. Place it on the face so the pointed end is between the eyes. Create two ¼-inch (6mm) balls of clay. Form both into small teardrops and place them on either side of the nose, with the point towards the nose. Blend it all together with the end of the sculpting tool.

11 Add the Forehead
Adding more forehead makes your character look wiser. Add a 1-inch (25mm) strip of clay above the eyes. Blend it in with the sculpting tool or your fingers. We just raised his IQ by about twenty points! Look at your work from all sides, including upside down and around the sides. This helps you spot any uneven or lopsided features.

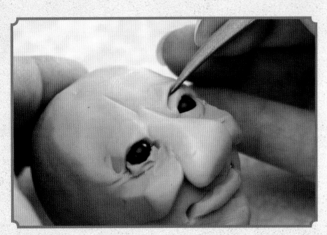

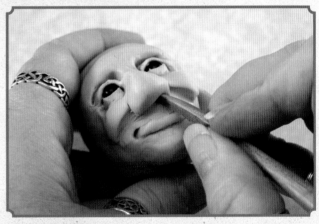

12 Smooth and Refine the Features
Blend the shapes with the pointed end of the sculpting tool. The clay will move around and do its own thing. This can be a good thing! Alouicious gets dents and lines, which add personality to his expression. Use the pointed end of the sculpting tool to score the line for the eyelid over the eyeball.

13 Refine the Nose
For nostrils, stick the pointed end of the sculpting tool in and gently pull outward to widen the nostril towards the cheek, creating the flared part. At the top of the nose, next to the corner of the eye, put the pointed end of the tool in and press down to shape.

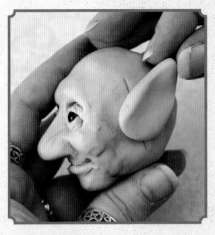
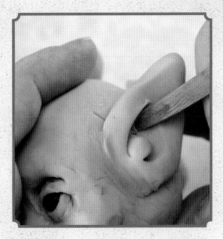
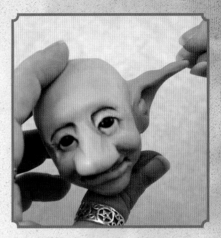

14 Add the Ears

Make two ⅝-inch (16mm) balls of clay, then form each into flattened 1-inch (25mm) teardrops. Place one on each side of the head, halfway between the cheek and the back of the head. Make the bottom of each ear about even with the nose. Smooth the front into the face with the end of the sculpting tool.

Continuing with the tool, draw a backwards C-shape into his left ear and a regular C-shape in the right ear. At the top of each C, draw a line following the top of the ear. Press the clay in to make an opening for the ear. Smooth the top of the ear and shape it with your fingers. Pull the point out as needed. Ears form part of the expression. They can point up (alert or happy) or they can be flat (neutral) or pointed down (sad or tired).

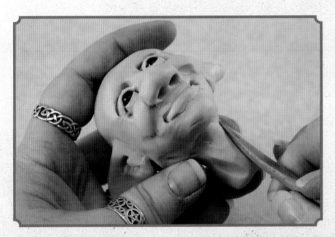

15 Form the Neck, Smooth the Sculpt and Bake

Roll a ⅞-inch (22mm) piece of clay into a 1-inch (25mm) cylinder, flattening each end. Place it at the bottom of the head, lining it up with the ears. Blend it with the pointed end of the sculpting tool or your fingers. Point the end of the tool towards the ear and press a line into the neck to make the neck muscles. Use a no. 2 or 3 filbert brush with a tiny bit of baby oil to smooth all the features, removing all the finger prints and extra marks.

Place the figure on a cookie sheet covered with batting to prevent flat spots. Bake at 275° F (135° C) for 20 minutes, or according to the clay package directions.

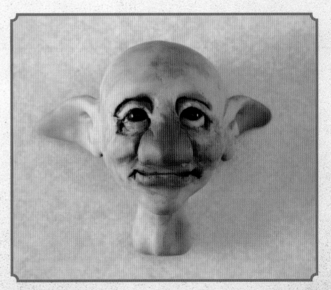

16 Add Color

Use a no. 8 round to paint a thin diluted wash of Burnt Umber acrylic paint over the head. Then gently wipe off most of the paint with a paper towel. Repeat as needed or use water to remove excess paint. Dab a thin layer of Terra Coral over the tips of the ears, the forehead, the end of the nose (a little darker here), the lips and the cheeks with a no. 3 round. Pat the edges of the paint lightly with your finger so there isn't a sharp line. To remove dry paint, scrape gently with the back of a craft knife blade.

body building

We're not going to make your fae lift weights, but there does need to be muscle over that wire skeleton you made. I build up the body a little at a time so I get exactly the shape I want. You'll be using quilt batting and cotton balls.

There are two important tools for wrapping a character body: a container of water that your fingers will fit into and a tool to stand in for your finger. Trust me, you don't want to touch hot glue! If you get hot glue on your finger, don't stop to try to peel it off. Don't try to wipe it off. Immediately stick the gluey appendage in the water. This will save you from bad burns and blisters.

The finger-replacing tool will keep your fingers out of the way of the glue. I use a knitting needle or chopstick. After the glue cools, just peel it off the tool. If you don't like to use hot glue, Fabri-Tac or another instant glue will work, but it's *really* messy.

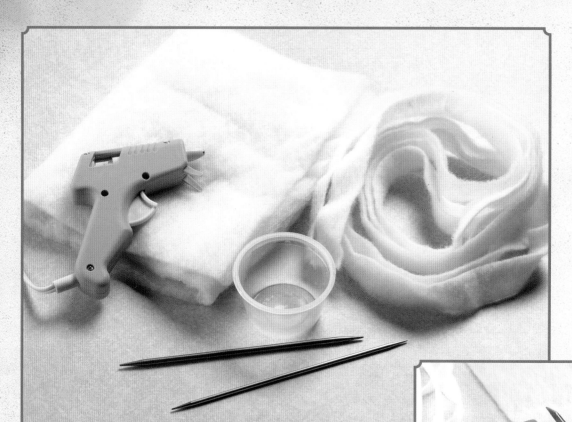

Basic Body Building Tools
To build your doll's body you'll need batting strips, scissors, a glue gun, a knitting needle and a cup of water for cooling burnt fingers!

Fetch's Fact: Batting's Better Side
Hold a strip of batting between your hands and gently pull, then turn it over and pull once again. One side will curl in at the edges when you pull on it; note which side curls, and make sure that side faces the figure as you wrap. If the curl faces to the outside, your character will have stripes and ridges all over!

Cut Batting Strips
To start, pick up a corner of the quilt batting and pull gently first one direction, then the other. One direction will tear, the other will not. Cut the batting into 1-inch (25mm) strips along the side that doesn't tear.

Padding a Character body

Wrap your character in layers, working symmetrically from side to side; if you use an entire strip of batting on one leg, do the same on the other. You can use the cotton balls to make big tummies and tushes, or big muscles!

MATERIALS

constructed armature, cotton balls, hot glue gun and glue sticks, knitting needle or chopstick, 1-inch (25mm) quilt batting strips, small water container

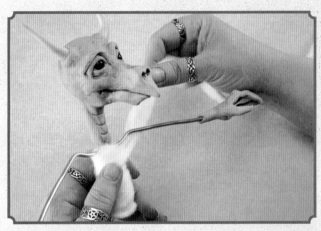

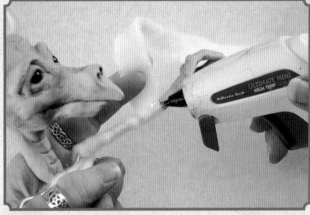

1 Start Wrapping the Body
Start to wrap up the wire, overlapping the edges of the batting to completely cover the wire. Wrap tightly, but don't pull the batting so hard it tears.

2 Secure the Batting With Hot Glue
Put a drop of glue on the wire and put the end of a batting strip in the glue. When you reach the end of a strip of batting, apply a dab of glue and hold down the batting with the end of the knitting needle or chopstick until the glue grabs. The glue will stay warm for a few seconds, so be careful! I have been burned through the batting.

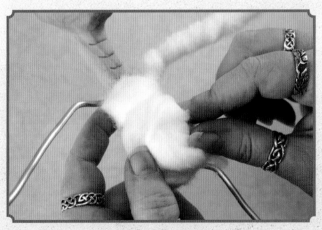

3 Use Cotton Balls to Pad the Body
When you want to pad out a body part quick, glue cotton balls to the batting and wrap over them. Told you it was easy!

Fetch's Fact: Pad Lightly

Remember that there will be costuming over the padding, so if your figure looks a little skinny, that's OK. Don't over-pad the body unless you want a heavier figure.

The Wardrobe Department

The process of costuming a doll is very organic, at least for me. I usually have a basket set aside when I first start the sculpt, and I throw anything into it that may be used for the finished costume: fabrics, props, buttons, etc.

I don't know which of the materials will or won't be used, but when I turn them out on my sewing table, the jumble can suggest combinations I may not have thought about.

None of this is written in stone—breaking the "rules" of costuming can add more to your character than doing the expected. Have fun with it!

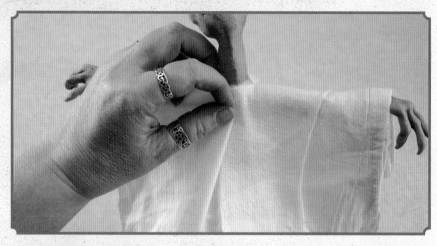

Gluing or Sewing

Most of the time, I use instant fabric glue to put together costumes because my dolls' clothing is not removable. Shirts, pants, vests and skirts can all be glued. When gathering waists and cuffs, gluing makes for less bulk than using a gathering stitch. Glued clothing will stay put and drape exactly the way you want it.

If you like to sew, go for it! A simple ladder stitch can be used on all garments and is practically invisible. If you want leggings to fit close, sewing works better—I just don't have enough hands to turn under a seam, hold the two sides together, put 'em where I want and apply glue all at once.

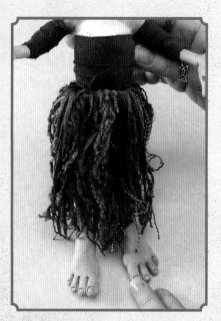

Twisting and Tying

Innovative methods of costuming add personality. If you can attach it to a doll, you can use it for clothing. It would take forever to apply the fibers of this fairy's skirt individually, but stringing them on a wire that will be hidden works perfectly and allows you to adjust the way they hang as you like.

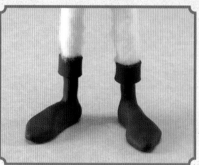

Shoes and Boots

I rarely make "real" shoes of leather. It's difficult to find leather thin enough to use for dolls of this size, and making leather shoes is a skill all its own that takes a lot of practice (and Bad Words). You can make some really fanciful shoes in clay that may not be possible to make with leather.

Wrapping and Gluing

I use cheesecloth when wrapping clothing because the edges of the fabric disappear, making the garment appear to be one piece. It's also inexpensive and you can dye it any color you wish. And it's easier than sewing!

The Prop Department

Making or finding props for your fae adds a lot of character.

 Adding something in scale, or compatible in size with the character, will make a different statement than a huge prop and a small fae. An in-scale prop suggests a miniature representation of a larger character, while a large prop conveys the idea of an actual-size miniature fae.

 You can use marbles for crystal balls, sticks for staffs or canes, or twist a bit of raffia around a stick, tie with thread, and you've made a witch's broom! A fairy lass holding a big silk flower might be caught in the rain but keeps dry with an improvised umbrella.

 Start collecting things you think your oddfae would use in their everyday lives—use your imagination, and you'll be surprised what you come up with!

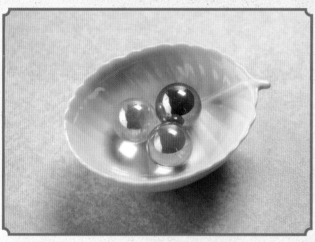

Crystal Balls
Marbles make great crystal balls. You can also use a small glass ball if you can find one.

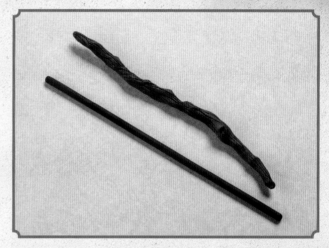

Staffs
You can make staffs and walking sticks from wood or clay.

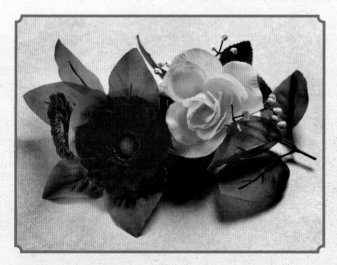

Silk Flowers and Leaves
Silk flowers are good props for fairies.

Witch's Broom
You can make a witch's broom with a stick and raffia.

hair

When choosing hair for a character, I think about the age, costuming and personality. A messy ogre will probably have coarse, uncombed hair, while a fairy will typically have long flowing tresses. Can you imagine a goblin with a neatly trimmed side part?

Choose your wigging materials accordingly, using length and texture. The demonstrations here use Tibetan lambskin or braided mohair. If you feel like your figure doesn't need hair at all, that's fine, too. Some dolls just will not let me give them hair, so I leave them bald!

No matter the type, some of the same techniques apply. For thick hair, butt the rows of hair up against one another. For thinner hair, leave a little room between rows. Glue the last row on backwards so it hangs over the face, then sweep back over the rest of the hair and secure with a bit of glue. Style the hair and spray it with hair spray to hold.

Cutting Braided Mohair
When wigging with mohair braid, cut off small lengths and fluff out, then lay the ends of the hair in the glue and leave it alone until the glue dries.

Applying Mohair
Run a line of white craft glue around the hairline, and let it set up until it's tacky. Carefully lay prepared mohair in the glue. Continue adding glue and hair, working your way from the back hairline forward, or from the hairline to the center of the head.

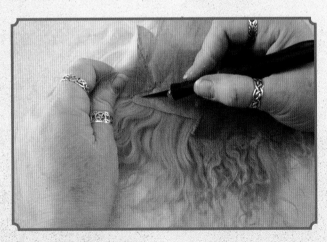

Cutting Tibetan Lambskin
Cut strips of lambskin that reach from ear to ear on the head. Use a knife with a very sharp blade. Turn the skin over so the hair side is down, and using light pressure, carefully cut through just the fabric. This way, you won't have one edge of shorter fur, and there won't be fine bits of fur everywhere. The strips should be a little less than a ½" (12mm) wide.

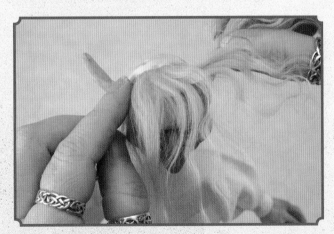

Applying Tibetan Lambskin
Run a line of white craft glue around the back of the hairline, and let it set up until it gets tacky. Carefully lay a strip of lambskin in the glue, trimmed to reach from ear to ear.

Pay attention to the way the hair grows on the skin, and make sure to glue it on so it hangs down the character's back. Continue adding glue and hair, working your way from the back hairline forward.

hats

Hats can really top off your character—no pun intended! A hat is sometimes just the finishing touch that is needed to define a character. If you've just made a wizard, but he's not quite "wizardly" enough, a hat with some stars is just the thing. Can you imagine a magician without a hat? Where would his rabbit live?

If I'm making a character that doesn't usually have a hat, I let the doll tell me if it needs one. It may sound strange, but you can just feel when you're not done costuming. Occasionally I get an idea for a hat that needs a doll!

Hats are usually made of stiffer fabric such as felt or Ultrasuede. These fabrics are heavy enough to retain their shape, but not so thick as to be out of scale with other accessories. Thin leather and silk are great fabrics for hats, but may need starch or stiffeners to hold the hat's shape.

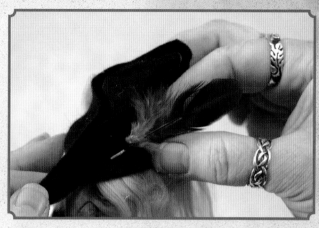

Elf Hat
The elf hat is based on a hunter's hat—not enough brim at the back to interfere with a bow, but enough in front to shade the eyes. It's the original baseball cap! Any fae who's off on adventure could wear a hat like this.

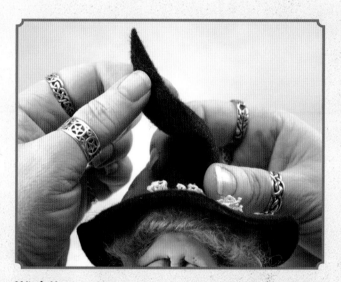

Witch Hat
The witch's hat has become a cultural icon. It's instantly recognizable and is based on a real hat worn in the 1700s. Your witch's hat can be a great part of her expression: a straight hat can indicate an evil, domineering witch; a crooked hat, a grandmotherly character; or a droopy hat may convey a sad witch. Construct it with a circle for the brim and a triangle rolled and trimmed into a cone. (See hat patterns in the appendix.)

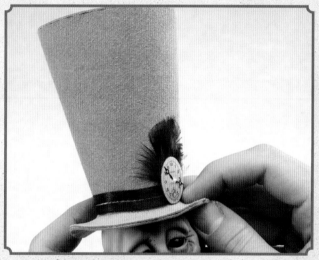

Top Hat
Top hats can convey elegance or a jaunty personality. It all depends on the angle it's worn. Making a top hat is easy: it's two circles on bottom, one on top and a tube in between. The construction is exactly like the witch's hat; just make a square instead of a triangle, roll it into a tube and put a flat top on it.

Walking with Oddfae

I am often asked, "What are oddfae?" Oddfae are simply the way I see faerie.

My first exposure to fairy tales was through the Brothers Grimm and Arthur Rackham with their stories and illustrations, many of which included gnarly and twisty little men. Pretty fae, not so much. Pretty fairies have never held much appeal for me.

After I started reading everything I could get my hands on about faerie, I realized that pretty fairies are actually a pretty modern idea, so to speak, first becoming popular in Victorian times; up until then, the fae were pretty scary. One never called them "fairies" for fear of their taking offense, and they were very easily offended! Fae were referred to as "The Good Folk," "The Little People" and any number of other euphemisms.

Country folk definitely didn't want to anger the fairies for fear of a faerie curse upon their house and

home. If one met a stranger upon the road, best be polite! That stranger might be a fae in disguise. However, it was possible to recognize a fairy, as it would always have some sort of unusual physical trait, such as a huge nose, only three fingers on each hand, or being unbearably ugly—their feet could even be on backwards!

My oddfae gradually evolved from the idea that fairies ain't pretty! Somehow they never turn into evil or malicious characters, just happy little ugly guys, who like leaves and trees and shiny stones and hiding in anything large enough for them to squeeze into. Oddfae are occasionally cranky, but they are never mean or cruel. (Autumn Things are a different kettle of fish, but that's a story for another time ...)

Besides, ugly and odd faces with lots of lines and wrinkles are so much more fun to sculpt than smooth, pretty faces!

What inspires me? My oddfae come to me in little snippets of stories that suddenly pop into my head, an odd turn of phrase, or puns. Sometimes a color suddenly tells me it needs an oddfae to wear it, or a rock needs a gnarly hand wrapped around it. Or I'll just sit down with some clay and see who's waiting inside.

Who's waiting for you?

CHRAINN the ELF

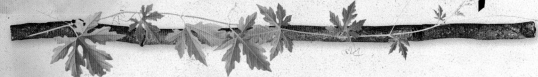

Children, children, don't forget
There are elves and fairies yet;
Where the knotty hawthorn grows
Look for prints from fairy toes.

—"CHILDREN, CHILDREN, DON'T FORGET" BY DORA OWEN

*L*ook for footprints of Chrainn the elf around all types of trees, not just hawthorn. He wanders the Wood, caring for trees and animals and protecting the forest from harm.

In Spring, Chrainn collects sticks and twigs to help birds build their nests. When Summer comes, he often has his toes in a stream, making sure the tadpoles are growing nicely and the catfish aren't picking on them.

Autumn is Chrainn's favorite season; he gathers feathers for the wood mice to line their dens in preparation for sleep, and he dances with the leaves as they turn color and fall. You will often see him in Autumn leaning on his stick, listening to the voices of the trees as they grow slow and drift off to sleep.

Chrainn has few charges to look after in Winter as the Wood sleeps under its blanket of snow. After making sure the chickadees and jays are fed, Chrainn takes advantage of his free time in games of tag with wind-blown snowflakes, and fashioning ice skates from spiderwebs and locust tree thorns to zip across frozen ponds.

If you happen to meet Chrainn while wandering, be sure to say hello!

MATERIALS

Polymer clay colors: flesh tone of your choice, gray

Acrylic paint colors: Burnt Umber, Terra Coral

Fabrics: black felt, black silk, brown microsuede, teal four-ounce leather, Tibetan lambskin or faux fur, white cotton

Sculpting tools: craft knife, manicure stick, needle tool, needle-nose pliers, wooden sculpting tool

Other supplies: aluminum foil, ⅛" (3mm) armature wire (approximately 12 gauge), baby oil, boxwood dowel, fabric glue, feathers, ½" (12mm) floral tape or masking tape, floral wire (32 gauge), hot glue gun and glue sticks, knitting needle for pressing fabric into hot glue, no. 4, filbert brush, nos. 3 and 8 round brushes, ⅓" (8mm) onyx beads (2), paper towels, polyfill for baking, quilt batting, sanding stick, scissors, small container of water for burnt fingers, super glue, white craft glue

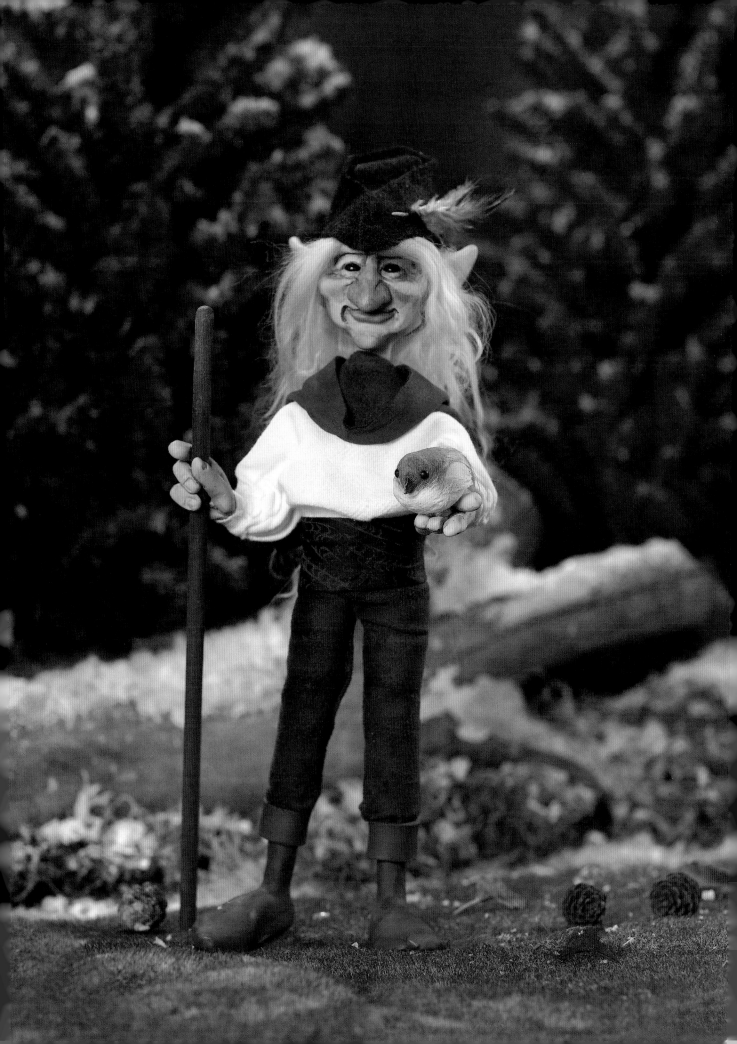

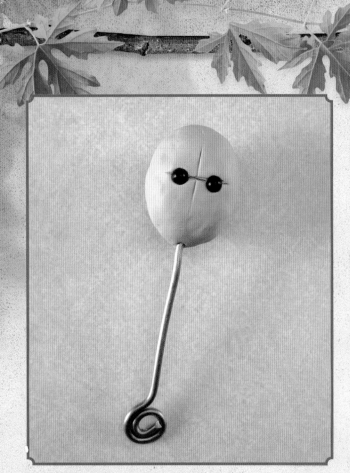

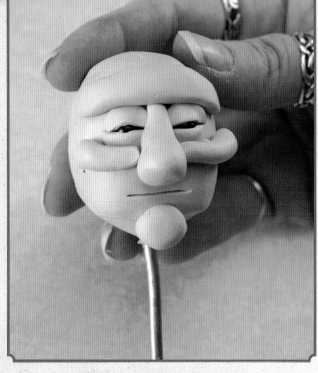

1 Form the Head and Establish Placement of Features

Cut a 7-inch (18cm) piece of ⅛-inch (3mm) wire for the head wire portion of the armature. Coil about ½" (12mm) of each end, and bend one coil at a right angle to the rest of the wire. With a 12-inch (30cm) square of aluminum foil, create a 2-inch (5cm) ball for the head over the bent coil. Completely cover the foil ball with ½-inch (12mm) floral tape.

Roll a 2-inch (5cm) ball of flesh-colored clay into a 5-inch (13cm) circle, ⅛" (3mm) thick. Press the clay over the foil ball with the seams towards the neck wire. Remove the excess clay and smooth the ball by rolling it between your hands. The foil is still moldable, so squish the ball to make it a little narrower side to side.

Use a needle tool to create a vertical line that aligns with the neck wire and a horizontal line that crosses in the middle. This forms the eyeline. For the eyes, place an onyx bead at either end of the horizontal line.

2 Place Clay Shapes to Form the Features

Make two ½-inch (12mm) balls of flesh-colored clay, flatten them into ½-inch (12mm) circles, and cut each circle in half. Place a half circle over the top and bottom of each eye for the eyelids. Flatten a ½-inch (12mm) ball into a 1" × ½" (25mm × 12mm) rectangle and place horizontally beneath the eyes. Flatten a ½-inch (12mm) ball into a 1½-inch (38mm) snake, and place it over the eyes for the forehead. Place a ⅜-inch (10mm) ball under the rectangle for the chin. Place a ½-inch (12mm) ball between the eyes for the nose. Place a ⅜-inch (10mm) ball just below each eye for the cheeks. Use the needle tool to draw a short line for the mouth halfway between the nose and the chin.

Fetch's Fact: Air Bubbles

If an air bubble forms while you're working clay (you'll be able to feel it sliding beneath the surface of the clay), pierce it with a craft knife or needle tool and press the air out.

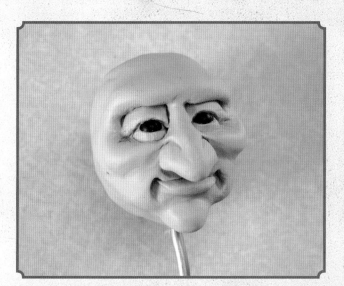

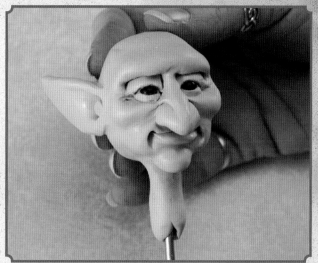

3 Blend and Shape the Features

At the corners of the eyes, tuck the lower eyelids under the upper eyelids with the rounded end of a manicure stick. Open the eyes and flatten the upper eyelids.

Use the rounded end of a manicure stick to blend the top of the brow bone into the head. Blend the outer edges of the brow bone down and the edges of the cheekbones up. Blend the top of the cheekbones into the lower eyelids.

Blend the top of the nose with the brow bone. Press with the rounded end of a manicure stick to make a dent at the place where the nose and brow bone meet. Then blend the sides of the nose onto the cheekbones. Blend the bottom of the nose and the bottom of the cheekbones into the face. Pinch the nose with your fingers to bring it out into a point. Insert the pointed end of a manicure stick under the nose next to the face to create the nostrils. Model the outer part of the nostril with the rounded end of a manicure stick.

Roll a ¼-inch (6mm) ball of flesh clay into a snake the length of the mouth. Place it even with the mouth line and blend the lower edge to form the bottom lip. Add small smile lines even with the sides of the nose. Blend in the chin. Use the round end of a manicure stick to create the space between the nose and mouth. Use a no. 4 filbert and baby oil to smooth out any fingerprints or unwanted indentations.

4 Add the Ears and Neck

Roll two ⅝-inch (16mm) balls of flesh clay into 1½-inch (38mm) teardrops for the ears. Gently squeeze the long edges together to create a slight curve. Place the ears halfway back on the head, making the top of the base even with the eye. Use the pointed end of the sculpting tool to blend and attach the ears. Use the pointed end of the manicure tool to make a backwards C-shape in his left ear and a regular C-shape in the right ear. Above each C-shape, draw a line following the top of the ear. Press in on the clay making an ear opening behind each C-shape. Gently pull out and up on the tip.

Roll a ⅝-inch (16mm) ball of flesh clay into a 1-inch (25mm) cylinder. Use a craft knife to slit halfway through the cylinder vertically and wrap it around the neck wire with the seam in the back. Smooth the seam together, and blend the neck into the head.

5 Make the Staff

Round the ends of a 9-inch (23cm) piece of boxwood dowel with a sanding stick. (In a pinch, you could use a chopstick, though you'd also need to sand the edges to make it round.) Paint the staff with a no. 8 round and Burnt Umber.

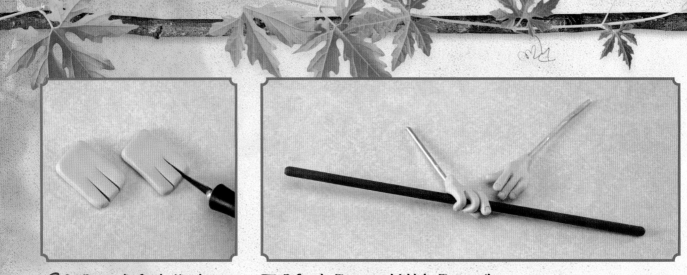

6 Cut Rectangles for the Hands, Divide the Fingers

Flatten two ¾-inch (19mm) balls of clay into 1" × 1½" (25mm × 38mm) rectangles, about ⅛" (3mm) thick. Use a craft knife to divide the hand into three fingers.

7 Refine the Fingers and Add the Fingernails

Use your fingers to gently smooth the cut edges of the clay fingers. Carefully pull the clay to lengthen and shape. Fingers aren't round tubes—they're slightly flat across the top, and they taper at the end. Make the middle finger the longest, the forefinger a little shorter, and the little finger the shortest.Use the round end of the manicure stick to mark the fingernails (don't lift the end of the fingernail this time). Roll two ⅜-inch (10mm) balls into ¾-inch (19mm) teardrops for the thumbs. Use the round end of the manicure stick to mark the thumbnail. Attach one to each hand (be sure to make a right and left hand!). Insert short, straight wires into the wrist end of each hand as a placeholder for the arm wire. Pose the fingers. Wrap the right hand around the staff, scoring the underside of the fingers to make them bend. Redefine fingers as needed. Leave the staff in place and bake at 275° F (135° C) for 20 minutes, or according to the package instructions.

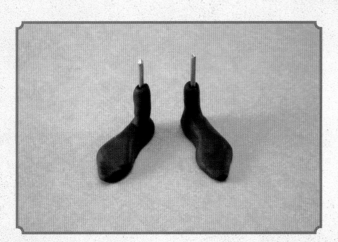

8 Build the Boot Bases

Form two 1⅛-inch (28mm) balls of dark gray clay. Shape each into a rectangle with a flat front. Pinch the back of the boot shape, gently rounding it to make the heel. Pull one side of the front into a point for the big toe with your fingers. Repeat on the other boot, making sure that you have a right and a left. Continuing with your fingers, pull the little toe side out wider on each boot. Stick a short, straight piece of wire at the back of each boot as a placeholder for the armature leg wires. Make two ⅝-inch (16mm) balls of dark gray clay, and roll each into a 1-inch (25mm) cylinder, flattening each end. Slice open each cylinder and wrap one around the wire of each boot, then blend the boot and cylinder together. Stick a short, straight placeholder wire in the top of each boot.

9 Add the Boot Tops and Details

Flatten two ⅝-inch (16mm) balls into two 1¾" × ½" (44mm × 12mm) rectangles. Form a loose circle around the shaft of the boot. Gently press the front and back together so the bottom edges connect to the boot. Leave the rest of the cuff loose.

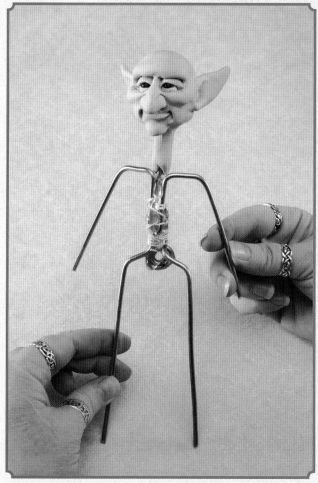

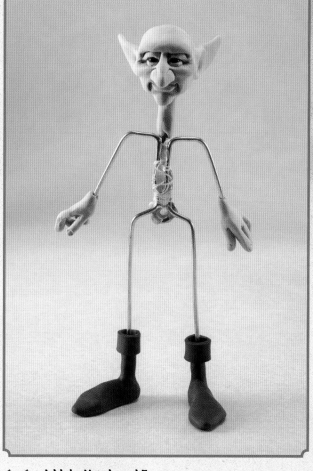

10 Build the Armature

Cut a 12-inch (30cm) piece of ⅛" (3mm) wire for the legs and a 10-inch (25cm) piece for the arms. (See the armature map in the patterns appendix.) Bend both wires in half with the needle-nose pliers. Bend the leg wires out at an approximately 50-degree angle for the hips (see the armature map), and then bend the wires straight down. Bend the arm at a 90-degree angle 1½ inches (38mm) from the center bend and then bend another 90-degree angle 1 inch (25mm) out from the first bend. Slip the coil from the head wire into the middle bend of the leg wire and wrap with floral wire. Lay the arm wire over the other two wires and continue wrapping with floral wire. Secure the armature with hot glue. Trim the arm and leg wires if needed, using the armature map for guidance.

11 Add the Hands and Feet

Twist and remove the placeholder wires from the hands and feet. They pop out easily once the clay has cooled. Do the same to remove the staff from the right hand. Add a drop of super glue to the hole in each hand, and stick the right arm wire into the right hand and the left arm wire into the left hand. Repeat this process with the feet. There should be 3" (8cm) of leg wire between the tops of the boots and the hips, and 2" (5cm) of arm wire between the tops of the hands and the shoulders. Trim if needed.

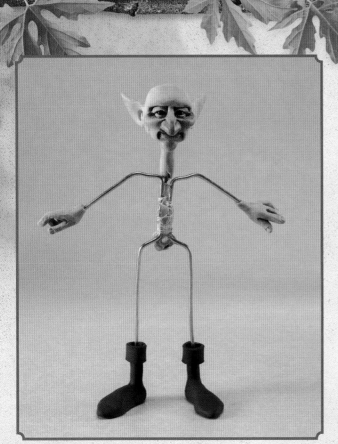

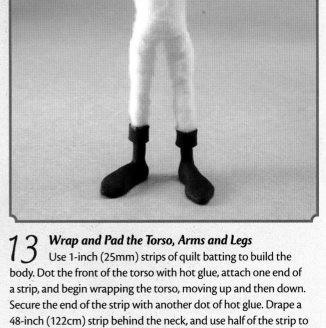

12 Add Color to the Completed Sculpt

Use a no. 8 round to paint a thin diluted wash of Burnt Umber over the head and hands, and gently wipe off most of the paint with a paper towel. Repeat as needed, or use water to remove excess paint. Dab on a thin layer of Terra Coral over the tips of the ears, the forehead, the end of the nose (a little darker here), the lips and the cheeks with a no. 3 round. Pat the edges lightly with your finger so there isn't a sharp line. To remove dry paint, scrape gently with a craft knife.

13 Wrap and Pad the Torso, Arms and Legs

Use 1-inch (25mm) strips of quilt batting to build the body. Dot the front of the torso with hot glue, attach one end of a strip, and begin wrapping the torso, moving up and then down. Secure the end of the strip with another dot of hot glue. Drape a 48-inch (122cm) strip behind the neck, and use half of the strip to wrap each arm, moving down and then back up the arm. Cross the leftover batting strip from the right arm over to the left side of the body, and start wrapping down the left leg and vice versa. Drape a 36-inch (91cm) strip around the waist from the back and continue wrapping the legs. Generally the legs and arms should have two layers of batting with an extra layer around the torso.

Technique: Painting Your Character

Dilute the paint used for the overall wash to the consistency of 2% milk. Paint it all over the sculpt, then wipe off most of the color with a paper towel. Repeat as needed to achieve the desired color. If the paint gets too dry to remove easily, scrub the sculpt gently with an old paintbrush under running water. Let it dry thoroughly and begin again.

14 Make the Pants

Cut a 5" × 5" (13cm × 13cm) piece of brown microsuede (see the trousers pattern in the appendix). Place a drop of fabric glue on the back of the waist. Stretch the fabric around the waist (make sure you work with the stretch of the fabric) and glue down both edges. Using scissors, cut the fabric between the legs, stopping short of the crotch. Run a bead of fabric glue down one edge of one pant leg. Fold over the other edge and press the edges together. Repeat for the other leg. Trim the pant legs if necessary, leaving enough to tuck into the tops of the boots. Use a knitting needle to press the edge of the pant legs into the boot cuffs.

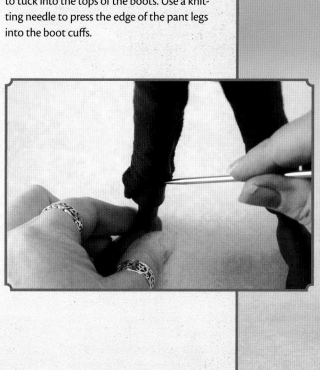

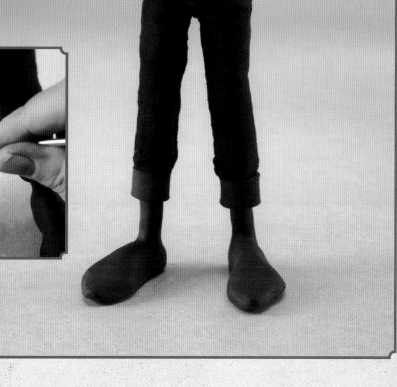

FETCH's FACT: MEASURING

All fabric measurements are approximate. Hold the fabric up to your doll to make sure you're cutting the right size.

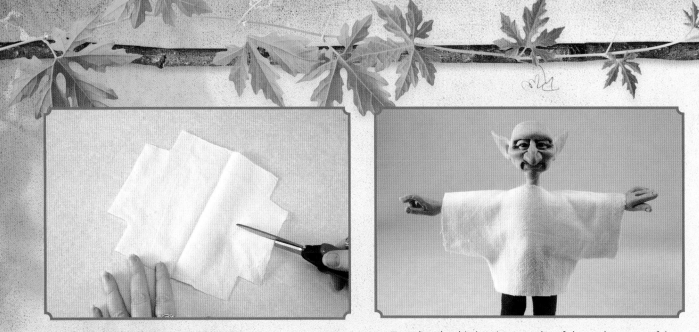

15 Make the Shirt

Cut a 6" × 7" (15cm × 18cm) piece of white cotton. Fold the fabric in half, putting the 7-inch (18cm) sides together. (See the shirt pattern in the appendix.) Cut a 1" × 1" (25mm × 25cm) notch from each unfolded corner, cutting through both layers. Cut halfway up the folded edge, turn the scissors 90 degrees and cut a ½-inch (12mm) slit. Drape the shirt over the shoulders, with the long slit in the back. Lay a bead of fabric glue down one edge. Fold the other edge over and press together to form a seam. Run a line of glue down each side of the shirt, and press the seam closed, right sides together. Glue the seam on the underside of the sleeves in the same manner.

To gather the shirt's waist, put a dot of glue at the center of the back. Press the fabric into the glue and hold until set. Put a dot of fabric glue at the center front of his waist. Press the fabric into the glue and hold until set. Pull the fabric away from his side to find the center, and secure with fabric glue. Do the same on the other side. Continue in this manner all around his waist, always securing at the center point between two glued spots. The shirt will be glued to his waist in eight places.

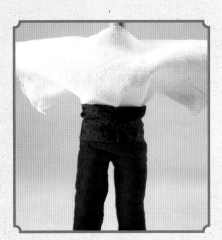

16 Add a Sash

Cut a 6½" × 2" (17cm × 5cm) piece of black silk. Place a dot of glue on the back waist, then stick down a short edge of the silk. Wrap the sash around the front, folding over the top and bottom edges to make it neater, and glue the other end in the back.

17 Add Cuffs to the Shirt

Pull the sleeve up slightly and put a dot of fabric glue at the top center of the wrist. Press the sleeve into the glue. Put a dot of glue at the bottom center of the wrist, opposite the first dot. Press the fabric into the glue.

Pull the fabric between the two glued spots away from the arm to find the center, and put a dot of glue on the arm, between the two previous dots of glue. Press the center of the fold into the glue. Continue securing at the center point between two glued spots until the sleeve is glued down in eight places. Repeat for the other sleeve.

Cut two 2" × ½" (5cm × 12mm) strips of white cotton. Fold the fabric in half lengthwise and secure with fabric glue. Repeat for the other cuff. To attach the cuffs, glue down one edge on the back of the wrist. Wrap the cuff around the wrist, and glue down the other end. Repeat for the other cuff.

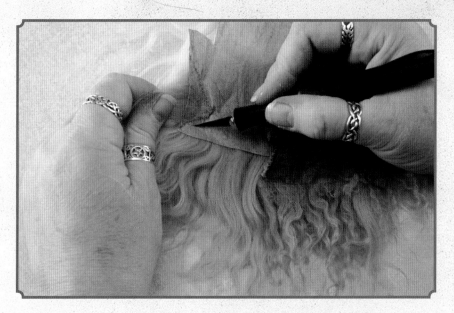

18 Cut Strips of Fur for the Hair

Hold a piece of blond Tibetan lambskin so the hair trails down. Flip it over and place on a flat surface. Use a craft knife to cut six ¼" × 2" (6mm × 5cm) strips, cutting through the skin but not the hair. (You can mark the measurements with a fabric marker or pencil on the back of the skin before you cut it.)

19 Apply Strips of Prepared Hair to the Head

Starting at the front, put down a bead of white craft glue along the hairline, going around the head. Fill in the hair area with a thin layer of glue (watch for drips and runs!). Laying the hair over the face, place one strip of skin in the glue. Then, starting in the back, continue laying pieces in the glue, working up the head to the front. Butt the strips together so none of the head shows through. (It's OK if a little shows at the top since we're going to glue on a hat.) Brush the front piece of hair to the sides and back over the rest of the hair. Make sure none of the scalp shows through. Smooth the hair and style however you like.

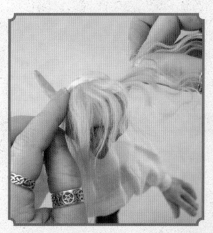

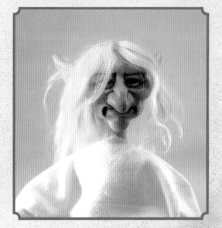

Fetch's Fact: Safety First

If you drop a craft knife, don't try to catch it!

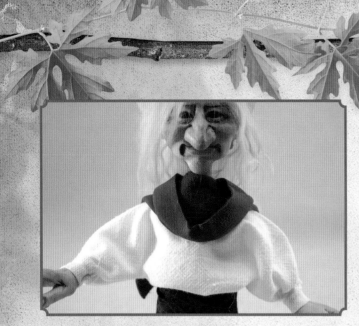

20 *Add the Collar/Cape*
Cut a 3" × 10" (8cm × 25cm) strip of teal four-ounce leather. Put a drop of fabric glue on the front of the shirt at the neckline. Fold the long edge of the leather under and press the middle of the long edge into the glue. Flip up the bottom of the long edge, and drape both sides over the shoulders to the back, adding a drop of glue on each shoulder to hold it in place. You can also glue down the long ends in the back to secure them better.

21 *Cut Shapes for Hat*
Using the elf hat pattern in the appendix, cut the hat shapes out of black felt. Fold the felt in half. Put the back of the hat pattern on the fold, and cut through both layers. Cut one teardrop pattern out of a single layer of felt.

22 *Assemble the Hat*
Use fabric glue to assemble the hat. Run a bead of glue along the edge of the teardrop. With the corner of the long piece pointed up, position it at the base of the teardrop and wrap it around the teardrop. Glue the points of the long piece together in the front.

23 *Add a Feather*
Position the hat on the head and glue it down. Cut two small slits on the side of the hat with scissors or a craft knife, and run the quill of a feather through the slits, with the plume towards the back of the hat. Secure the feather with dots of glue.

Finished Elf

Chrainn is ready to set off on adventure!
Think of some other accessories an adventurer could use—perhaps a belt with a pouch or a bag that slings over the shoulder. In addition to wearing feathers on his hat, he might tie some to his stick as well.

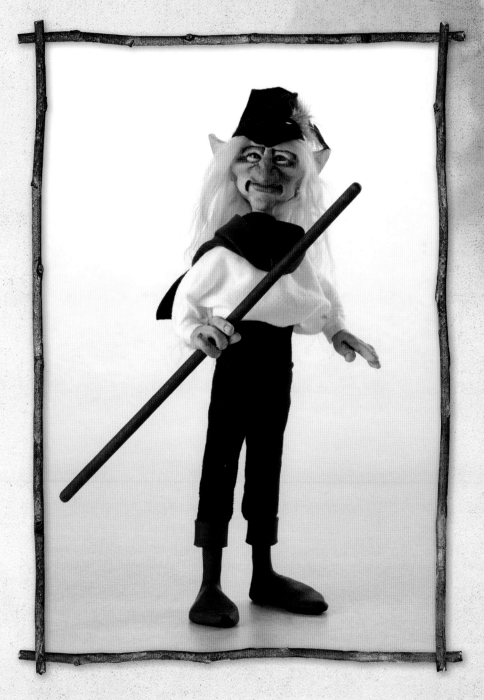

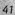

Fetch's Fact: Artful Hats

Hatmaking, also called millinery, is an art all its own! You can really get carried away with hats, adding feathers, lace or anything else your character desires. Do some research and find some funky hats from history for inspiration.

FETCH the TROLL

Beneath that ancient hewn stone span
There lives a great stone troll,
Or so it is said in Lengolréd,
And to pass you must pay a toll.

—"THE TROLL" BY JOHN BLIVEN MORIN

Maybe some Trolls are like that, but not Fetch! Fetch is both his name and what kind of troll he is. As a matter of fact, all trolls of his kind are named Fetch or Carry (the girls) because that is what they live to do. They will attach themselves to a person, especially artists since their studios are always messy, and Fetch or Carry all day and night. They're incredibly helpful creatures to have in one's studio.

Fetches are busy little guys, running to-and-fro with things. If you see a Fetch troll empty-handed you should probably take his temperature. Feel his nose—is it warm and dry? Not good. It should be a little cool and slightly drippy; a troll with a warm nose is an Unhappy Troll!

Some folks think Fetch trolls may have a drop of dragon blood ... they do love to hoard things, particularly tools. I know if a sculpting tool goes missing in my studio I need to check all the troll hoards (unless it's a paint brush, in which case the fairies probably have it).

I bargain with thimblefuls of sesame seeds to get my tools back. Fetch trolls are mad for sesame seeds, as are oddfae of any kind.

How does one know if one has a Fetch or a Carry? Fetches have blue bows on their tails; Carries wear pink bows, of course! Our Fetch has a purple bow because he wants to look extra-special while helping out with this book.

MATERIALS

Polymer clay colors: flesh tone of your choice

Acrylic paint colors: Burnt Umber, Terra Coral, Fabrics, brown microsuede, flesh-colored cheesecloth, gray cheesecloth, green cheesecloth, Tibetan lambskin or faux fur

Sculpting tools: craft knife, manicure stick, needle tool, needle-nose pliers, wooden sculpting tool

Other supplies: aluminum foil, ⅛" (3mm) armature wire (approximately 12 gauge), baby oil, button or charm, cotton balls, fabric glue, ½" (12mm) floral tape or masking tape, floral wire (32 gauge), hot glue gun and glue sticks, knitting needle for pressing fabric into hot glue, no. 4 filbert brush, nos. 3 and 8 round brushes, ⅓ (8mm) onyx beads (2), paper towels, polyfill for baking, purple ribbon, quilt batting, scissors, small container of water for burnt fingers, super glue

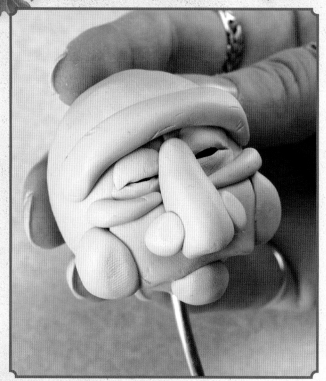

1 Form the Head and Establish Placement of Features

Following the process outlined in Step 1 of the Chrainn the Elf demonstration, make the head portion of the armature. Cover the ball with a circle of flesh-colored clay, pressing the seams towards the neck wire, and establish the placement of the features.

2 Place Clay Shapes to Form the Features

Make two ½-inch (12mm) balls of flesh-colored clay, flatten them into ½-inch (12mm) circles, and cut each circle in half. Place a half circle over the top and bottom of each eye for the eyelids. Flatten a ⅞-inch (22mm) ball of flesh-colored clay into a 1½" × ¾" (38mm × 19mm) rectangle and place it below the eyes with the longer side horizontal. Form a ⅝-inch (16mm) ball into a 2-inch (5cm) snake, and place it above the eyes for the forehead. Roll a ½-inch (12mm) ball of flesh clay into a 1-inch (25mm) cone for the nose. Place the point of the cone between the eyes. Form two ¼-inch (6mm) balls of clay to form the ala (nose wing) on either side of the nose. Form a ⅜-inch (10mm) ball of clay and place it under the face for the chin. For the cheeks, form two ⅜-inch (10mm) balls and place them on the ends of the face rectangle. Roll two ¼-inch (6mm) balls into ¾-inch (19mm) teardrops. Place the point of each teardrop at the nose and the base on the top of either cheek.

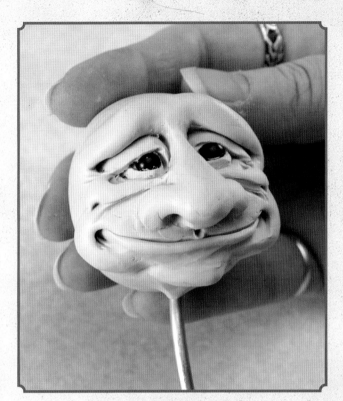

3 Blend and Shape the Features

Blend the brow bone back into the head with your fingers. Use the round end of a manicure stick to tuck the lower eyelids under the upper eyelids and open the eye. Pinch the bridge of the nose to make it a little thinner. Smooth the upper eyelids with the round end of a manicure stick. Blend the top of the nose and the brow. Blend the sides of the nose down toward the cheeks and under the eyes. Insert the pointed end of a manicure stick at the point where the upper eyelids, nose and brow meet to make a small indentation. Blend the cheeks into the lower eyelids with the round end of a manicure stick. Blend the outer sides of the cheeks up into the outer edges of the brow. Blend the nose wings into the nose. Using the rounded end of a manicure stick, blend the bottom of the nose into the face. Blend the lower edge of the cheek teardrops down. Blend in the large cheek balls. Insert the pointed end of a manicure stick at the base of the nose to form nostrils. Use the rounded end of a manicure stick to make small indentations on the outer part of the nose to further define the nostrils. Blend in the ball of the chin.

Use the needle tool to draw a wide smile halfway between the nose and chin. Add smile lines at each end of the smile with the round end of a manicure stick. Roll a ¼-inch (6mm) ball of flesh clay into a snake the same length as the smile. Place the snake beneath the smile line, and blend in the bottom of the snake with the round end of a manicure stick. With the same end draw a short philtrum between the bottom of the nose and the mouth. Press the round end of a manicure stick at either corner of the nose and draw a smile line. Add wrinkles at the corners of the eyes with the round end of a manicure stick. Use a no. 4 filbert and baby oil to smooth out fingerprints and unwanted indentations.

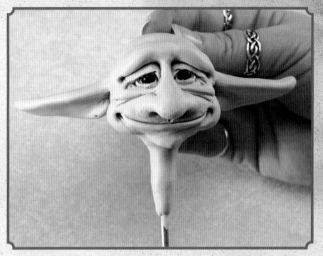

4 Add the Ears and Neck

Make two ¾-inch (19mm) balls and roll them into 1½-inch (38mm) cone shapes, then flatten the cones and place one on each side of the head, bending each base to form a C-shape. The tops of the ears should be even with the eyes and angled down just a bit. Blend in with your fingers and a manicure stick. Bend the front edge of each ear down and the tip up. Roll a ¾-inch (19mm) ball of flesh clay into a 1½-inch (38mm) cylinder. Use a craft knife to slit it halfway through and wrap around the neck. Use the pointed end of a sculpting tool to blend the neck into the head. Bake at 275º F (135º C) for 20 minutes, or according to the package directions.

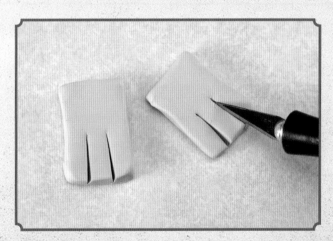

5 Cut Rectangles for the Hands, Divide the Fingers

Flatten two ¾-inch (19mm) balls of clay into 1" × 1½" (25mm × 38mm) rectangles, about ⅛" (3mm) thick. Use a craft knife to divide the hand into three fingers.

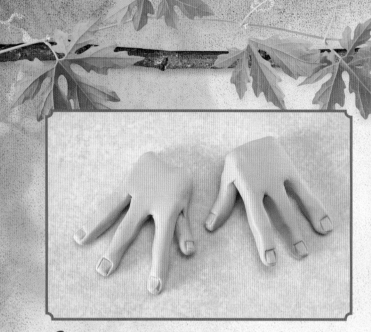

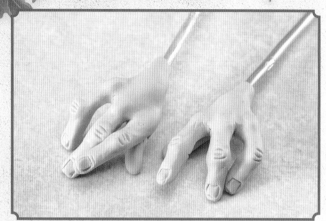

6 Refine Fingers and Add Fingernails

Use your fingers to gently smooth the cut edges of the clay fingers. Carefully pull the clay to lengthen and shape. Fingers aren't round tubes—they're slightly flat across the top, and they taper at the end. Make the middle finger the longest, the forefinger a little shorter, and the little finger the shortest of the three. Use the square end of a sculpting tool to press in lines for the fingernails. Use a craft knife to lift the front edge of each fingernail. Using the round end of a manicure stick, draw little lines for the cuticles. Use the pointed end of a manicure stick to make a depressions between the fingers. For the thumbs, make two ⅜-inch (10mm) balls of clay and roll each out into a 1-inch (25mm) teardrop. Attach the thumbs and blend with the pointed end of the sculpting tool. Use the same techniques to add details to the thumbs.

7 Add Knobby Knuckles and Details to the Fingers

Roll a ⅜-inch (10mm) ball of flesh clay into a thin 3½-inch (9cm) snake. Make ⅛-inch (3mm) slices with a craft knife. Roll the slices into tiny balls and place one on the middle knuckle and one on the base knuckle of each finger. Blend in the knobby knuckles with the round end of a manicure stick. Make the knuckle lines with the round end of a manicure stick. Insert a short, straight wire at the base of each hand as a placeholder for the arm wires. Bake at 275° F (135° C) for 20 minutes or according to package directions.

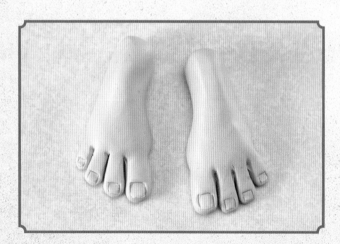

8 Measure Clay for the Feet and Start Shaping

Roll a 1½-inch (38mm) ball into a 2-inch (5cm) cylinder. Square off the cylinder and flatten one end to form a basic foot shape, making one side of the toe area a little longer. Repeat for the other foot. Pinch the heel into a rounded point with your fingers. Use your thumb to make a depression for the arch. Use a craft knife to cut four toes on each foot. The big toe is on the same side as the arch. Use the rounded end of a manicure stick to smooth the cut edges. Round off the front of the toes with your fingers, flattening the front edge slightly. Rock the side of the manicure tool below the little toe on the side of the foot to create a little notch. Repeat on the other foot and on the big toe side of each foot. Use the square end of the sculpting tool to make the toenails with a line across and down each side of the nail. Lift the toenails with a craft knife. Use the rounded end of a manicure stick to add cuticle lines.

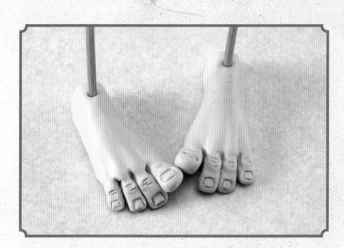

9 Add Knobby Knuckles and Details to the Toes

Roll a ⅜-inch (10mm) ball of flesh clay into a thin 3½-inch (9cm) snake. Make ⅛-inch (3mm) slices with a craft knife. Roll the slices into tiny balls and place one on the middle knuckle and one on the base knuckle of each toe (the big toes get just one knobby knuckle at the base). Blend in the knobby knuckles with the round end of a manicure stick. Make the knuckle lines with the round end of a manicure stick. Continuing with the manicure stick, draw lines running from between the toes up through the foot for the tendons. Gently pose the toes. (It's fun to make it look like they're wiggling.) Insert a short, straight wire into each foot to make a hole for the armature leg wires (leave the wire in place for baking). Bake at 275° F (135° C) for 20 minutes or according to package directions.

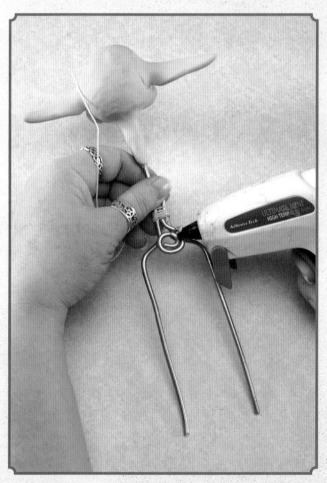

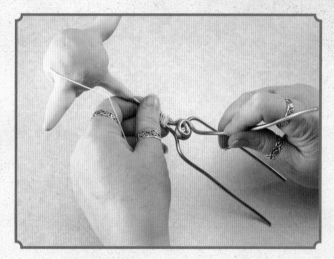

10 Assemble the Armature

Cut a 12-inch (30cm) piece of wire for the legs and an 10-inch (25cm) piece for the arms. (See the armature map in the appendix.) Bend both wires in half with needle-nose pliers. Bend the leg wires out at a 50-degree angle for the hips, then bend the wires straight down. Bend the arms at a 90-degree angle 1½" (38mm) from the center bend and then bend another 90-degree angle 1" (25mm) out from the first bend. Slip the coil from the head wire into the middle bend of the leg wire and wrap with floral wire. Cut a 7-inch (18cm) piece of wire for the tail. Coil up about ½" (12mm) at one end and bend the coil at a 45-degree angle. Dot hot glue on the head wire coil, and press together with the tail wire coil. Continue wrapping with floral wire. Lay the arm wire over the other wires and continue wrapping with floral wire. Secure the armature with hot glue. Trim the arm and leg wires if needed, using the armature map for guidance.

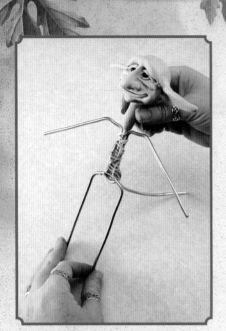
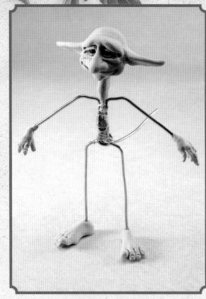

11 Add the Hands and Feet

Twist and remove the placeholder wires from the hands and feet. Add a drop of super glue to the hole in each hand, and stick the right arm wire into the right hand and the left arm wire into the left hand. Repeat this process with the feet. There should be 4" (10cm) of leg wire between the tops of the feet and the hips and 2½" (6cm) of arm wire between the tops of the hands and the shoulders. Trim if needed.

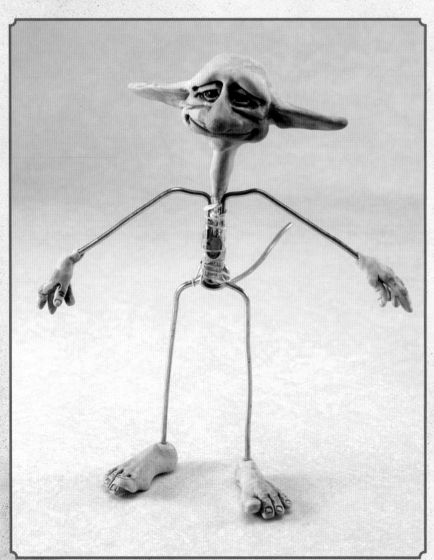

12 Add Color to the Completed Sculpt

Use a no. 8 round to paint a thin diluted wash of Burnt Umber over the head, hands and feet, then gently wipe off most of the paint with a paper towel. Repeat as needed or use water to remove excess paint. Dab on a thin layer of Terra Coral over the tips of the ears, forehead, end of the nose (a little darker here), the lips and cheeks with a no. 3 round. Add a little more Terra Coral to the knuckles of his toes and the tops of his feet. Pat the edges of the darker areas lightly with your finger so there isn't a sharp line. To remove dry paint, scrape gently with the back edge of a craft knife.

13 Pad and Wrap the Body

Stretch 1-inch (25mm) strips of batting. Dot the front of the torso with hot glue, and attach one end of a strip and begin wrapping the tail, using a figure-eight wrapping motion. Finish wrapping out to the end of the tail and back to the body. Wrap the body. Hot glue a cotton ball to the tummy, and wrap over the ball. Glue a second ball over the first, and wrap again for an extra-large tummy. Wrap the arms and legs. (See step 13 of the Chrainn the Elf demonstration for detailed instruction.) The legs and arms should have two layers of batting, with an extra layer closer to the torso.

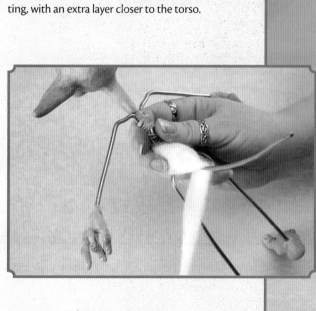

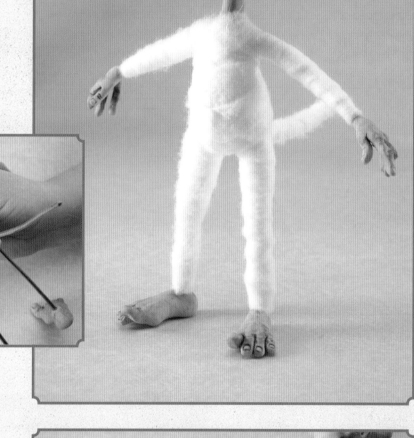

14 Wrap the Tail and Add Hair

Place a piece of Tibetan lambskin hair-side down on a flat surface, and use a craft knife to cut a ¼" × 3" (6mm × 8cm) strip, cutting through the skin but not through the hair. Put a dot of hot glue on the end of the tail, attach one end of the skin strip and wrap around the tip. Secure the other end with a dot of hot glue. Cut a long 1-inch (25mm) strip of flesh-colored cheesecloth. Starting near the tip (overlapping the lambskin), wrap the tail, covering all the batting. Wrap the end once around the waist and secure with hot glue at the top of the tail. Cut a 13-inch (33cm) piece of purple ribbon and tie it around the tip of the tail.

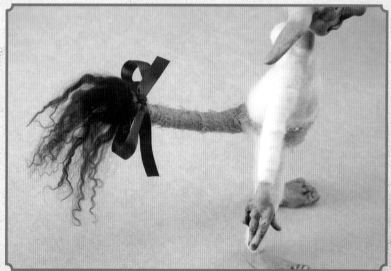

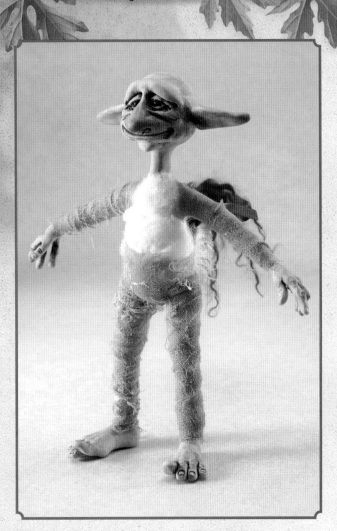

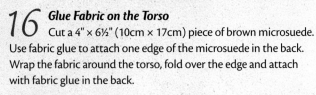

16 Glue Fabric on the Torso

Cut a 4" × 6½" (10cm × 17cm) piece of brown microsuede. Use fabric glue to attach one edge of the microsuede in the back. Wrap the fabric around the torso, fold over the edge and attach with fabric glue in the back.

15 Wrap Legs and Arms With Cheesecloth

Cut three long 1-inch (25mm) strips of green cheesecloth. Starting at the top of the foot, wrap the cheesecloth up the leg, covering all the batting. Hot glue the end of the strip in place. Repeat for the other leg. Drape the third strip across the back of the shoulders and use half to wrap each arm.

Cut a small triangle of flesh-colored cheesecloth and hot glue one end to the tummy, pull it between the legs, and glue the other corner to the backside.

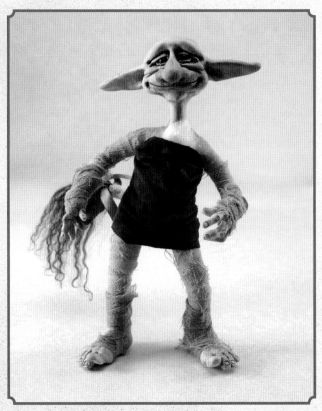

17 Wrap the Wrists and Ankles

Cut a couple long 1-inch (25mm) strips of gray cheesecloth. Place a dot of fabric glue on one wrist and attach a strip. Wrap the cloth around the wrist and part of the hand, poking one thumb through the cloth. Trim off the rest of the strip and glue in place. Repeat for the other wrist. Wrap each ankle in the same fashion, going down and around the heel of each foot. Shred the edges a bit so they look a little furry.

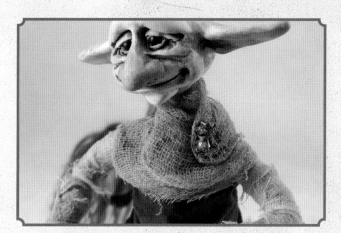

18 Make the Collar and Embellish

Cut a long 1-inch (25mm) strip of gray cheesecloth. Dot the back of the neck area with hot glue, attach one end of the strip, and loosely twist and drape the cheesecloth around the neck and shoulders, securing with hot glue as needed. Continue wrapping to create the collar. Secure the end with hot glue. Use a dot of hot glue to attach a small button or charm for embellishment.

Finished Troll

Fetch wonders where I hid the sesame seeds. . . .

Try giving your troll some larger props—something not too heavy but big enough that it dwarfs him. This will convey the impression he's a lot stronger than a creature his size should be. How about a ball of yarn, a piece of plastic fruit or a basket balanced on his head?

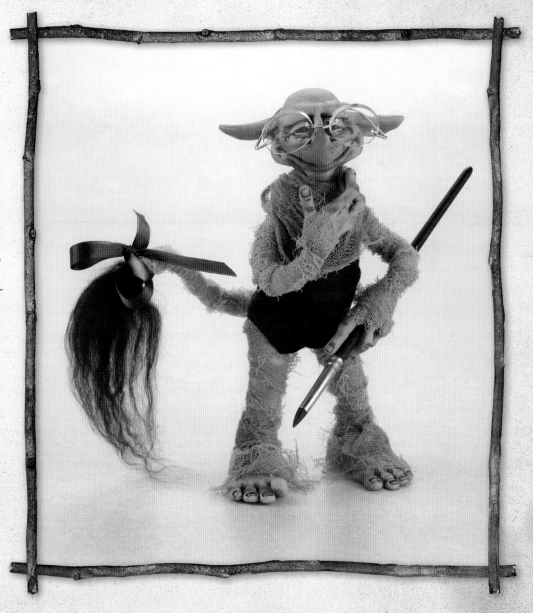

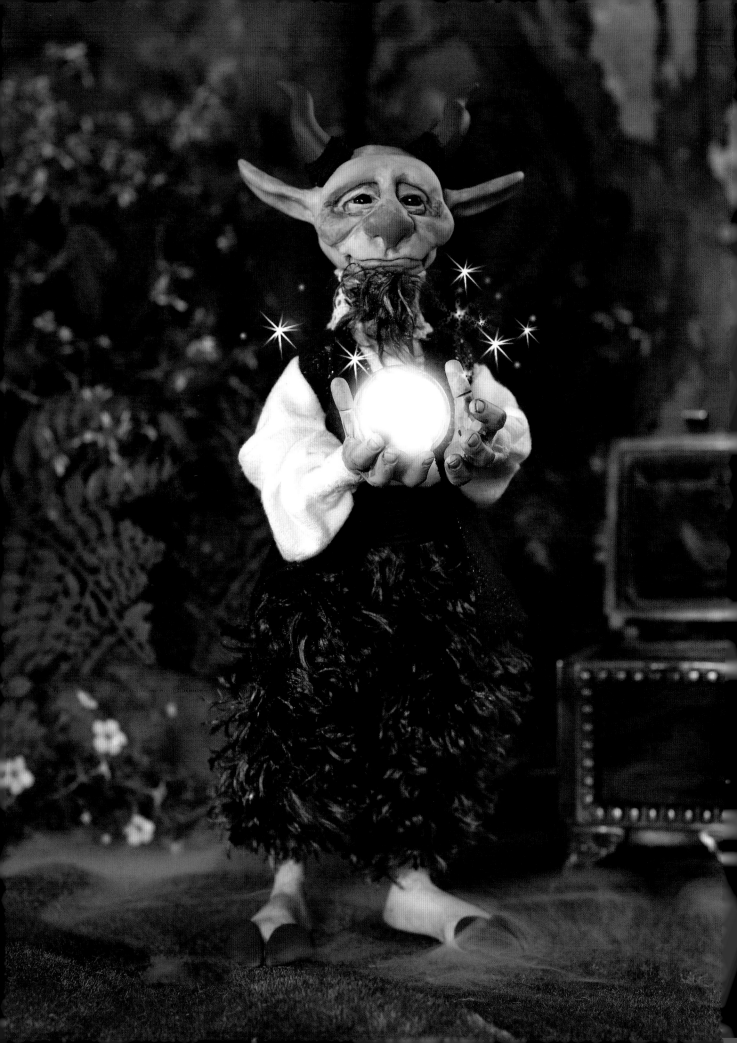

Teigh the Satyr

When the flowery hands of Spring
Forth their woodland riches fling,
Through the meadows, through the valleys
Goes the satyr carolling.

—"The Satyr" by C.S. Lewis

Teigh is the Seer of the oddfae. If it's a method of divination, Teigh has given it a try—even the Magic Eight Ball!

Don't for one second think he is just a sideshow charlatan; Teigh always has a Clear View. He can see when the Seasons will change, when the fairies should start painting the flowers … and where I keep my stash of sesame seeds.

Teigh is very old and wise, having learnt his craft at the feet of the Oracle at Delphi, and has honed his skills over many centuries. His most cherished possession is his gazing crystal, made of glass as finely spun as a spider's web. He won it eons ago in a dance competition (satyrs are fantastically gifted dancers) and claims it was awarded him by Athena herself.

Looking into the Future and reading the Past is very taxing, so periodically Teigh retires to a spa to have his horns trimmed and his fur groomed and scented. The redcaps at the spa are skilled with any sharp implements and administer an expert mani and pedi.

Much refreshed and looking straight from the pages of *Olympus Quarterly*, Teigh settles against a tree at the edge of the meadow and once more begins his augury.

Is Teigh seeing a tall, dark stranger in your future? Don't get too excited … that giant is traveling around the World to the left, and everyone meets him sooner or later.

MATERIALS

Polymer clay colors: brown, flesh tone of your choice

Acrylic paint colors: Burnt Umber, Terra Coral

Fabrics: brown microsuede, cotton lace, faux fur, red and black striped silk, white cotton

Sculpting tools: craft knife, manicure stick, needle tool, needle-nose pliers, wooden sculpting tool

Other supplies: aluminum foil, ⅛" (3mm) armature wire (approximately 12 gauge), baby oil, cotton balls, fabric glue, ½" (12mm) floral tape or masking tape, floral wire (32 gauge), glass ball or marble, hot glue gun and glue sticks, knitting needle for pressing fabric into hot glue, no. 4 filbert brush, nos. 3 and 8 round brushes, ⅓ (8mm) onyx beads (2), paper towels, polyfill for baking, quilt batting, scissors, small container of water for burnt fingers, super glue, white craft glue, wire (20 gauge)

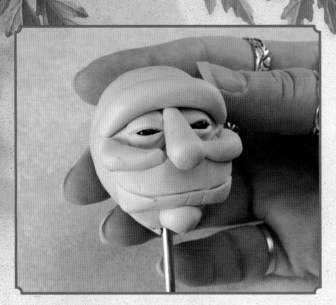

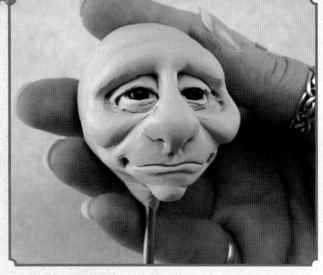

1 Form the Head and Place Clay Shapes to Form the Features

Following the process outlined in step 1 of the Chrainn the Elf demonstration, make the head portion of the armature. Cover the ball with a circle of flesh-colored clay, pressing the seams towards the neck wire, and establish the placement of features.

Make two ½-inch (12mm) balls of flesh-colored clay, flatten them into ½-inch (12mm) circles, and cut each circle in half. Place a half circle over the top and bottom of each eye for the eyelids. Flatten two ⅞-inch (22mm) balls of flesh-colored clay into 1½" × ¾" (38mm × 19mm) rectangles and layer both below the eyes, with the longer side horizontal. Form a ⅝-inch (16mm) ball into a 2-inch (5cm) snake and place it above the eyes for the forehead. Roll a generous ½-inch (12mm) ball of flesh clay into a 1-inch (25mm) cone for the nose. Place the point between the eyes. Form a ⅜-inch (10mm) ball of clay and place it under the face for the chin. For the cheeks, roll two ¼-inch (6mm) balls into ¾-inch (19mm) teardrops. Place the point of each teardrop at the nose and the base on the outside of the cheeks. Use a needle tool to draw a line for the mouth halfway between the nose and chin.

2 Blend and Shape the Features

Blend the brow bone into the head with your thumbs. Use the round end of a manicure stick to tuck the corners of the lower eyelids under the upper eyelids, open the eyes and flatten the upper eyelids. Then blend the nose up into the brow and the brow down into the nose. Insert the pointed end of the manicure stick at the point where the eyelid, nose and brow come together.

Blend the cheeks into the lower eyelids with the rounded end of the manicure stick. Blend the outer ends of the brow bone and the cheeks together. Blend the sides of the nose into the face. Using the round end of the manicure stick, move a little clay from the end of the nose up into the bridge of the nose. Blend the end of the nose into the face. Put your thumb on the end of the nose and press gently to flatten and spread. Insert the pointed end of a manicure stick at the base of the nose, against the face, to form the nostrils. Use the rounded end of a manicure stick to shape the nostrils from the outside.

With the same tool, blend the bottom of the cheeks into the face. Blend the sides of the face rectangles and cheeks back into the head with your fingers.

Continuing with your fingers, blend in the chin. Redefine the mouth with the round end of a manicure stick, then draw a line from either corner of the nose toward either side of the mouth. Bring the edges of the mouth out a little and add smile lines on either end. Use the pointed end of a manicure stick to form the lower lip. Switch to the rounded end and draw a short philtrum between the bottom of the nose and the top of the mouth. Use the same tool to add wrinkles at the outer corners of the eyes. Use a no. 4 filbert and a little baby oil to smooth and refine the face.

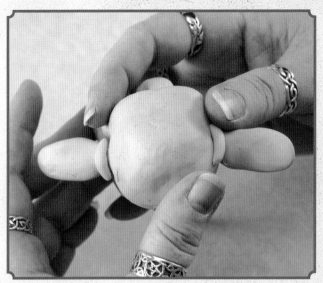

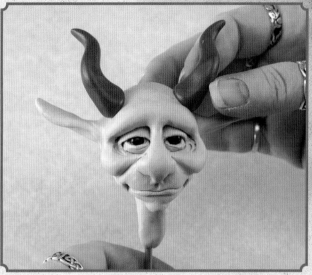

3 Add the Ears

Flatten two ⅝-inch (16mm) flesh clay balls into 1½" × ½" (38mm × 12mm) ovals. Roll in the long sides of each oval slightly and attach them to the head. Roll two ¼-inch (6mm) balls of clay into ½-inch (12mm) snakes and wrap one around each ear. Blend in both parts. Pull the ends of the ears back slightly.

4 Add the Neck and Horns

Roll a ¾-inch (19mm) ball of flesh clay into a 1½-inch (38mm) cylinder. Cut halfway through the cylinder; wrap it around the neck wire and blend into the head. Roll two ⅝-inch (16mm) balls of brown clay into 1¾-inch (44mm) cones, flattening each base. Cut two 1-inch (25mm) pieces of 20-gauge wire and insert one into the head above and between the ear and brow on either side. Press a cone over each wire. Shape each horn into an S-curve.

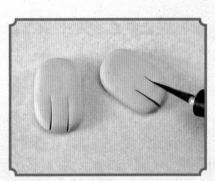

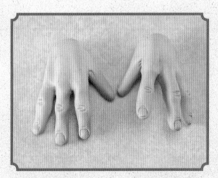

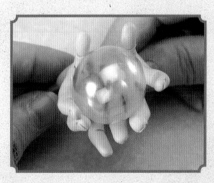

5 Cut Rectangles for the Hands, Divide the Fingers

Flatten two ¾-inch (19mm) balls of clay into 1" × 1½" (25mm × 38mm) rectangles, about ⅛" (3mm) thick. Use a craft knife to divide the hand into three fingers. Make the middle finger the longest, the forefinger a little shorter, and the little finger the shortest of the three.

6 Refine the Fingers and Add the Fingernails

Use your fingers to gently smooth the cut edges of the clay fingers. Carefully pull the clay to lengthen and shape. Form the fingernails and draw the knuckle lines. Use the pointed end of the manicure stick to make depressions between each of the fingers, then use your fingers to pull up a small bit of clay for each knuckle. For the thumbs, make two ⅜-inch (10mm) balls of clay and roll each out into a 1-inch (25mm) teardrop. Place the larger end of the teardrops on the palms of the hands. Blend and smooth the thumbs and add the nails and knuckle lines.

7 Pose the Hands With the Crystal Ball

Gently pose both hands around a 1⅛-inch (28mm) glass ball or marble. Score the underside of the fingers so they will bend more easily. Pose one hand at a time with the ball or marble. Redefine the fingernails as necessary. Insert a short, straight wire at the base of each hand as a placeholder for the armature arm wires.

8 Sculpt the Legs and Hooves

Form two 1⅛-inch (28mm) balls of flesh clay. Shape each into a rectangle with a flat front. Pinch the back of each foot shape so it is gently rounded to make the heel. Flip each foot over and use your thumb to make an indentation for the arch. Insert a short, straight wire at the base of each foot. Make two ⅝-inch (16mm) balls of flesh clay, and roll each into a 1-inch (25mm) cylinder, flattening each end. Use a craft knife to cut halfway through each cylinder and wrap a cylinder around each leg wire, blending into the foot. Roll four ½-inch (12mm) balls of brown clay into 1-inch (25mm) flat teardrops. Press one on either side of the toe of each foot to form the hooves. Do not blend the hooves into the feet.

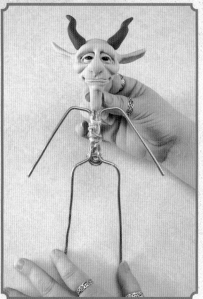

9 Build the Armature

Following the process outlined in step 10 of the Chrainn the Elf demonstration, assemble the armature.

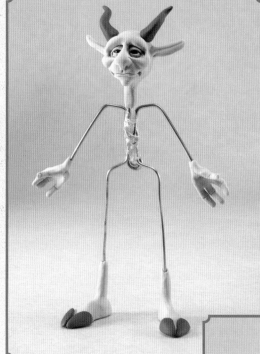

10 Add the Hands and Feet

Twist and remove the place-holder wires from the hands and feet. Add a drop of super glue to the hole in each hand, and stick the right arm wire into the right hand and the left arm wire into the left hand. Repeat this process with the feet. There should be 3" (8cm) of leg wire between the tops of the clay legs and hips, and 2½" (6cm) of arm wire between the tops of the clay arms and the shoulders. Trim the wires if needed.

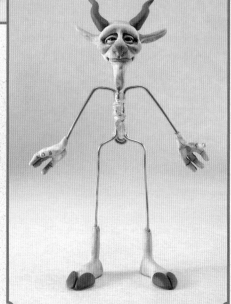

11 Add Color to the Completed Sculpt

Use no. 8 round to paint a thin diluted wash of Burnt Umber acrylic paint over the head, hands, feet (including the hooves) and horns. Gently wipe off most of the paint with a paper towel. Repeat as needed or use water to remove excess paint. Dab on a thin layer of Terra Coral over the tips of the ears, the forehead, the end of the nose (a little darker here), the lips and the cheeks with a no. 3 round. Pat the edges of the Terra Coral areas lightly with your finger so there isn't a sharp line.

12 *Wrap and Pad the Body*
Following the process outlined in step 13 of the Chrainn the Elf demonstration, wrap and pad the body. When wrapping the torso, hot glue a cotton ball to the tummy, and continue wrapping over the ball. The arms should have two layers of batting and the legs just one layer, with an extra layer closer to the body.

13 *Add Fur to the Legs*
Place synthetic fur fur-side down on a flat surface. Use a craft knife to cut two 3" × 5½" (8cm × 14cm) strips. Holding each strip so the hair flows down toward the foot, wrap one around each leg and glue the edges together with fabric glue. Pull the excess fur at the top of the legs around to the back and glue over the backside. Run a line of glue around the top of the clay leg, then push the excess fur up the leg and press against the glue.

14 *Make and Attach the Tail*
Use a craft knife to cut a 2" × 1" (51mm × 25mm) piece of synthetic fur (place the fur fur-side down on a flat surface to cut). Roll the piece lengthwise and glue the long sides together with fabric glue. Glue the tail just above the furry legs in the back.

Fetch's Fact: Gotta Dance!
When wrapping Teigh's legs with the batting, keep in mind that they should look too thin when you're finished. His fur is going to add a lot of volume, and you don't want his bottom out of proportion to his top. Being out of proportion makes it really hard to tango.

15 *Make the Shirt*

Cut a 6" × 10" (15cm × 25cm) piece of white cotton. Fold the fabric in half, putting the 10-inch (25cm) sides together. (See the shirt pattern in the appendix.) Cut a 1" × 2" (25mm × 51mm) notch from each unfolded corner, cutting through both layers. Following the process outlined in step 15 of the Chrainn the Elf demonstration, assemble the shirt.

16 *Make the Sash*

Cut a 6½" × 2" (17cm × 5mm) piece of red and black striped silk. Place a dot of glue on the back waist, then stick down a short edge of the silk. Wrap the sash around the front, folding over the top and bottom edges to make it neater, making sure to cover the top of the fur and the bottom of the shirt. Glue the other end in the back.

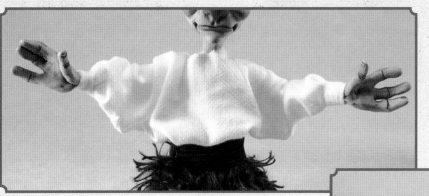

17 *Add Cuffs to the Shirt*

Following the process outlined in step 17 of the Chrainn the Elf demonstration, add cuffs to the shirt.

18 *Make the Vest*

Cut a 7" × 5" (18cm × 13cm) piece of brown microsuede fabric. Fold the fabric in thirds, bringing the short edges in to meet at the middle. (See vest pattern in appendix.) Cut about half way down on both folds. Wrap the fabric around the figure, bringing the short edges around to the front. Glue the vest to the shirt in the back and on top of the shoulders. Fold under the front edges on top of the shoulders and glue to the back edge with fabric glue.

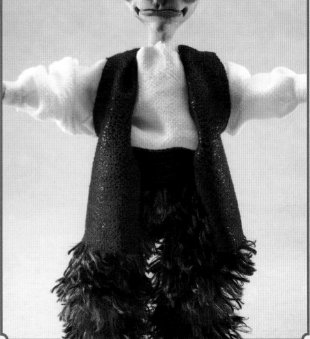

19 *Add Horn "Turbans"*
Cut two 1" × 3" (25mm × 8cm) strips of the sash material. Use fabric glue to tack down one short end of one strip to the back of one of the horns. Wrap and twist the fabric around the base of the horn and glue down the other end. Repeat for the other horn.

20 *Make the Collar*
Use fabric glue to tack down one end of a strip of 1-inch (25mm) cotton lace behind the neck, covering the top of the vest. Continue tacking and wrapping the lace around the neck. Trim and tack down in the back.

21 *Add the Facial Hair*
Cut a tiny piece of synthetic fur and glue it to the chin with fabric glue.

Finished Satyr

Teigh sees more than his eyes tell.

Place a dot of white craft glue in the palm of the right hand. Press the glass ball or marble into place. Lengthen Teigh's vest to his ankles and use a fabric with stars or moons on it to make him more "mystical." If you want a more traditional satyr, wrap his torso and arms with cheesecloth and dress him only in the vest, leaving off the shirt. Give him a flute or panpipes. Wrap a scarf around his neck rather than lace.

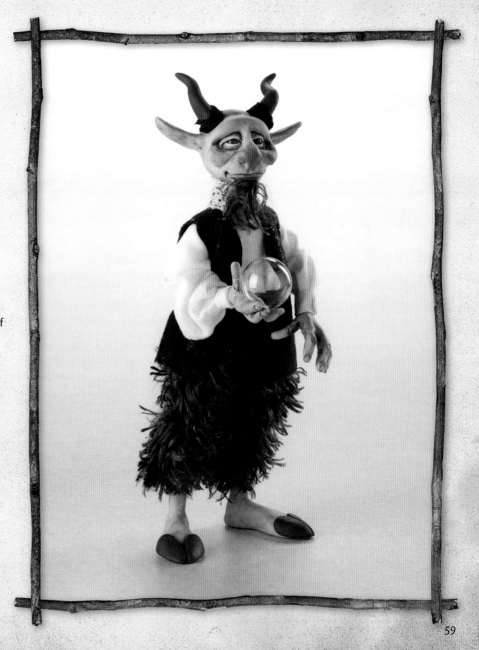

Zylphia the Witch

You must break the shell to bits, for fear
The witches should make it a boat, my dear:
For over the sea, away from home,
Far by night the witches roam.

—"CHARM AGAINST AN EGG-BOAT," ANONYMOUS

Zylphia would never make an egg-boat; eggshells are saved for brewing beer! It's the only way to get rid of those obnoxious changelings.

Living in a cozy cottage deep in the Wood, she reads tea leaves and tarot cards, but secretly wishes they had a better plot. Zylphia is a sweet old gal who likes nothing better than to dance in the light of the moon with the fireflies. She likes to garden and grows her own herbs for her potions and spells.

And what spells she makes! Long ago, Zylphia knew a wizard who was a master of pyrotechnics. He passed on his secrets to her, which has a lot to do with her living in the Wood—the townsfolk's nerves were absolutely shot due to the incessant explosions in her house. The blacksmith did like the extra income from constantly repairing her cauldron, though.

One night, tired of all the complaints, she enchanted her cottage to walk into the Wood. No, not on chicken feet like the house of Baba Yaga (Zylphia's cousin). Zylphia's house is a typical Victorian, crammed to the rafters with knickknacks and ruffles and all manner of witchy things, so … she gave her cottage elephant feet to support all the weight. And if the house ever strays, it'll always be able to remember its way back.

If you ever need a spell, just follow the sound of detonations, and it'll be easy to find Zylphia's place. Make sure she realizes you're a customer—that giant frog she keeps as a watchdog is rumored to be the last salesman to bother her.

MATERIALS

Polymer clay colors: black, flesh tone of your choice

Acrylic paint colors: Burnt Umber, Terra Coral

Fabrics: black cotton, black felt, cotton lace, gray cheesecloth, white or gray braided mohair

Sculpting tools: craft knife, manicure stick, needle tool, needle-nose pliers, wooden sculpting tool

Other supplies: aluminum foil, ⅛" (3mm) armature wire (approximately 12 gauge), artificial sinew, baby oil, cotton balls, fabric glue, ½" (12mm) floral tape or masking tape, floral wire (32 gauge), hot glue gun and glue sticks; knitting needle for pressing fabric into hot glue, no. 4 filbert brush, nos. 3 and 8 round brushes, ⅓" (8mm) onyx beads (2), paper towels, polyfill for baking, quilt batting, raffia, sanding stick, scissors, small container of water for burnt fingers, super glue, white craft glue, willow twig, wire (20 gauge)

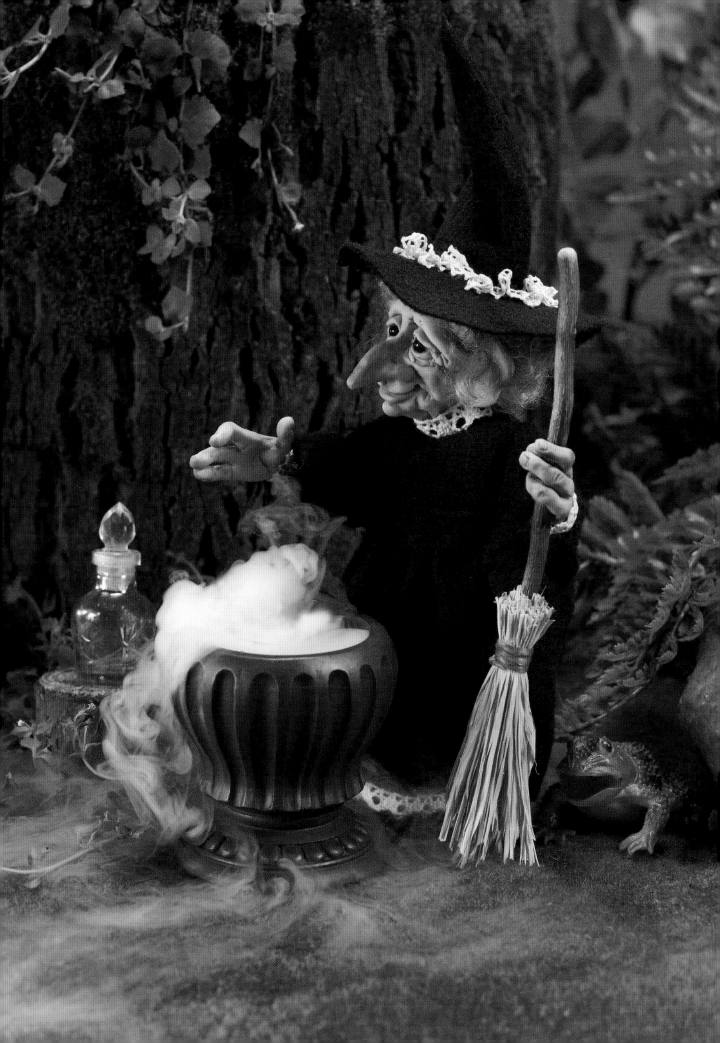

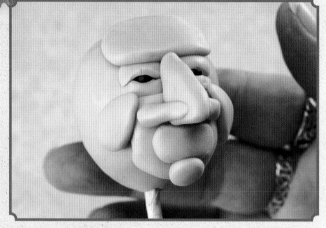

1 Form the Head and Place Clay Shapes to Form the Features

Following the process outlined in step 1 of the Chrainn the Elf demonstration, make the head portion of the armature. Cover the ball with a circle of flesh-colored clay, pressing the seams towards the neck wire, and establish the placement of the features.

Make two ½-inch (12mm) balls of flesh-colored clay, flatten them into ½-inch (12mm) circles, and cut each circle in half. Place a half circle over the top and bottom of each eye for the eyelids. Flatten a ⅞-inch (22mm) ball of flesh-colored clay into a 1" × ¾" (25mm × 19mm) rectangle and place it below the eyes, with the longer side vertical. Form a ⅝-inch (16mm) ball into a 1" × ½" (25mm × 12mm) rectangle and place it above the eyes. Form a ½-inch (12mm) ball of flesh clay into a 1-inch (25mm) teardrop and place it between the eyes, pulling the round end into a point. For the nose wings, make two ¼-inch (6mm) balls, and form each into ½-inch (12mm) teardrops.

2 Place Shapes for the Lower Face

Flatten a ⅜-inch (10mm) ball of clay into a ¼" × ½" (6mm × 12mm) rectangle and place it horizontally beneath the nose. Place a ¼-inch (6mm) ball beneath the rectangle for the chin. For the cheeks, roll and flatten two ⅜-inch (10mm) balls into ½-inch (12mm) teardrops. Place with the pointed end at the corner of the eye.

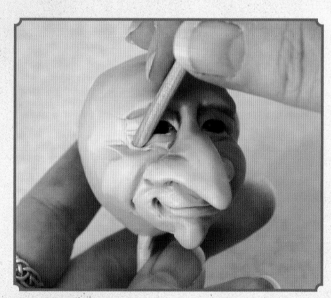

3 Blend and Shape the Features

Use the square end of a sculpting tool to blend the top and side edges of the forehead out. Use the rounded end of a manicure stick to open up the eyes, pushing the eyelid clay back. Press down on each lower eyelid to form wrinkles. Insert the pointed end of the manicure stick where each eyelid and the nose meet to make a depression. Flatten the upper eyelid with the flat part of the manicure stick. Then shape the brow bone and blend in the top part of the nose.

Using the round end of the manicure stick, blend in the side of the nose. Then, blend the sides of the nose pieces together, keeping it long and pointed. Create the nostrils against the face , then round and model the nose wings and blend in the sides of the mouth.

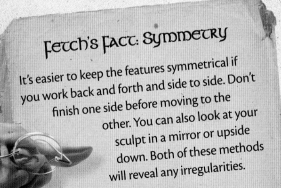

Fetch's Fact: Symmetry

It's easier to keep the features symmetrical if you work back and forth and side to side. Don't finish one side before moving to the other. You can also look at your sculpt in a mirror or upside down. Both of these methods will reveal any irregularities.

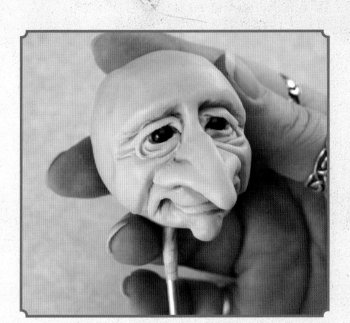

4 Finish Refining the Features

Draw a line for the mouth with a needle tool. Use the round end of the manicure stick to add round ends at the corners of the mouth. Using the pointed end of the manicure stick, shape the bottom lip with a pressing motion.

With the round end of the manicure stick, blend in the chin, then pull it to a point with your fingers. With the same tool, make a depression on either side of the chin. Blend the bottom of the chin into the head.

Blend in the cheeks. Then sculpt a line from the inner corner of the eye, around the side of the nose, down to the side of the mouth. Repeat on the other side. Insert the round end of the manicure stick at the outside corner of each eye and pull out a bit to form a wrinkle. Keep using the rounded end of the manicure stick to add as many wrinkles as you like around the eyes and mouth.

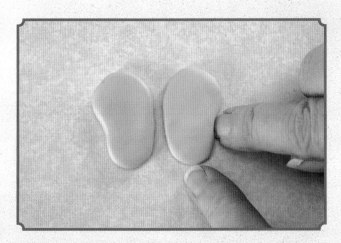

5 Add the Ears

Roll and flatten two ⅝-inch (16mm) balls into 1¼" × 1" (31mm × 25mm) ovals. About halfway up each ear shape, make a small indentation and pull out the top so it becomes wider than the bottom. Place the ears on the head, about halfway back from the outer corner of the eyes. Blend the clay into the head. Then draw a backwards C-shape on the witch's left ear and a regular C-shape on the right ear. Using the pointed end of the manicure stick, form a depression at the top of each ear.

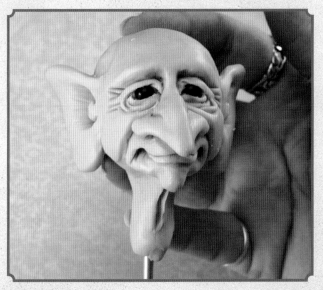

6 Add the Neck

Roll a ¾-inch (19mm) ball into a 1-inch (25mm) cylinder and flatten both ends. Cut a slit halfway through and place it around the neck wire, against the bottom of the head and blend. Roll a ⅜-inch (10mm) ball of clay into a snake. Place one end under the chin and run it vertically down the neck. Blend in the edges of the snake. Use the rounded end of a manicure stick to make a little groove down the front center of the neck. Use a no. 4 filbert and a little baby oil to smooth. Bake at 275° F (135° C) for 20 minutes or according to package directions.

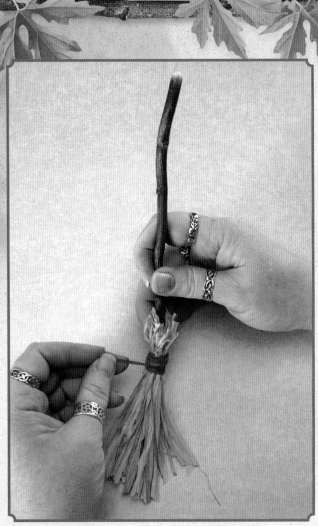

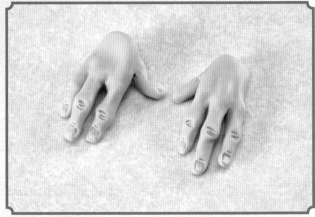

8 Cut Rectangles for the Hands, Divide the Fingers

Flatten two ¾-inch (19mm) balls into 1" × 1½" (25mm × 38mm) rectangles, about ⅛" (3mm) thick. Use a craft knife to cut three fingers on each hand. The little finger is the shortest, the middle finger is the longest, and the forefinger is a bit shorter than the middle finger.

7 Make the Broom

Cut a 7½-inch (19cm) piece of willow twig with wire cutters or heavy scissors. Round off the sharp edges of one end with a sanding stick. Fold a bundle of raffia in half so the ends are about 5" (13cm) long. The bundle should be about 1" (25mm) thick. Cut the raffia at the bend in the middle. Stick about ¾" (19mm) of the unsanded end of the willow twig into the raffia bundle. Wrap 12 to 18 inches (30cm to 46cm) of artificial sinew around the raffia bundle to attach it to the twig. The sinew sticks to itself, so you don't have to glue it. Pull back the raffia and add a drop of hot glue to secure the raffia to the twig. Pull the raffia apart at the bottom to find the end of the twig and add another drop of glue. Trim the raffia to about 3" (8cm), and make it a bit more even around the base of the broom.

9 Refine the Fingers and Add the Fingernails

Use your fingers to gently smooth the cut edges of the clay fingers. Carefully pull the clay to lengthen and shape. Fingers aren't round tubes—they're slightly flat across the top, and they taper at the end. Use the square end of a sculpting tool to press in the fingernails. Use a craft knife to lift the front edge of each nail. Using the round end of a manicure stick, draw lines for the knuckles and each cuticle line. Use the pointed end of the manicure stick to make a depression between the fingers, then use your fingers to pull up a small bit of clay for each knuckle. For the thumbs, make two ⅜-inch (10mm) balls of clay and roll each out into a 1-inch (25mm) teardrop. Place the larger end of the teardrops on the palms of the hands. Blend and smooth the thumbs with the square end of the sculpting tool. Then form the thumbnails. Lift the ends of the nails with a craft knife. Add the cuticle and knuckle lines with the rounded end of a manicure stick.

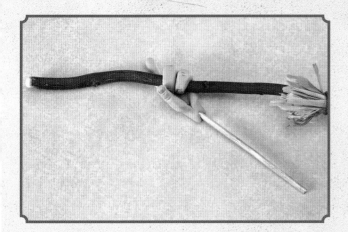

10 Pose the Hands With the Broom

Use your fingers to gently pose the hands. To make the fingers bend, make a small line on the under side of the fingers of each hand with the pointed end of the sculpting tool. Gently pose the fingers of the left hand around the broom handle. Look at your own hands to see how they work to grasp an object. Stick a short, straight piece of wire in the end of each hand. Leave the wire in both hands for baking, but remove the broom from the left hand. Bake the hands for 20 minutes at 275° F (135° C) or according to package directions.

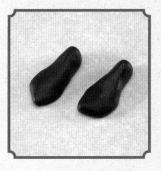

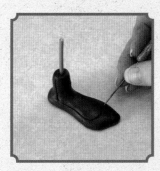

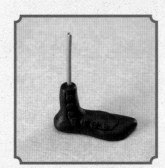

11 Sculpt the Boots

Following the process outlined in step 8 of the Chrainn the Elf demonstration, form the boots with black clay. With a needle tool, draw a line starting at the top outside of each boot, curving around to follow the shape of the foot, then go up and across the toe.

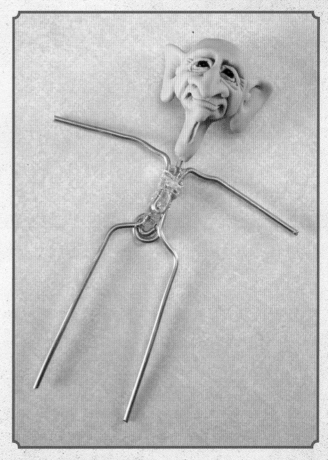

12 Add the Buttons

Roll a ¼-inch (6mm) ball of black clay into a long, thin snake. Cut the snake into ⅛-inch (3mm) slices, and roll the slices into tiny balls to create buttons. Press the buttons along the boot line, and use the needle tool to create two button holes in each. Bake the boots for 20 minutes at 275° F (135° C) or according to package directions.

You can also use real buttons rather than clay, but don't glue them on until the boots come out of the oven.

13 Assemble the Armature

Following the process outlined in step 10 of the Chrainn the Elf demonstration, assemble the armature.

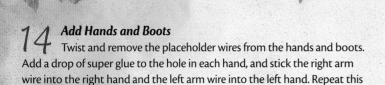

14 Add Hands and Boots

Twist and remove the placeholder wires from the hands and boots. Add a drop of super glue to the hole in each hand, and stick the right arm wire into the right hand and the left arm wire into the left hand. Repeat this process with the boots.

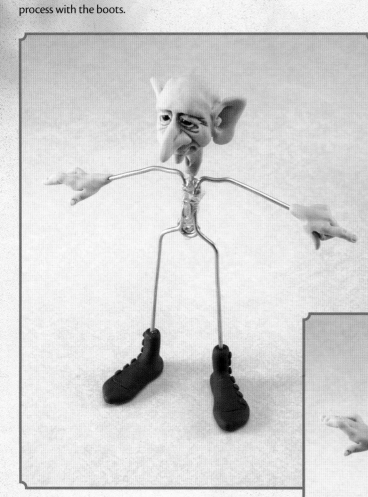

15 Paint the Head and Hands

Use no. 8 round to paint a thin diluted wash of Burnt Umber acrylic paint over the head and hands, then gently wipe off most of the paint with a paper towel. Repeat as needed or use water to remove excess paint. Dab on a thin layer of Terra Coral over the tips of the ears, the forehead, the end of the nose (a little darker here), the lips, and the cheeks with a no. 3 round. Pat the edges lightly with your finger so there isn't a sharp line.

16 Wrap and Pad the Body

Following the process outlined in step 13 of the Chrainn the Elf demonstration, wrap and pad the body. When wrapping the torso, hot glue a cotton ball to the tummy, and continue wrapping over the ball. Generally the legs and arms should have two layers of batting, with an extra layer on the torso.

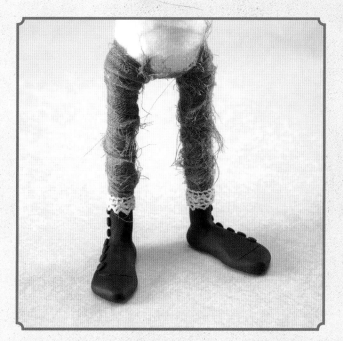

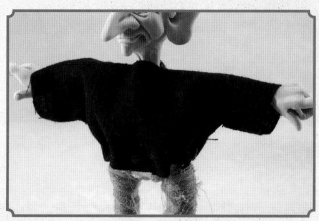

17 Make the Bloomers

Cut two 1½-inch (38mm) strips of gray cheesecloth, about 24" (61cm) long. Fold one strip in half lengthwise and wrap the leg starting at the boot, covering the batting completely. Hot glue the end of the strip at the top of the leg. Repeat for the other leg. Dot fabric glue to the back of the ankle, attach the end of a piece of ½-inch (12mm) lace and wrap around the ankle twice, covering the end of the bloomers and the top of the boot. Snip off the end of the lace and glue it in place. Repeat on the other leg.

18 Make the Blouse

Cut a 6" × 7" (15cm × 18cm) piece of black cotton and fold it in half lengthwise. Cut a 1-inch (25mm) notch from each corner away from the fold, cutting through both layers. Unfold the fabric and fold it in the opposite direction, then cut along the fold to the center, then turn your scissors at a right angle to the fold and make a 1-inch (25mm) cut. The two cuts will make a T-shape. Stick the head through the T-shape and drape the shirt over the arms so the seam is in the back. Run a line of glue down one side of the back seam, then fold over the other side and press the two sides together. Use the same method to glue both sleeve seams and the side seams. To gather the shirt at the waist, dot the front torso with glue and stick the shirt down, repeat on the back, sides, and then between the four sides.

19 Make the Skirt

Cut a 12" × 5" (30cm × 13cm) piece of black cotton. Use fabric glue to attach ½-inch (12mm) cotton lace to one of the long sides of the rectangle. With the lace at the bottom, wrap the fabric around the waist. Put a dot of fabric glue on the back of the waist, press down one corner of the fabric, and run fabric glue down the back seam of the skirt. Fold over the edge of the other side and press the two together to form the seam. Place a dot of glue on the front of the doll's waist and attach the front of the skirt. Repeat for the sides and in the spaces between the four sides for a total of eight dots.

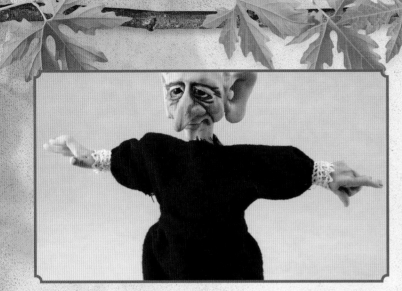

20 Add a Belt and Lace to the Sleeves

Cut a 6" × 1" (15cm × 25mm) piece of black cotton for the belt. Fold it in half lengthwise. Put a dot of glue on the back of the waist and attach one end. Wrap the belt around the waist and glue down the other end. Use four evenly spaced dots of glue on each wrist to gather and attach the sleeves. Place a dot of glue on the underside of the sleeve cuff, attach ¼-inch (6mm) cotton lace, and wrap around the wrist at least twice, covering part of the wrist and the sleeve. Cut the lace and glue into place. Repeat for the other cuff.

21 Add the Collar and Embellishments

Starting at the back of the neck, run a little bead of glue around the neck opening of the blouse. Wrap ½-inch (12mm) cotton lace over the glue, trim and glue into place. You can embellish the collar with a small button, charm or rhinestone if you like.

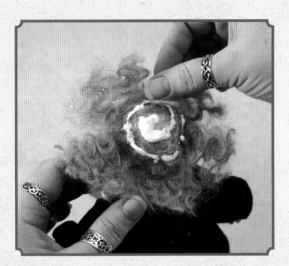

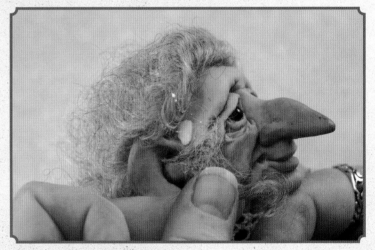

22 Cut and Apply Hair to the Head

Cut nine 2-inch (51mm) strips of gray braided mohair, fluffing out the pieces before you cut them. Starting at the front, put down a bead of white craft glue along the hairline, going around the head. Laying the hair over the face, place the end in the glue. Continue laying the hair in the glue until you have a wing surrounding the head.

23 Style the Hair and Add Side Curls

Cover the bald spot in the middle of the head with white craft glue. Pull the loose ends of the hair back and stick them to the glue in the center of the head. Add a small dot of glue just below the hairline in front of the ear, and add a tiny side curl. Repeat on the other side of the face.

24 Make the Hat

Using the hat pattern in the appendix, cut a triangle from a single layer of black felt. Cut around the semicircle pattern on a folded piece of felt to create a complete circle with a hole in the center. Cut ¼-inch (6mm) slits along the wide edge of the triangle. Run a bead of fabric glue along one of the straight sides of the triangle, and fold the other side around to attach. Run a bead of glue along the inner circle, place the cone over the circle, and attach the tabs that the slits formed.

25 Add the Lace Trim

Cut a 16-inch (41cm) piece of ¼-inch (6mm) lace to go around the base of the cone. Place a dot of glue at the back of the hat and attach both ends of the lace. Place another dot at the front and press the center of the resulting lace loop. Continue tacking with glue for a total of eight dots. The lace should be gathered in a loopy fashion, covering the cone tabs. Cut a 12-inch (30cm) piece of 20-gauge wire. Stick the wire up into the hat, and curl the remaining wire into a circle. This creates a poseable hat.

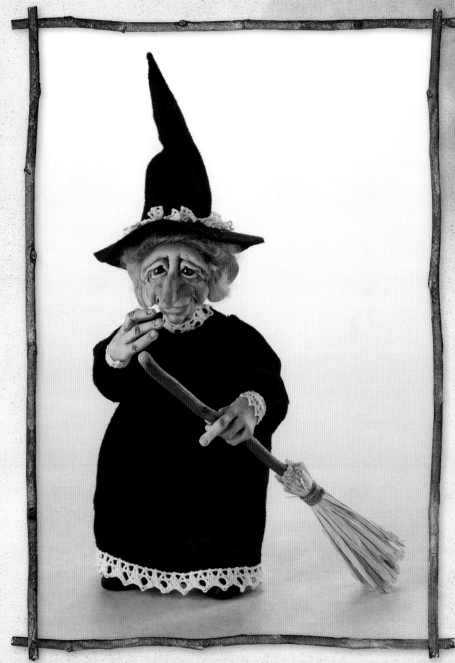

Finished Witch

Zylphia's got the giggles—must be a bat in her hat.

Make an apron for your witch: Cut a rectangle of fabric a little shorter than her skirt. Then cut a ribbon long enough to go around her waist, and glue it to one of the short ends of the rectangle. Glue some lace on the bottom and you're done.

You can have *big* fun with a witch hat, too! You can embellish it with small silk flowers or some organza netting, or hang a spider on the tip. Just go absolutely nuts with it!

Ithe the Ogre

Ogres are thought to be big and mean and stupid, but really? Ogres just love food. And they're not as big as everyone seems to think, though they are rather ugly, which is a great advantage since ogres love to drink curdled milk. Where do you think the old saying "Ugly enough to sour milk" came from?

I think that whole "big" thing is some sort of ogre mind trick. I've never seen one more than 10" (25cm) tall.

Ogres are always welcome at our house. We set a little place at the table for them, as they are charming dinner companions and they always laugh at your jokes. Ithe is at our place so often he's pretty much part of the family.

The other day the kittykids had Ithe cornered in the kitchen; he was trying to steal food from their bowls. What I said about ogres not being stupid? Ithe had blindfolded himself before attempting his daring raid. Apparently he thinks if he can't see the cats, they can't see him.

OK, Ithe isn't the sharpest knife in the drawer, but he is a good cook. That's right, he always knows just which spice will take a dish from merely good to delicious. Ithe climbs the dishtowel hanging on the fridge and hops up on the cupboard, hoisting the spice bottles up on his shoulder as he peers over the edge of the pots and pans on the stove or into a mixing bowl.

And don't try to stop him from helping—he'll grab the pepper pot and you'll be sneezing until the next blue moon!

MATERIALS

Polymer clay colors: brown, flesh tone of your choice, white

Acrylic paint colors: Burnt Umber, Terra Coral

Fabrics: faux fur, gray cheese-cloth, reddish brown four-ounce leather

Sculpting tools: craft knife, manicure stick, needle tool, needle-nose pliers, wooden sculpting tool

Other supplies: aluminum foil, ⅛" (3mm) armature wire (approximately 12 gauge), baby oil, baby wipes, charm or button, cotton balls, fabric glue, ½" (12mm) floral tape or masking tape, floral wire (32 gauge), hot glue gun and glue sticks, knitting needle for pressing fabric into hot glue, nos. 3 and 8 round brushes, ⅓" (8mm) onyx beads (2), paper towels, polyfill for baking, quilt batting, scissors, small container of water for burnt fingers, super glue

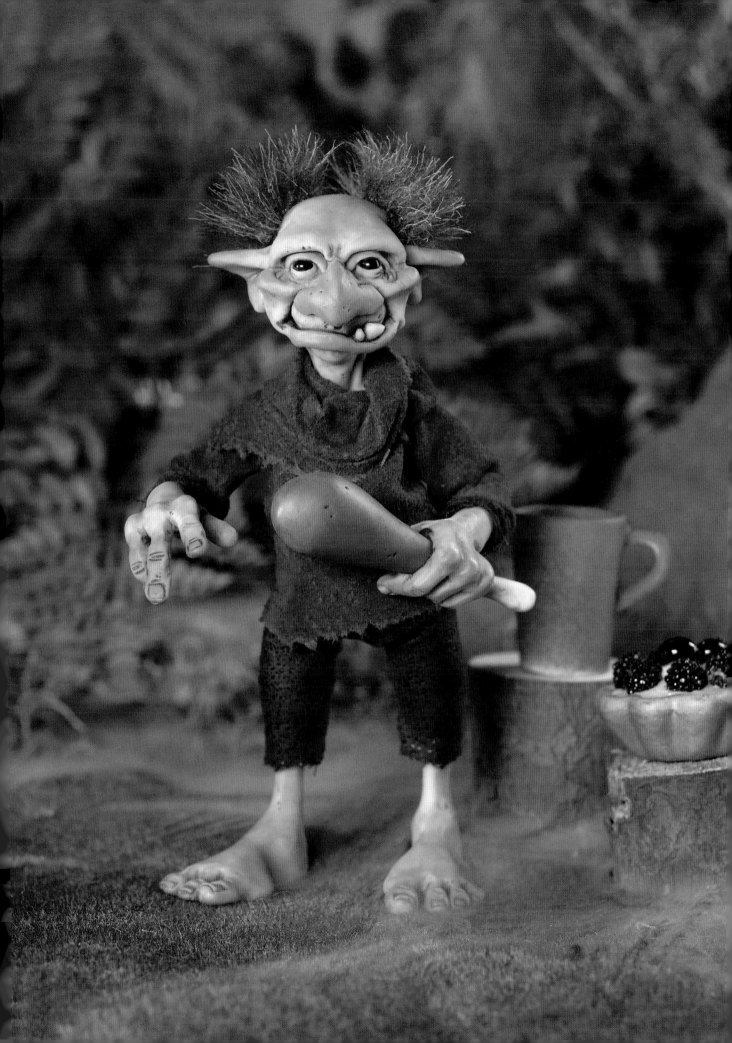

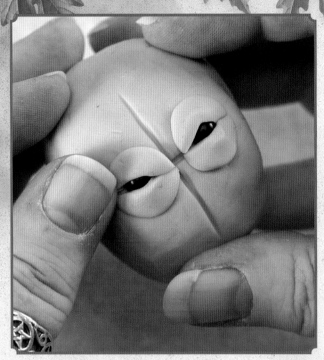

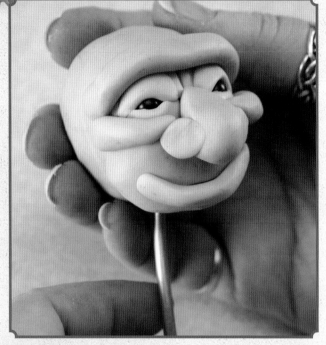

1 Form the Head and Place the Eyelids

Following the process outlined in step 1 of the Chrainn the Elf demonstration, make the head portion of the armature. Cover the ball with a circle of flesh-colored clay, pressing the seams towards the neck wire, and establish the placement of the features.

Make two ½-inch (12mm) balls of flesh-colored clay, flatten them into ½-inch (12mm) circles, and cut each circle in half. Place a half circle over the top and bottom of each eye for the eyelids.

2 Place Clay Shapes to Form the Other Features

Flatten a ⅞-inch (22mm) ball into a 1½" × ¾" (38mm × 19mm) rectangle and place it below the eyes, with the longer side horizontal. Form a ⅝-inch (16mm) ball into a 2-inch (51mm) snake and place it above the eyes for the forehead. Form a ½-inch (12mm) ball. Give it a slight point and place the point between the eyes. For the mouth, draw a line down from the outside corner of one eye to the outside corner of the other with the needle tool. Roll a ⅜-inch (10mm) ball of clay into a snake (make it as long as the mouth line you drew on the face) and position right under the line drawn for the mouth. For the nose wings, make two ¼-inch (6mm) balls and place on either side of the nose. For the cheeks, roll and flatten two ⅜-inch (10mm) balls into 1-inch (25mm) teardrops. Place them on each side of the nose with the pointed end at the corner of the eye.

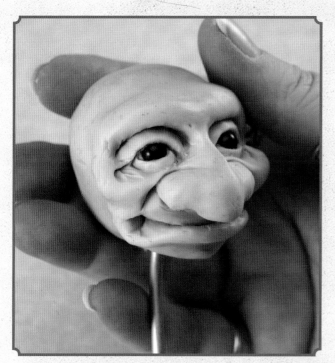

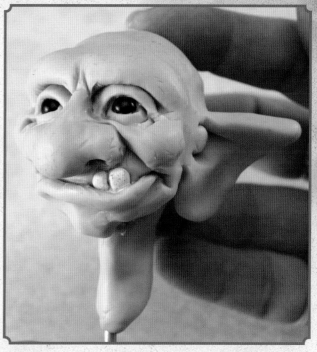

3 Blend and Shape the Features

Using the pointed end of a sculpting tool, tuck the corners of the lower eyelids under the upper eyelids. With the round end of a manicure stick, blend the upper eyelids under the brow bone. Blend the brow bone into the head with your fingers or the sculpting tool. Use the rounded end of the manicure stick to open up the eyes. Then blend the ends of the cheekbones into the head and up into the brow bone, also bringing the brow bone down into the cheek. With the same tool, blend the top of the nose up into the brow bone. Redefine the eyelids as necessary. Continuing with the manicure stick, blend the top of the cheekbones into the face. Define the lower eyelids and add wrinkles.

Using the rounded end of the manicure stick, blend the nose wings into the nose, and use your fingers to pinch the end of the nose into a soft point. Using the same tool, blend the bottom of the nose into the front of the face. Insert the pointed end of the manicure stick into the base of the nose against the face to create the nostrils. Redefine the nose as needed.

With the round end of the manicure stick, tuck the corners of the bottom lip under the upper lip. Rock the side of the manicure stick back and forth under the bottom lip to blend it in. With the round end, extend the line of the nose wing down past the corner of the mouth on each side. Finish blending in the cheeks.

4 Add the Teeth, Ears and Neck

Flatten a ⅛-inch (3mm) ball of white clay into a triangle. Insert the round end of a manicure stick in a downward motion into the lower lip below the left nostril to make a pocket for the tooth. Place the pointed end of the triangle into the pocket. Flatten the top of the tooth, pushing it into place. Use a craft knife to section off a quarter of the tooth into a separate tooth. Round the ends of the separate teeth.

Make two ¾-inch (19mm) balls of flesh clay and flatten into 1½-inch (38mm) conch shapes, and place one on each side of the head, blending in with your thumb. Use the rounded end of a manicure stick to blend in the top of the ear. Draw a reverse C-shape in the left ear and a regular C-shape in the right ear. The top of the C's should line up with the corner of the eye, and the bottom with the bottom of the nose. Bend the top of each ear down at a 90-degree angle to his head.

Roll a ¾-inch (19mm) ball of flesh clay into a 1½-inch (38mm) cylinder. Use a craft knife to slit it halfway through and wrap around the neck. Use the pointed end of the sculpting tool to blend the neck into the head. Using a thumb and forefinger, pinch the clay on the neck to the front to form a large Adam's apple. Tuck a ¼-inch (6mm) ball of flesh clay under his lower lip, and blend it back into his neck with the pointed end of the sculpting tool. Bake at 275° F (135° C) for 20 minutes or according to package directions.

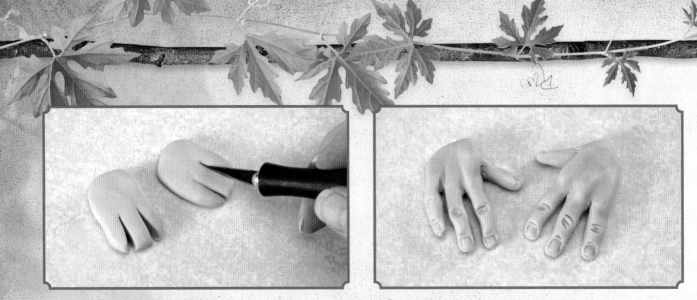

5 Cut Rectangles for the Hands, Divide the Fingers

Flatten two ¾-inch (19mm) balls into 1" × 1½" (25mm × 38mm) rectangles, about ⅛" (3mm) thick. Use a craft knife to cut three fingers on each hand. The little finger is the shortest, the middle finger is the longest, and the forefinger is slightly shorter than the middle finger.

6 Refine the Fingers and Add the Fingernails

Use your fingers to gently pull and lengthen each finger, flattening slightly, skipping a space for the knuckle, then flatten the tip of the finger somewhat. See step 9 of the Zylphia the Witch demonstration for instructions on forming the nails, making the knuckle lines and cuticles, and adding the thumbs. Bake at 275° F (135° C) for 20 minutes or according to package directions.

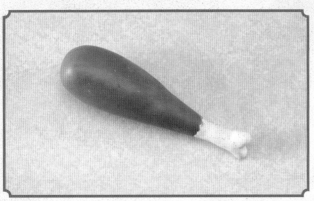

7 Sculpt the Turkey Leg

Roll a ¾-inch (19mm) ball of white clay into a 2-inch (5cm) snake. Rock the side of a manicure tool back and forth against the end of the snake to divide the bone. Roll a 1½-inch (38mm) ball of brown clay into a fat 2½-inch (6cm) teardrop. Use a manicure stick to create a hole for the bone in the narrow end. Put the bone in the hole, squeeze them together and smooth the brown clay over the white clay. Bake at 275° F (135° C) for 20 minutes or according to package directions.

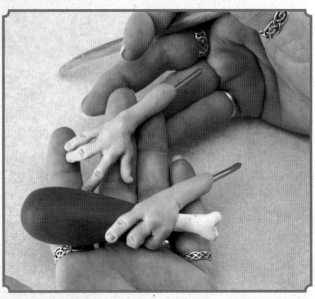

8 Pose the Left Hand With the Turkey Leg and Add Forearms

Gently wrap the left hand around the baked turkey leg. Use the pointed end of the sculpting tool to score the underside of the fingers so they will bend more easily. Touch up the details as needed. Insert a short, straight wire into the end of each hand. Roll a ⅝-inch (16mm) ball of flesh clay into a 1½-inch (38mm) cylinder. Cut halfway into the cylinder vertically and wrap around the right hand wire, blending into the hand clay with your fingers. Repeat for the left hand.

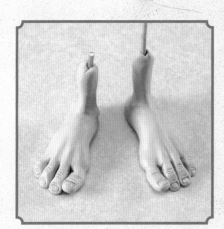

9 Sculpt the Legs and Feet

Following the instruction outlined in steps 8 and 9 of the Fetch the Troll demonstration, build and shape the feet and toes. Gently pose the toes. Insert a short, straight wire into each foot.

Roll a ⅞-inch (22mm) ball of flesh clay into a 1½-inch (38mm) cylinder. Use a craft knife to slit halfway through the cylinder vertically and wrap it around the foot wire, blending it into the foot and making it leg-shaped with a thinner ankle and wider calf. Repeat for the other leg. Make four ¼-inch (6mm) balls of flesh clay for the anklebones. Place one on each side of each ankle. Place the inside bones slightly higher than the outside bones. Blend in with the square side of the sculpting tool and your fingers. Bake at 275º F (135º C) for 20 minutes or according to package directions.

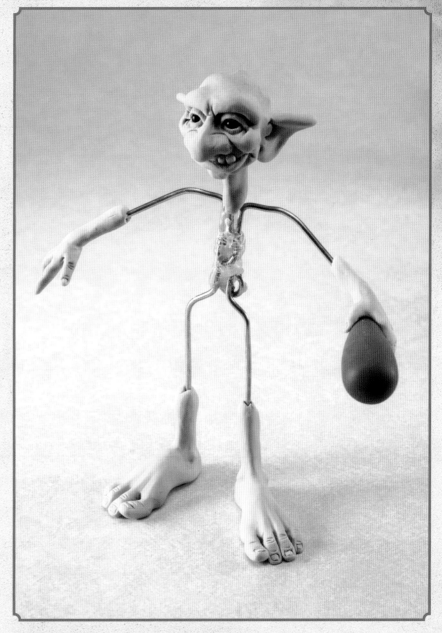

10 Build the Armature and Add the Hands and Feet

Following the process outlined in step 10 of the Chrainn the Elf demonstration, assemble the armature.

Twist and remove the placeholder wires from the hands and feet. Add a drop of super glue to the hole in each hand, and stick the right arm wire into the right hand and the left arm wire into the left hand. Repeat this process with the feet. There should be 2" (51mm) of leg wire between the tops of the clay legs and hips, and 1½" (38mm) of arm wire between the tops of the clay arms and the shoulders. Trim excess wire before gluing if needed.

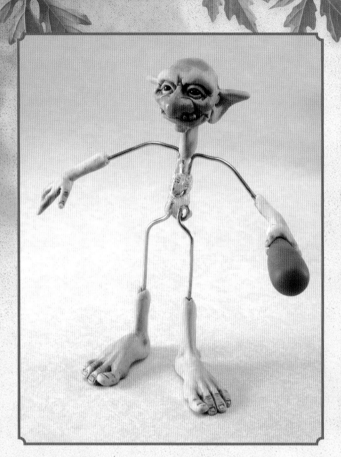

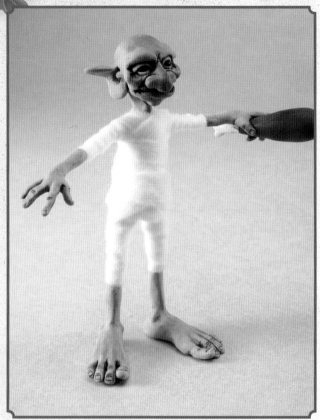

11 Add Color to the Completed Sculpt

Use a no. 8 round to paint a diluted wash of Burnt Umber acrylic paint over the head, hands, feet and turkey leg, then gently wipe off most of the paint with a paper towel. Repeat as needed or use water to remove excess paint. Dab on a thin layer of Terra Coral over the tips of the ears, the forehead, the end of the nose (a little darker here), the lips and the cheeks with a no. 3 round. Add a little Terra Coral to the knuckles of his toes and the tops of his feet. Pat the edges of the coral areas lightly with your finger so there isn't a sharp line.

12 Wrap and Pad the Body

Following the process outlined in step 13 of the Chrainn the Elf demonstration, wrap and pad the body. When wrapping the torso, hot glue a cotton ball to the tummy, and continue wrapping over the ball. Glue a second ball over the first and wrap again to create an extra-large tummy. The legs and arms should have two layers of batting, with three layers on the torso.

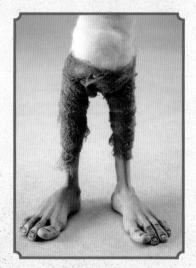

13 Make the Pants

Cut two long 1-inch (25mm) strips of gray cheesecloth. Starting at the knee bone (where the clay joins the wrapped body), wrap the cheesecloth up the leg, covering all the batting. Hot glue the end of the strip in place. Repeat for the other leg.

Cut a small triangle of cheesecloth. Hot glue one end to the tummy, then pull it between the legs, and glue the other corner to the backside.

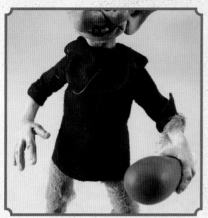

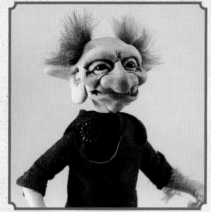

15 Add the Hair and Embellish the Shirt Collar

Using a sharp craft knife, cut two ½" × ½" (12mm × 12mm) pieces of fake fur (the coarser the fur, the better). Cut through the backing on the fur, but don't cut through the fur. Use fabric glue or hot glue to attach a tuft of fur above each ear. Make sure the fur sticks up, and arrange it so it covers the backing.

Dot a little fabric glue on the collar and embellish with a charm or button. I added a little bronze sunflower.

14 Make the Shirt

Cut two 2" × 2½" (5cm × 6cm) pieces of reddish brown four-ounce leather for the sleeves. Wrap a sleeve around each arm, run fabric glue down one edge, overlap the other edge and press together. Fold the end of each sleeve over to form a cuff and secure it with glue. Cut a 6" × 3" (15cm × 8cm) piece of the leather and wrap around the body, starting in the back. Run glue down the back and press down the other end. Cut a 6" × 2" (15cm × 5cm) piece of the leather. Glue one end at the back of the neck, and twist and drape it around the neck to cover the batting and the ends of the sleeves, then glue the other end in the back. Add dots of glue to make it stay where you want it. Wrap a bit of cheesecloth around one cuff so he has a place to wipe his mouth!

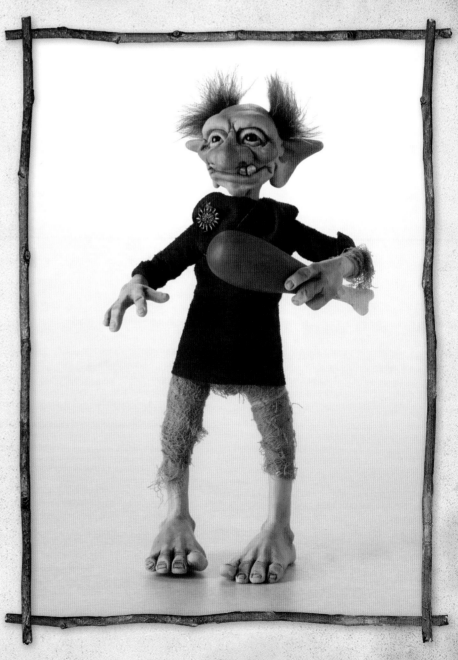

Finished Ogre

Ithe would like some gravy, if you please.

Think about some other foods your ogre would like—how about a life-size cookie, or a big cupcake? These props would make Ithe an even more humorous character than he already is. Or try some longer hair, keeping the sticking-up-every-which-way style.

If your ogre's underwear shows when you bend his arms at the elbows, cover it with a bit of cheesecloth.

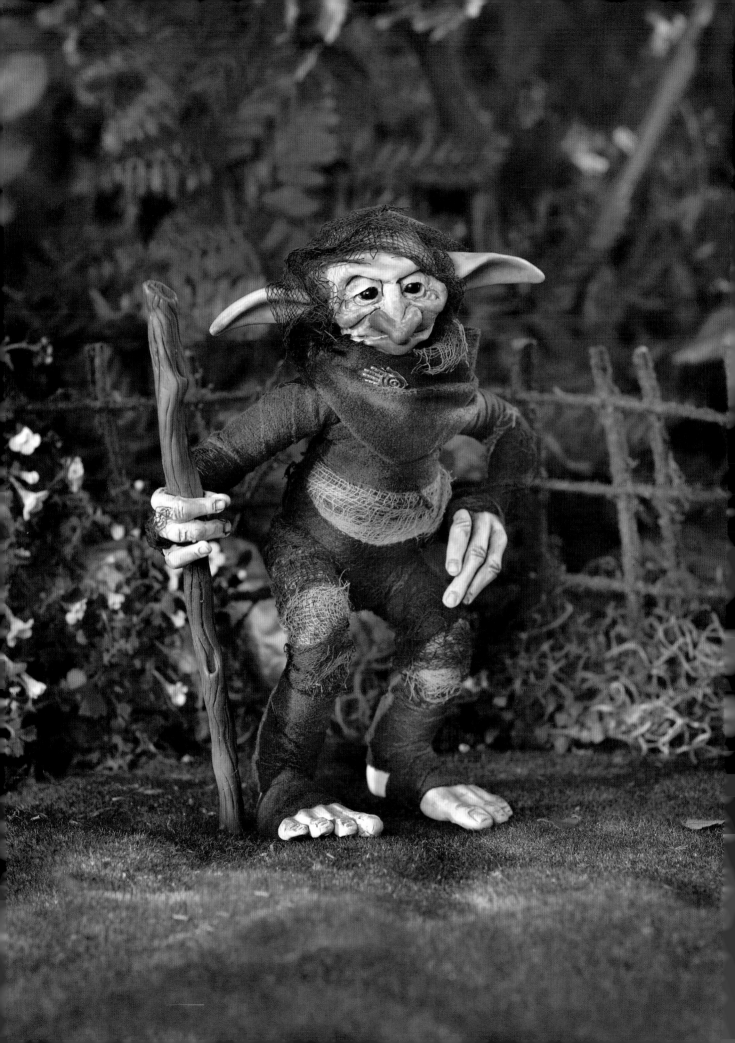

CRIMBIL THE GOBLIN

They all climbed up on a high board-fence—
Nine little Goblins, with green-glass eyes—
Nine little Goblins that had no sense,
And couldn't tell coppers from cold mince pies.

—"NINE LITTLE GOBLINS" BY JAMES WHITCOMB RILEY

I know there's not ten goblins on the fence because the tenth one moved into our house. He hates mince pies and would much rather hoard coppers than eat them. One can never find spare change in our house, and the piggybanks are always broken.

Oh, yes, Crimbil lives in our house, and he bumps and he thumps and fancies he frightens the cats. They mostly ignore him, so he goes under the sofa and terrorizes the dust rhinos. No, not dust bunnies—they're much bigger than that! I don't sweep under there since Crimbil came to live with us, because he snatches the broom away and gobbles down the straw. I gave up after he ate the third broom. So we have dust rhinos, not dust bunnies.

When you're trying to sleep at night, and the dripping water from the tap keeps you awake? That's not the tap, it's Crimbil with his stick, doing what goblins do, which is anything they can to annoy you!

They break crockery and spill flowerpots. You think you always lose one sock of the pair in the dryer, but really it's goblins—they eat socks! However, they eat only one of every pair. Eating a complete pair of socks will give a goblin indigestion.

When you can't find your keys? Goblins. They hide your reading glasses, too, and pull the cat's tails when they're catnapping, and kick the litter out of the catbox. Goblins put vinegar in the milk to make it sour (they're not as ugly as ogres). And if anyone has ever telephoned you and asked if your refrigerator is running?

Yep. Goblins.

MATERIALS

Polymer clay colors: brown, flesh tone of your choice

Acrylic paint colors : Burnt Umber, Terra Coral

Fabrics: black cheesecloth, brown cheesecloth, brown microsuede

Sculpting tools: craft knife, manicure stick, needle tool, needle-nose pliers, wooden sculpting tool

Other supplies: aluminum foil, ⅛" (3mm) armature wire (approximately 12 gauge), baby oil, button or charm, cotton balls, fabric glue, ½" (12mm) floral tape or masking tape, floral wire (32 gauge), hot glue gun and glue sticks, knitting needle for pressing fabric into hot glue, no. 4 filbert brush, nos. 3 and 8 round brushes, ⅓" (8mm) onyx beads (2), paper towels, polyfill for baking, quilt batting, small container of water for burnt fingers, super glue

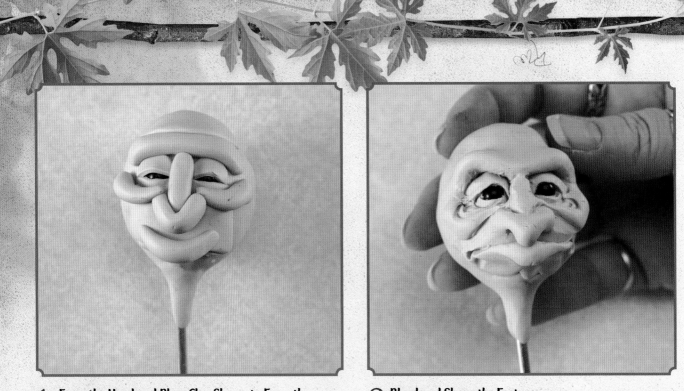

1 Form the Head and Place Clay Shapes to Form the Features

Following the process outlined in step 1 of the Chrainn the Elf demonstration, make the head portion of the armature. Cover the ball with a circle of flesh-colored clay, pressing the seams towards the neck wire, and establish the placement of the features.

Make two ½-inch (12mm) balls of flesh-colored clay, flatten them into ½-inch (12mm) circles, and cut each circle in half. Place a half circle over the top and bottom of each eye for the eyelids. Flatten a ⅞-inch (22mm) ball of flesh-colored clay into a ¾" × 1" (19mm × 25mm) rectangle and place it below the eyes. Roll a ½-inch (12mm) ball into a 1¼-inch (31mm) snake and place it above the eyes. Flatten a ⅝-inch (16mm) ball into a 1-inch (25mm) circle and place it just above the brow bone. Roll three ⅜-inch (10mm) balls into ¾-inch (19mm) snakes, and run one vertically between the brow bone and face rectangle. Bend the second into a V-shape and place beneath the other snake. Roll the ends of the third into points and place beneath the second snake for the lower lip. Roll and flatten two ⅜-inch (10mm) balls into ½-inch (12mm) teardrops. Place them on each side of the nose with the pointed end at the corner of the eye.

2 Blend and Shape the Features

Blend in the circle on top of the head with your fingers. Use the pointed end of a sculpting tool to blend the bottom of the circle and the top of the brow bone into each other. Use your thumbs to push the circle into a point just above the brow bone. Use the rounded end of a manicure stick to tuck the corners of the lower eyelids under the upper eyelids, open the eyes and flatten the upper eyelids. Blend the top of the nose and the bottom of the brow together, keeping the nose bridge narrow. Insert the pointed end of a manicure stick to form an indentation at the point where the nose, brow and inner corners of the eyes meet. Use your thumb to push down on the brow to form a frown. Use the rounded end of a manicure stick to blend the cheeks into the lower eyelids, then blend the sides of the cheeks and the outer edges of the brow together, smoothing back into the sides of the head. Add lots of wrinkles at the outer corners of the eyes.

Blend the nose wings into the main part of the nose, pinching the end of the nose to form a point. Insert the pointed end of a manicure stick at the base of the nose, against the face, to form the nostrils. Use the rounded end of a manicure stick to shape the nostrils from the outside.

Blend the bottom edge of the lower lip in, then use a needle tool to draw a line curving downward from either end of the lip. Place the side of a manicure stick beneath the lower lip and rock it back and forth to form the pouty lip. Use the rounded end of a manicure stick to make a downward line at each corner of the mouth. Define the mouth as needed with a needle tool.

Blend the lower edge of the cheek down into the face and back into the sides of the head to form sharp cheekbones. Use the round end of a manicure stick to draw a line from either corner of the nose down the outside corners of the mouth, softening the lines with the flat side of the round end of the manicure stick. Use a no. 4 filbert and a little baby oil to smooth and refine the head.

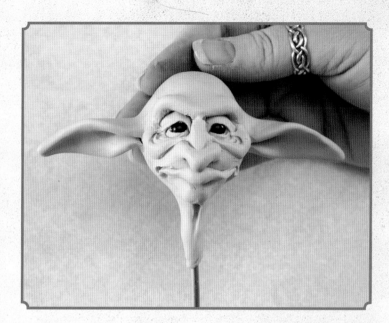

3 Add the Ears, Neck and Chin

Make two ¾-inch (19mm) balls and roll them into 1½-inch (38mm) cone shapes, then flatten the cones and place one on each side of the head, bending each base to form a C-shape. The top edges should be even with the eyes and the lower edges even with the nose. Blend in with your fingers and the round end of a manicure stick. Bend the tips down. Roll a ¾-inch (19mm) ball of flesh clay into a 1½-inch (38mm) cylinder. Use a craft knife to slit it halfway through and wrap around the neck. Use the pointed end of the sculpting tool to blend the neck into the head. Place a ½-inch (12mm) ball of clay beneath the lower lip and smooth it back into the neck for a receding chin. Use the round end of a manicure stick to draw a groove from the end of the chin down into the neck. Bake at 275º F (135º C) for 20 minutes or according to package directions.

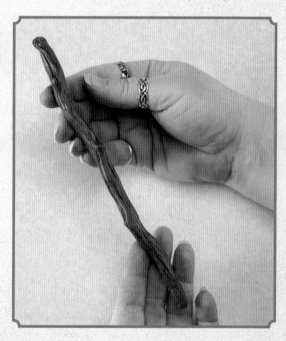

4 Sculpt the Staff

Cut a 7-inch (18cm) piece of ⅛-inch (3mm) armature wire and wrap with floral tape. Add a few bends and twists. Roll a 1⅛-inch (28mm) ball of brown clay into an 8½-inch (22cm) snake. Slit halfway through the snake with a craft knife and wrap around the staff wire. This doesn't have to be tidy—it's OK to have bumps and lumps! Use a needle tool to add lines, running from one end to the other. Gently twist the clay on the stick for a more natural appearance. Redefine the lines if necessary. Insert the pointed end of the manicure stick at the bumps to make it look as though a branch has broken off. Pull out either end into a rough point using the round end of a manicure stick to make it look broken off. Bake it on a bed of polyfill at 275º F (135º C) for 20 minutes or according to package directions.

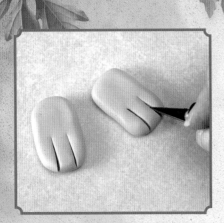
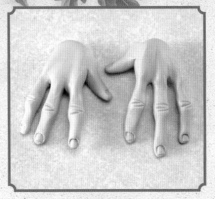
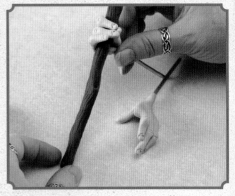

5 Cut Rectangles for the Hands, Divide the Fingers

Flatten two ¾-inch (19mm) balls into 1" × 1½" (25mm × 38mm) rectangles, about ⅛" (3mm) thick. Use a craft knife to cut three fingers on each hand. The little finger is the shortest, the middle finger is the longest, and the forefinger is in the middle.

6 Refine the Fingers and Add the Fingernails

Use your fingers to gently smooth the cut edges of the clay fingers. Carefully pull the clay to lengthen and shape. Fingers aren't round tubes—they're slightly flat across the top, and they taper at the end. See step 9 of the Zylphia the Witch demonstration for instructions on forming the nails, making the knuckle lines and cuticles, and adding the thumbs.

7 Pose the Hands With the Staff

Gently pose the right hand around the staff. Score the underside of the fingers so that they bend more easily. Put the first and second fingertips and the thumb together and squeeze gently. Pose the other hand, and insert a short, straight wire at the base of each hand. Bake at 275° F (135° C) for 20 minutes or according to package directions.

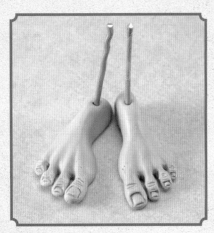
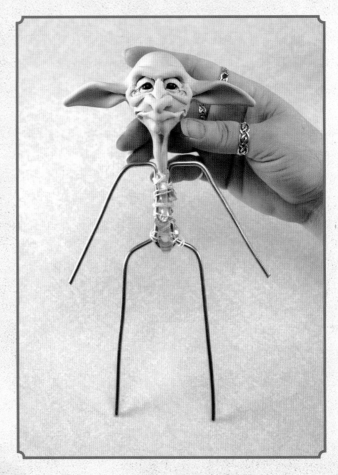

8 Sculpt the Feet

Roll a 1½-inch (38mm) ball into a 2-inch (51mm) cylinder. Square off the cylinder and flatten one end to form a basic foot shape, making one side of the toe area a little longer. Repeat for the other foot. See steps 8 and 9 of the Fetch the Troll demonstration for more instructions on shaping the feet and the toes. Using the manicure stick, draw lines running from between the toes up through the foot for the tendons. Insert a short, straight wire into each foot. Bake at 275° F (135° C) for 20 minutes or according to package directions.

9 Build the Armature

Following the process outlined in step 10 of the Chrainn the Elf demonstration, assemble the armature.

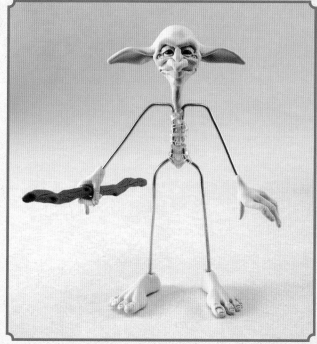

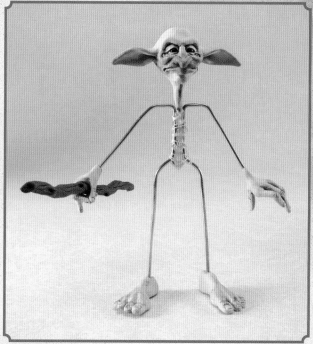

10 Add the Hands and Feet

Twist and remove the placeholder wires from the hands and feet. Add a drop of super glue to the hole in each hand, and stick the right arm wire into the right hand and the left arm wire into the left hand. Repeat this process with the feet. There should be 3½" (9cm) of leg wire between the tops of the feet and hips and 2½" (6cm) of arm wire between the tops of the hands and the shoulders. Trim wire to proper length before gluing if necessary.

11 Add Color to the Completed Sculpt

Use a no. 8 round to paint a diluted wash of Burnt Umber acrylic paint over the head, hands, feet and staff, then gently wipe off most of the paint with a paper towel. Repeat as needed or use water to remove excess paint. Dab on a thin layer of Terra Coral over the tips of the ears, the forehead, the end of the nose (a little darker here), the lips and the cheeks with a no. 3 round. Add a little Terra Coral to the knuckles of his toes and the tops of his feet. Pat the edges of the coral areas lightly with your finger so there isn't a sharp line.

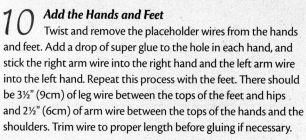

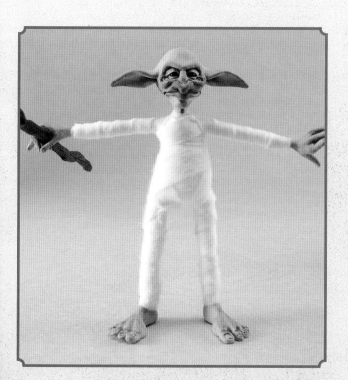

12 Wrap and Pad the Body

Following the process outlined in step 13 of the Chrainn the Elf demonstration, wrap and pad the body. When wrapping the torso, hot glue a cotton ball to the tummy, and continue wrapping over the ball. Glue a second ball over the first and wrap again to create an extra-large tummy. The arms and legs should have two layers of padding, with an extra third layer around the torso.

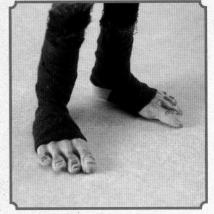

14 Wrap the Feet

Cut long 1-inch (25mm) strips of brown microsuede. Starting at one ankle, tack down the end of a strip with fabric glue, wrap down around the foot, back up and around the leg. Trim the strip and secure the end with fabric glue. Repeat on the other ankle, foot and leg.

13 Wrap the Body With Cheesecloth

Cut several long 1-inch (25mm) strips of black cheesecloth (mine has large tan polka-dots!). Hot glue the end of one strip to an ankle and wrap the cheesecloth up the leg, covering all the batting. Hot glue the end of the strip in place. Wrap the other leg, the torso and the arms. You can pull the cheesecloth over the hands and poke the thumb through to form gloves if you like.

Cut a small triangle of cheesecloth and hot glue one end to the tummy, pull it between the legs, and glue the other corner to the backside.

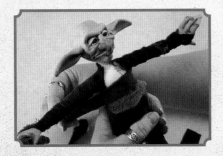

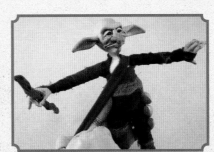

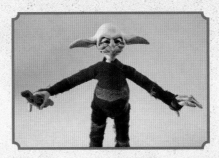

15 Wrap the Upper Arms

Cut long 1-inch (25mm) strips of brown microsuede. Tack the end of one strip down under one arm near the elbow and continue wrapping around the upper arm. Cross the strip over the shoulder, across the back and under the opposite arm. Wrap over that shoulder and back across the body, forming an X on the chest and back. Wrap the back and continue wrapping the second arm.

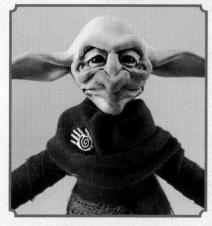

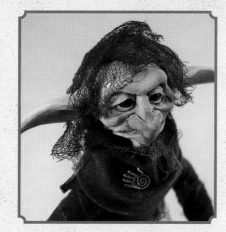

17 Wrap the Head With Cheesecloth

Wrap a 1-inch (25mm) strip of black cheesecloth over the head, allowing the ears to poke through. Bring the cloth down under the chin. No glue required.

16 Wrap the Collar and Add Embellishment

Cut a 4" × 9" (10cm × 23cm) piece of brown microsuede. Glue down one short edge in the back with fabric glue. Twist and drape the fabric around, covering the tops of the shoulders. Wrap the end to the back, trim if necessary, and tack down with fabric glue. Use hot glue to embellish the collar with a button or charm.

Finished Goblin

Crimbil is in search of mischief.

Would goblins ever wear pastel? I bet they'd be embarrassed. Or perhaps it's a secret vice to wear un-gobliny colors. Try sculpting a sneaky or uncomfortable expression on your next goblin, then dress him in sky blue and pale purple!

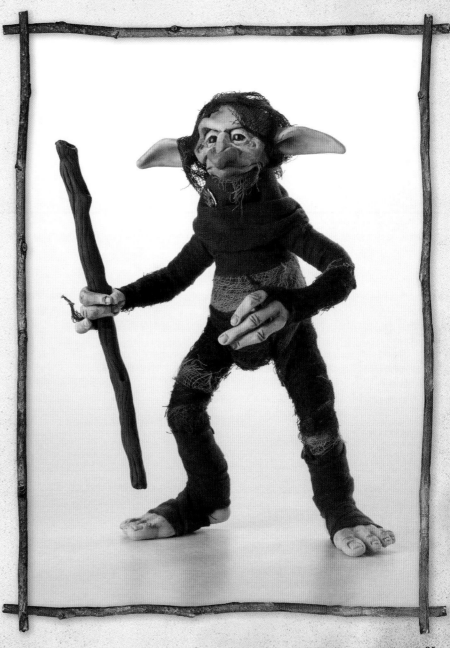

CEOLANN THE FAIRY

No need for journeying, Seeking afar:
Where there are flowers, there fairies are!
—"WHERE?" BY CICELY MARY BARKER

*I*f you've ever heard the wind sigh through a bed of flowers, you've been close to fairies! Ceolann and her kind are the caretakers of flowers of all kinds. What you may think is the wind is actually tiny fae voices singing to help the flowers grow and thrive. When you hear wind chimes but none are to be found, that, too, is the fairies playing amongst the flowers. At Dusk, the lights that move at the bottom of the Garden may be fireflies … or it just might be fairies making certain their floral charges are closed up and tucked safely in their beds 'til Dawn should come again.

While they love to sing, their most favorite thing is to paint the flowers! How drab a garden would be without the fae to splash color on the petals. With paint and brushes stolen from nearby artists—what, you've never "misplaced" a brush?—they drip and splatter and swash the colors with joyous abandon, and never a drop lands on themselves.

Ceolann is one of the fairies charged with the painting of blue and purple flowers: hyacinths, hydrangeas, pansies and violets. It's really very easy to tell, as these fae wear the colors of the flowers they paint. Should there be no paint nearby to "borrow," Ceolann will simply wring the colors from her skirt, which magickally never fades, onto the petals!

MATERIALS

Polymer clay colors: flesh tone of your choice

Acrylic paint colors: Burnt Umber, Terra Coral

Fabrics: dark blue microsuede, purple four-ounce leather, Tibetan lambskin, white organza

Sculpting tools: craft knife, manicure stick, needle tool, needle-nose pliers, wooden sculpting tool

Other supplies: aluminum foil, ⅛" (3mm) armature wire (approximately 12 gauge), art fiber, baby oil, cardboard, cotton balls, fabric glue, ½" (12mm) floral tape or masking tape, floral wire (32 gauge), hot glue gun and glue sticks, knitting needle for pressing fabric into hot glue, no. 4 filbert brush, nos. 3 and 8 round brushes, ⅓" (8mm) onyx beads (2), paper towels, polyfill for baking, quilt batting, scissors, small container of water for burnt fingers, super glue, white craft glue, wire (20 gauge)

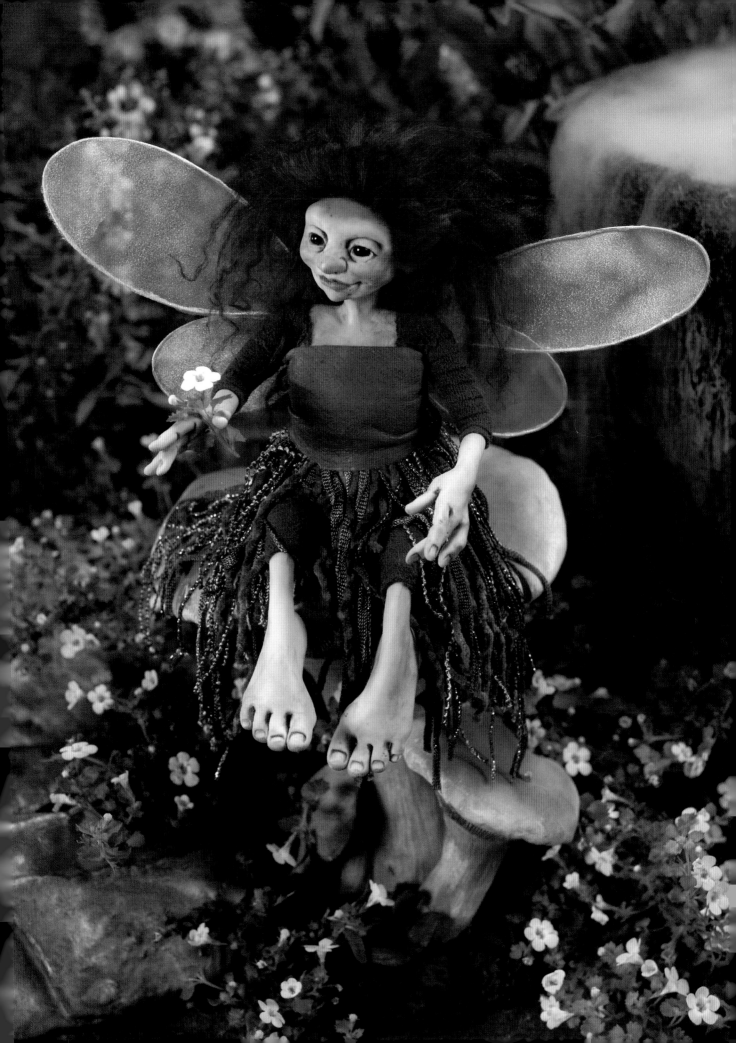

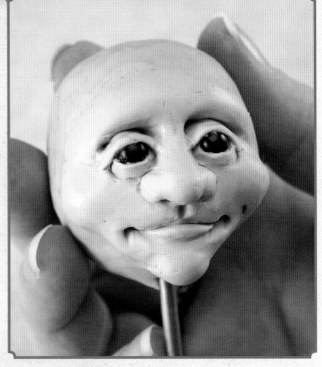

1 Form the Head and Place Clay Shapes to Form the Features

Following the process outlined in step 1 of the Chrainn the Elf demonstration, make the head portion of the armature. Cover the ball with a circle of flesh-colored clay, pressing the seams towards the neck wire, and establish the placement of the features.

Make two ½-inch (12mm) balls of flesh-colored clay, flatten them into ½-inch (12mm) circles, and cut each circle in half. Place a half circle over the top and bottom of each eye for the eyelids. Flatten a ½-inch (12mm) ball into a 1" × ½" (25mm × 12mm) rectangle and place it horizontally beneath the eyes. Place a ½-inch (12mm) ball under the rectangle for the chin. Place a ½-inch (12mm) ball on each side of the lower face rectangle for the cheeks, and another ½-inch (12mm) ball just below the center of the eyes for the nose. Flatten a ½-inch (12mm) ball into a 1½-inch (38mm) snake, and place it over the eyes for the forehead. Use the needle tool to draw a short line for the mouth halfway between the nose and the chin.

2 Blend and Shape the Features

Blend the forehead snake shape into the top of the head with your thumb. Use the round end of the manicure stick to tuck the lower eyelids under the upper eyelids, open the eyes, and flatten the eyelids. Using the same tool, draw a line just above each eyeball to define the eyelids. Blend the brow bone down to the top of these lines.

Blend down the sides of the nose with the round end of the manicure stick, then blend the top of the nose up between the eyes. Blend the bottom of the nose down into the face. Keeping the nose as small and buttonlike as you can, form the nostrils with the pointed end of the manicure stick. Shape the top of the nose with the rounded end of the manicure stick, keeping the lines very light. Tuck the end of the nose down a bit if the nostrils are visible from the front.

Blend the cheeks in toward the nose and out to the sides of the face. Blend the ends of the brow bone and the edges of the cheeks together with your thumb.

Use the round end of the manicure stick to draw the philtrum running from the bottom of the nose down to the mouth line. Using the flat side of the round end of the manicure stick, make a Cupid's bow top lip. Use the pointed end of the manicure stick to sculpt the bottom lip out of the existing clay. Insert the round end of the manicure stick at each corner of the mouth to form the smile. Smooth the cheeks with your thumb. Use a finger to smooth the bottom of the cheeks toward the chin. Insert the round end of the manicure stick about an ⅛" (3mm) out from the smile line on the left side of the face to create a dimple. Use your thumbs to smooth out the bottom of the chin. Use a no. 4 filbert and a little baby oil to smooth out fingerprints and indentations.

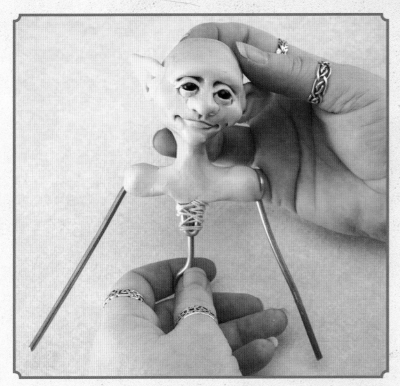

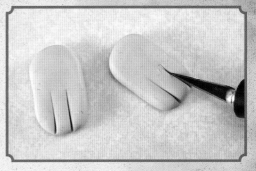

4 Cut Rectangles for the Hands, Divide the Fingers

Flatten two ⅝-inch (16mm) balls of flesh clay into 1" × ½" (25mm × 12mm) rectangles. Cut three fingers on each hand with a craft knife.

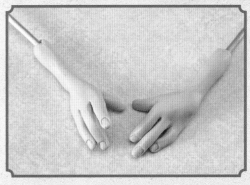

3 Add the Neck, Shoulders and Ears

Add the arm part of the armature before baking the head so you can build the shoulders in clay. Cut a 10-inch (25cm) piece of wire for the arms. Bend the wire in half with the needle-nose pliers, then bend each arm at a 90-degree angle 1½" (38mm) from the center bend, and then bend another 90-degree angle 1" (25mm) out from the first bend. Place the arm wire over the neck wire and wrap floral wire around the two to secure them. Bracing the neck wire, tilt the head very gently to the left. Roll a ⅝-inch (16mm) ball of flesh clay into a 1-inch (25mm) cylinder. Use a craft knife to slit halfway through the cylinder vertically and wrap it around the neck wire, blending into the head. Roll a 1-inch (25mm) ball of flesh clay into a 2¾-inch (7cm) cylinder (make it as wide as the shoulders), and cut it in half. Use a craft knife to cut halfway through each cylinder half and wrap around the shoulder section of the arm wire. Use your free hand to secure the armature as you blend and shape the shoulder clay with your fingers and sculpting tool. Make sure the ends of the shoulders are round.

Roll two ⅝-inch (16mm) balls of flesh clay into 1½-inch (38mm) teardrops for the ears. Place the ears halfway back on the head, making the top of the base even with the eye. Use the pointed end of the sculpting tool to blend and attach the ears. Use the rounded end of the sculpting tool to make a backwards C-shape in the left ear and a regular C-shape in the right ear. Shape the ears by gently pulling out and up on the tips. Bake at 275° F (135° C) for 20 minutes or according to the package directions.

5 Refine the Fingers and Add the Fingernails

Use your fingers to gently smooth the cut edges of the clay fingers. Carefully pull the clay to lengthen and shape. Fingers aren't round tubes—they're slightly flat across the top, and they taper at the end. Make the middle finger the longest, the forefinger a little shorter, and the little finger the shortest of the three. Press the pointed end of the manicure stick between each of the fingers to soften the cuts. Use the round end of the manicure stick to mark the fingernails (don't lift the end of the fingernail this time). Roll two ⅜-inch (10mm) balls into ¾-inch (19mm) teardrops. Use the round end of the manicure stick to mark the thumbnail. Attach one to each hand. Insert short, straight wires into the end of each hand. Pose the fingers gracefully. Roll two ½-inch (12mm) balls into 1-inch (25mm) cylinders. Use a craft knife to slit halfway through the cylinders and wrap around the hand wires, blending into the hands with the rounded end of the manicure stick. Bake at 275° F (135° C) for 20 minutes or according to the package directions.

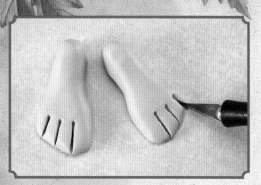

6 Make the Basic Foot Shapes

Make two 1-inch (25mm) balls of flesh clay. Flatten the front and pinch the back of each ball to create a basic foot shape. Make a longer big toe side on each foot (make sure you have a left and a right!). Flip each foot over and use your thumb to make the indentation for the arch. Use a craft knife to cut a big toe, a little toe and two medium toes on each foot.

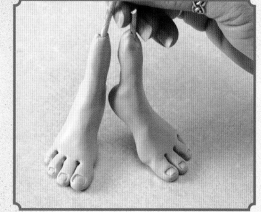

7 Add Detail to the Feet and Toes

Use your fingers to smooth and round off each of the toes. Don't add a lot of detail. Rock the side of the manicure stick against the side of the foot just below the little toe to create a notch. Repeat for the other little toe and both of the big toes. Use the square end of the sculpting tool to draw a horizontal line and two vertical lines for each toenail (do not lift the ends of the toenails). Stick a short, straight wire in the base of each foot. Roll two ⅞-inch (22mm) balls of clay into 1½-inch (38mm) cylinders. Use a craft knife to slice halfway through each cylinder, and wrap one around each leg wire, using your fingers to blend into the feet. Put your forefinger where the foot and leg meet and gently bend the wire back so the foot is slightly pointed. Holding the foot by the wire, put the toes on a flat surface and gently press. Repeat on the other foot. Bake at 275° F (135° C) for 20 minutes or according to the package directions.

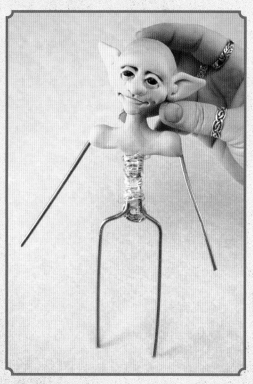

8 Assemble the Bottom Half of the Armature

Cut a 12-inch (30cm) piece of wire for the legs. Bend the wire in half with the needle-nose pliers. Bend the leg wires out at an approximately 50-degree angle for the hips, (see the armature map in the patterns appendix) and then bend the wires straight down. Slip the coil from the head wire into the middle bend of the leg wire and wrap with floral wire. Secure the armature with hot glue.

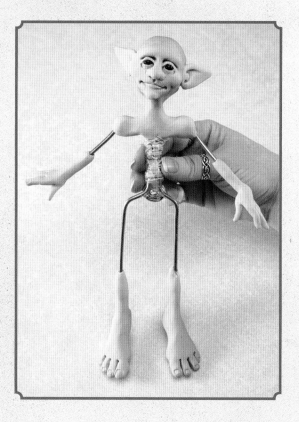

9 Add Hands and Feet

Twist and remove the placeholder wires from the hands and feet. Add a drop of super glue to the holes in the hands and feet, and attach the arm and leg wires of the armature. The clay part of the legs should be 2" (51mm) down from the hip joints. The clay part of the arms should be 1" (25mm) down from the shoulder plate. Trim the arm and leg wires before gluing, if necessary.

10 Add Color

Use a no. 8 round to paint a thin diluted wash of Burnt Umber acrylic paint over the head and hands, then gently wipe off most of the paint with a paper towel. Repeat as needed or use water to remove excess paint. Dab on a thin layer of Terra Coral over the tips of the ears, the forehead, the end of the nose (a little darker here), the lips and the cheeks with a no. 3 round. Pat the edges lightly with your finger so there isn't a sharp line.

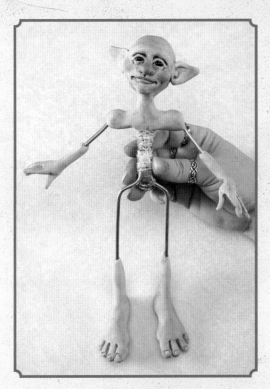

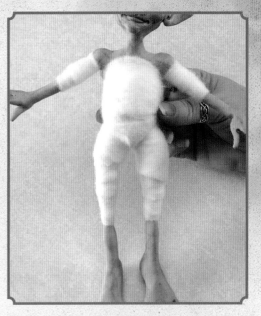

11 Wrap and Pad the Body

Attach one end of a long 1-inch (25mm) quilt batting strip with hot glue and wrap the torso. Hot glue two cotton balls to the chest, and continue wrapping over the balls. Use shorter strips of batting to wrap each arm between the clay shoulder plate and forearm. Cross the leftover batting strip from the right arm over to the left side of the body and start wrapping down the left leg and vice versa. Drape a 36-inch (91cm) strip around the waist from the back and continue wrapping the legs. The arms and legs should have two layers of padding, with an extra third layer around the torso.

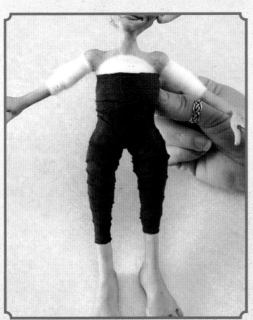

12 Wrap the Legs With Microsuede

Cut two long 1-inch (25mm) strips of dark blue microsuede, cutting with the stretch of the fabric. Use fabric glue to attach one end of a strip, fuzzy side out, at the knee bone (where the clay joins the wrapped body), wrap the fabric up the leg, covering all the batting, and take the excess between the legs and around the body. Use fabric glue to secure the end of the strip. Repeat for the other leg.

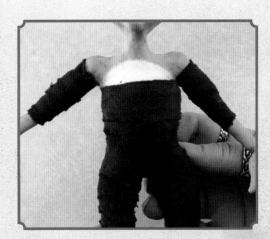

13 Make the Sleeves

Use the leg wrapping technique to cover the batting portion of both arms with 1-inch (25mm) strips of the dark blue microsuede. The fabric edge should cover the end of the clay shoulder plates and forearms.

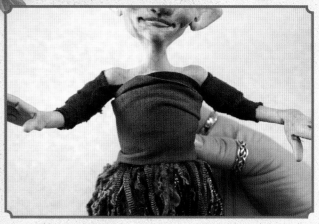

14 Make the Skirt

Wrap the strands of an art fiber bundle around a 5" × 5" (13cm × 13cm) piece of cardboard. Loop a short piece of 20-gauge wire through the fibers at the top of the cardboard and twist to secure. Cut through the fibers at the base of the card. Keeping the fibers on the wire, wrap it around the waist and twist it in the back. Secure with a dot of fabric glue. Distribute the fibers evenly around the waist, hiding the wire. Cut any missed loops and trim.

15 Make the Bodice

Cut a 3" × 5" (8cm × 13cm) piece of purple four-ounce leather. Run a bead of fabric glue down the back, then artfully gather and press down a short end of the strip. Wrap the leather around the front, covering any batting and the top of the skirt, and glue down the other edge in the back.

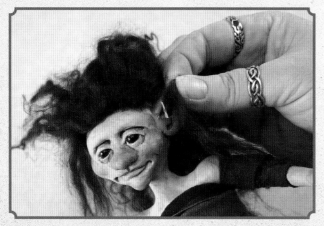

16 Add the Hair

Hold a piece of Tibetan lambskin so the hair trails down. Flip it over and place it on a flat surface. Use a craft knife to cut six ¼" × 2" (6mm × 51mm) strips, cutting through the skin but not the hair.

Starting at the front, put down a bead of white craft glue along the hairline, going around the head. Fill in the hair area with a thin layer of glue. Laying the hair over the face, place the skin in the glue. Then, starting in the back, continue laying pieces in the glue, working up the head to the front. Brush the front hair over the rest. Make sure none of the scalp shows. Cut two small tufts of hair (leave it on the skin) and attach in front of the ears. Smooth the hair.

17 Make the Wings

Cut a 23-inch (58cm) piece and 15-inch (38cm) piece of 20-gauge wire. Bend the shorter wire in half, then bend one end around to the middle bend and twist the end of the wire around it. (See the wing pattern in the appendix.) Repeat with the other side to create two loops. Repeat these steps on the longer wire so it also has two loops. Run a bead of fabric glue along one of the smaller loops, then press against a piece of white organza, and trim off the excess fabric with short-bladed scissors (regular scissors are OK). Repeat, attaching fabric to one loop at a time. Put the flatter edges of the loops together and use a short piece of wire to attach them. For a fancier wing, use glitter glue rather than fabric glue.

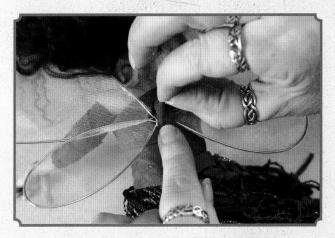

18 Attach the Wings

Holding the hair out of the way, place a dot of fabric glue just below the shoulder blades and attach the wings. Cut a tiny triangle of the bodice leather and glue it over the twisted part of the wing wires.

Finished Fairy

Ceolann is poised to take flight.

As an alternative for Ceolann's skirt, try cutting organza silk fabric into strips and using the same process as with the fiber. Same idea, different look and feel.

This character is a perfect example of oddfae: a fairy, not really ugly, but not your usual "pretty children with butterfly wings" fairy. She's really more of a Nature spirit.

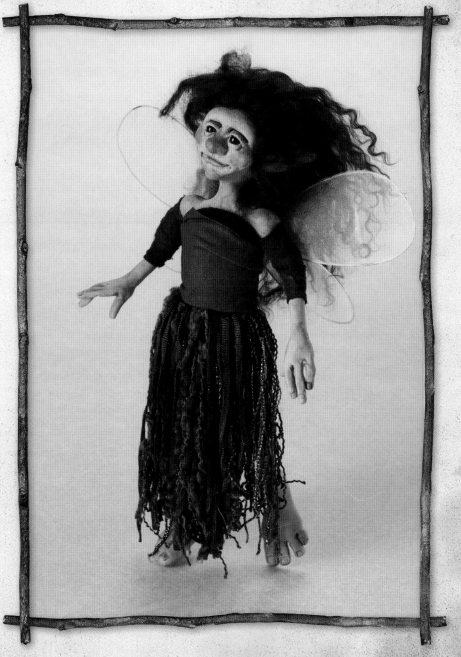

DAIN THE DRAGON

> 'Twas brillig, and the slithy toves
> Did gyre and gimble in the wabe;
> All mimsy were the borogoves,
> And the mome raths outgrabe.
>
> —"JABBERWOCKY" BY LEWIS CARROLL

OK, it's not really about a dragon, but there's no way I could write a book with poems and not include "Jabberwocky"! Besides, it's the sort of thing Dain would write.

The black sheep of the conflagration (a family of dragons) was Dain's great-great-great granddragon, a dragon who loved poetry (it's rumored he once met St. George). When Dain heard the family fables, it sparked a fire to not only read poetry, but to write it as well. Oh, dear.

His parents were convinced it was "just a phrase he was going through" and indulged him in his writing of rhymes and scrawling of sonnets. Over time they have resigned themselves to his runics, their dreams of him accumulating a heaping hoard gone up in smoke.

Imagine their surprise when Dain became a published playwright; his best-known work is "The Stalking of the Spark," performed at hot spots around the world. Garnering gold is no longer a worry, and he's made his family proud with his reserve of riches!

While Dain is usually published under the name Dodgson Burns, he is also known by the pen name Drakespeare, though it's been conjectured he's really Francis Drake-on.

MATERIALS

Polymer clay colors: green, off-white

Acrylic paint colors: Burnt Umber

Fabrics: gray cheesecloth, green cheesecloth, microsuede, silk, tan cheesecloth, white cotton

Sculpting tools: craft knife, manicure stick, needle tool, needle-nose pliers, wooden sculpting tool, texture tool (homemade)

Other supplies: aluminum foil, ⅛" (3mm) armature wire (approximately 12 gauge), baby wipes, charm, bead or button, cotton balls, fabric glue, ½" (12mm) floral tape or masking tape, floral wire (32 gauge), hot glue gun and glue sticks, knitting needle for pressing fabric into hot glue, needle and thread, no. 8 round brush, ⅓" (8mm) onyx beads (2), paper towels, polyfill for baking, quilt batting, scissors, small container of water for burnt fingers, super glue, wire (20 gauge)

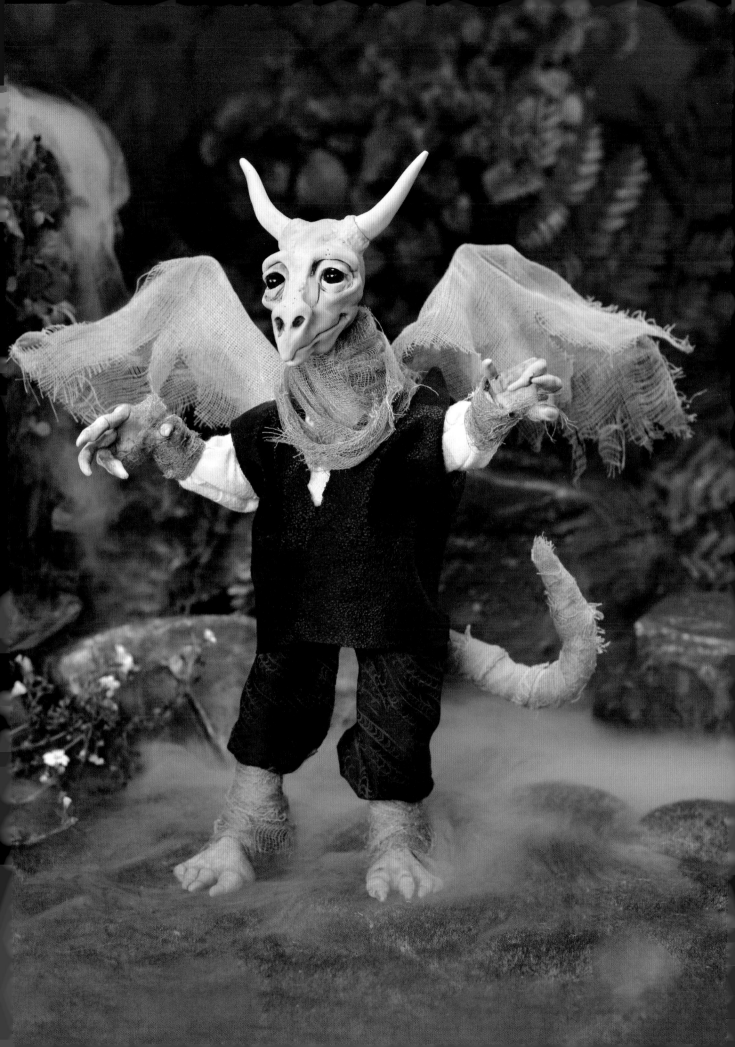

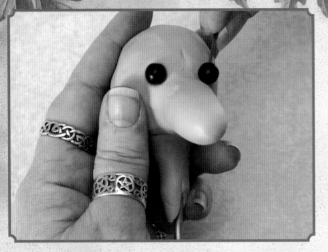

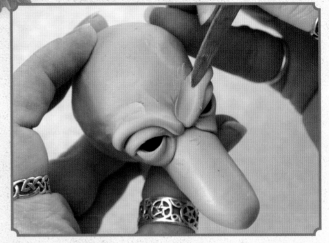

1 Form the Head and Establish Placement of the Features

Following the process outlined in step 1 of the Chrainn the Elf demonstration, make the head portion of the armature. Cover the ball with a circle of green clay, pressing the seams towards the neck wire, and establish the placement of the features.

Form a 1-inch (25mm) ball of clay and roll it into a 1½-inch (38mm) cylinder and flatten the end. Place the top of the cylinder even with the horizontal eyeline. Blend with your fingers.

2 Place Clay Shapes to Form the Features

Add onyx bead eyeballs on either side of the snout. Form two ½-inch (12mm) balls, flatten each into a ½-inch (12mm) circle, and cut each in half. Place half over the lower half of each eye. Place the other halves for the upper eyelids. Use the pointed end of the sculpting tool to blend into the face. Push extra clay off the eyes with the sculpting tool and shape the corners. Roll two ⅜-inch (10mm) balls of clay into 1-inch (25mm) snakes. Place one over each eye to create the bony protuberance. Blend the back edge into the forehead area.

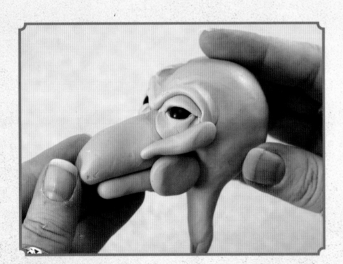

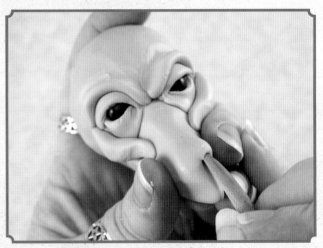

3 Finish Adding Shapes for the Snout and Cheeks

Smooth the bottom of the snout with your thumb to make it flatter. Pinch the top to create a ridge. Take a ½-inch (12mm) ball and flatten it out into a ¼-inch (6mm) thick rectangle about 1" (25mm) long. Place it beneath the snout. Take a ¼-inch (6mm) ball and press it into place, directly below the eyeball. Repeat for the other side.

For the cheeks, form two ¼-inch (6mm) balls into two teardrops. Place the first one at the lower outside corner of the eye and attach the pointed side to the nose. Repeat on the other side.

4 Blend and Shape the Upper Jaw

Take the bottom of the upper jaw between your thumb and forefinger and pull it out into a point. Use the pointed end of the sculpting tool to create the nostrils, pulling up slightly. Add a little dent between the nostrils.

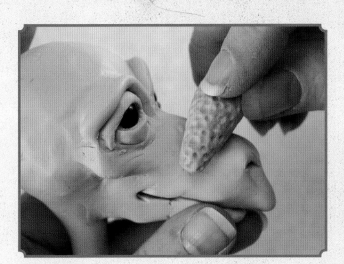

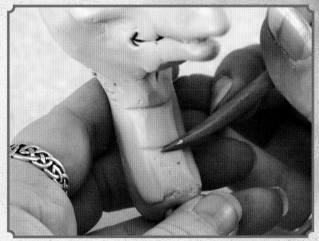

5 Blend and Shape the Other Features

Flatten the eyelids out where they meet the brow bone. Continuing with the sculpting tool, blend the lower eyelid and the cheek into the nose. Refine the lines and the shape of the eyelid. Flatten the top of the brow bone with your finger. Blend the parts of the bottom jaw with the sculpting tool. Use your thumb to blend the larger pieces. The bottom jaw forms most of the mouth, but pull the smile line a little farther with the pointed end of the sculpting tool. Add texture with a homemade clay texture tool. Roll the tool back and forth to create bumps on the top of the snout, under the jaw and above the brow bones.

6 Add the Neck

Roll a 1-inch (25mm) ball of green clay into a 1½-inch (38mm) cylinder. Slice halfway through the cylinder with the craft knife, and wrap it around the neck wire. Smooth it into the head with your fingers. Smooth out the seam in the front. Use the pointed end of the tool to make a line down each side of the neck. Smooth the lines a little. Draw three lines across the front of the neck to form the scaly plates. Use the homemade texture tool to roll texture down the back of his neck.

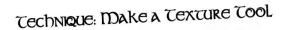

Technique: Make a Texture Tool

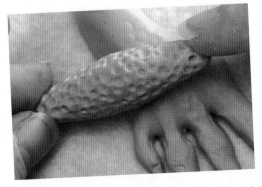

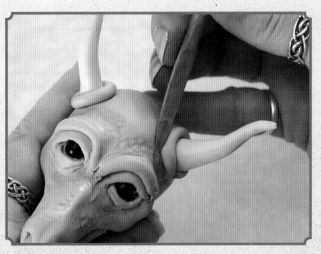

It's easy to give Dain scales using a tool you make yourself! Grab some scrap clay, roll it into a fat snake, and push dents into it all over with a stylus. Bake it on a bed of polyfill, and when it comes out of the oven, you've got a little texture tool. Simply roll it over the unbaked clay wherever you want scales.

7 Add the Horns

Roll two ½-inch (12mm) balls of off-white clay into long cone shapes. Flatten the big end of each cone, and place them on top of the head, to the side and slightly above each eye. Roll two ½-inch (12mm) lumps of green clay into snakes to fit around the bottom of each horn. Blend the green clay into the head, squeeze it up around the horn, and run the texture tool around it. Bake at 275º F (135º C) for 20 minutes or according to the package directions.

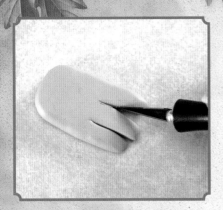

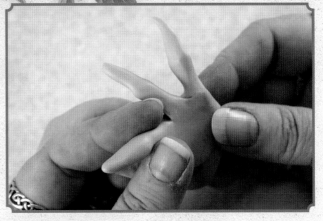

8 Cut Rectangles for the Hands, Divide the Fingers

Form two ⅞-inch (22mm) lumps of green clay into two rectangles about 1½" (38mm) long. Divide each rectangle into three equal fingers with a craft knife.

9 Refine the Fingers and Add Fingernails

Use your fingers to gently smooth the cut edges of the clay fingers. Carefully pull the clay to lengthen and shape. When you get to the end of the finger, roll it back and forth to make a point and bend it down into a claw. Repeat for each finger on both hands. It may be easier to start with the middle finger and then do the fingers on either side, though I usually work from one end to the other.

10 Add Knobby Knuckles, Thumbs and Details

Bend the fingers at the palm into a 90-degree angle. Pull the clay up with your thumb and forefinger to shape the knuckles. Using the sculpting tool, put a line on the back of the hand between each knuckle. Form two ½-inch (12mm) lumps of clay into elongated teardrop shapes for the thumbs. Flip the hands over, and stick them to the palms. Blend them in with your fingers. Roll each out a bit into thumb shapes. Roll the ends into claws. Choose a pose and gently adjust the features into place. Stick a short, straight piece of wire into the base of the hand. Wrap a ⅜-inch (10mm) ball of clay around the wire, and blend it into the hand. Use the homemade texture tool to roll texture on the back of the hand. Repeat the entire step for the other hand. Bake at 275° F (135° C) for 20 minutes or according to the package directions.

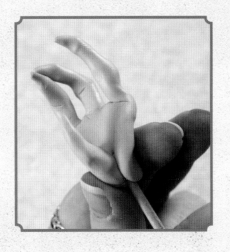

11 Make the Basic Feet Shapes

Flatten the toe end of a 1-inch (25mm) lump of green clay and squish the heel end together to create a 2½-inch (6cm) long foot. Cut the toes with a craft knife. There is one big toe, then two that are the same size and then a little one. Repeat for the second foot, making sure you make a right and left foot.

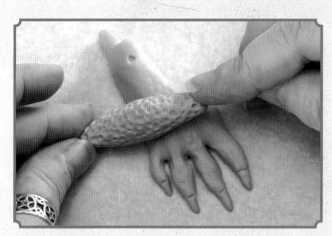

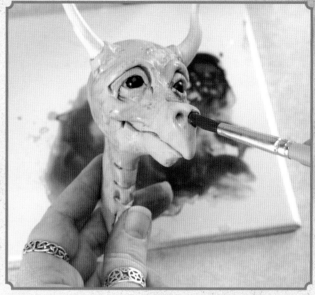

12 Add Detail to the Feet and Toes
Roll each toe, creating a knob for the knuckle and a claw as you did for the fingers. Press the pointed end of the sculpting tool between each toe and press it back towards the foot to separate the toes. Then add detail to the claws. Draw a line across the front of the toe and then roll the part you've segmented off into a point. Next, draw a line from the point between each toe back into the foot to create the tendons. Turn the foot around and roll the heel to create a point, then use the sculpting tool to draw a line where the point meets the foot. Roll the texture tool down the top of each foot. Stick a short piece of wire into the base of each foot. Bake at 275º F (135º C) for 20 minutes or according to the package directions.

13 Add Color to the Head, Hands and Feet
Working quickly, apply thin diluted washes of Burnt Umber acrylic paint with a no. 8 round. Then sponge with a paper towel to remove most of the paint. The goal is to get the paint into the cracks and emphasize the texture. Try to avoid the eyes as well as you can. If you get too much paint on them, you can use a baby wipe or water to remove it.

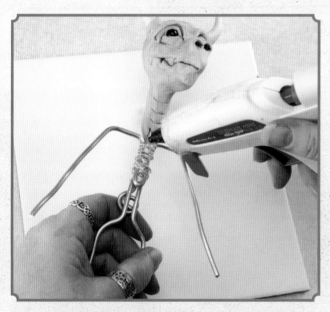

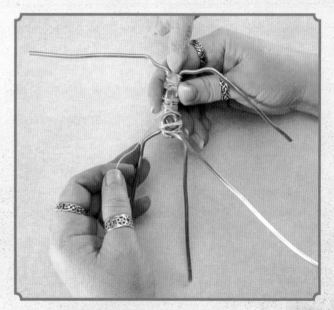

14 Build the Armature
Following the process outlined in step 10 of the Chrainn the Elf demonstration, assemble the armature.

15 Add the Tail Construction
You can make the tail any length you like. Cut a piece of wire and coil one end as you did for the head wire. Bend the coil at a right angle to the wire. Match the tail wire coil to the head wire coil on the armature, and use floral wire to tie them together. Secure the tail with hot glue.

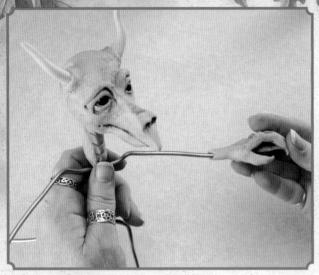

16 Add the Hands and Feet

Twist and remove the hands and feet from the placeholder wires. Put a drop of super glue in the hole at the base of one of the feet and insert into the appropriate leg wire. Repeat for the other foot and for both hands, inserting them into the appropriate arm wires.

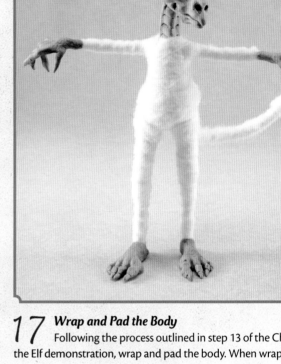

17 Wrap and Pad the Body

Following the process outlined in step 13 of the Chrainn the Elf demonstration, wrap and pad the body. When wrapping the torso, hot glue a cotton ball to the tummy, and continue wrapping over the ball. Wrap the tail. The arms and legs should have two layers of padding, with an extra third layer around the torso.

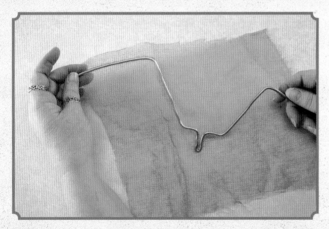

18 Make the Wings

Cut an 18-inch (46cm) piece of 20 gauge-wire. Find the middle and bend it in half, using needle-nose pliers. About 1" (25mm) down from the bend, bend each side out at a right angle, then 1" (25mm) out from those bends, bend it down at about 45 degrees. In the middle of the remaining wire, bend each side down at another 45-degree angle.

Cut an 11-inch (28cm) square of green cheesecloth. Put fabric glue on the wing wires, one side at a time, avoiding the center bend. Place the tip of the wing into one of the corners of the cheesecloth and press the wire down onto the cheesecloth. Repeat on the other side.

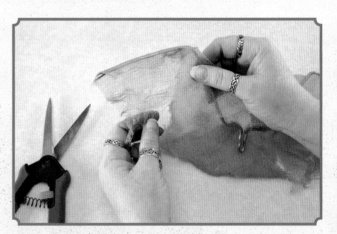

19 Finish the Wings

Wrap the cloth over the top of the wire, sticking down the wrapped fabric. Cut through the fabric between the wings, down the bend in the center. Wrap the fabric around. Put a dot of glue in the center of the wire bend and stick the loose corner of fabric from the bottom in the glue. Make random cuts in the fabric hanging from the wings, stretch it out and shred it.

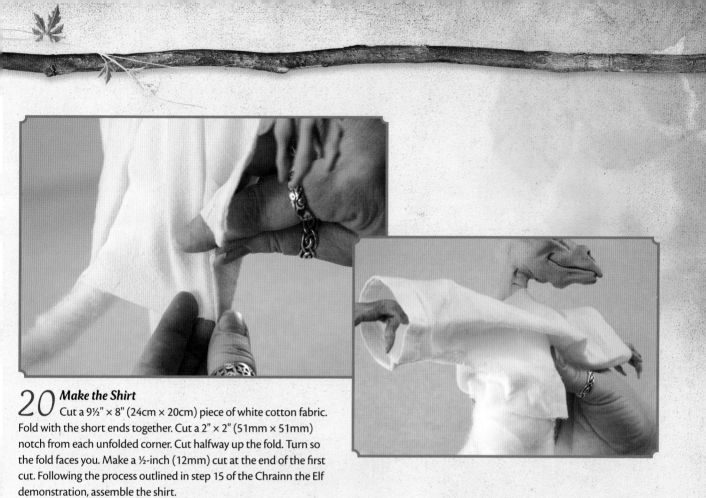

20 Make the Shirt

Cut a 9½" × 8" (24cm × 20cm) piece of white cotton fabric. Fold with the short ends together. Cut a 2" × 2" (51mm × 51mm) notch from each unfolded corner. Cut halfway up the fold. Turn so the fold faces you. Make a ½-inch (12mm) cut at the end of the first cut. Following the process outlined in step 15 of the Chrainn the Elf demonstration, assemble the shirt.

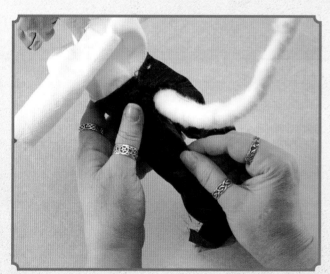

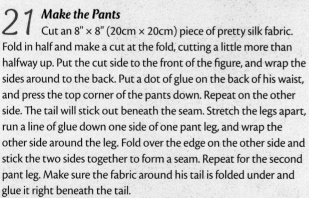

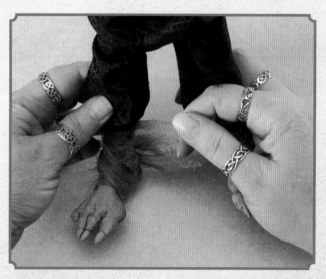

21 Make the Pants

Cut an 8" × 8" (20cm × 20cm) piece of pretty silk fabric. Fold in half and make a cut at the fold, cutting a little more than halfway up. Put the cut side to the front of the figure, and wrap the sides around to the back. Put a dot of glue on the back of his waist, and press the top corner of the pants down. Repeat on the other side. The tail will stick out beneath the seam. Stretch the legs apart, run a line of glue down one side of one pant leg, and wrap the other side around the leg. Fold over the edge on the other side and stick the two sides together to form a seam. Repeat for the second pant leg. Make sure the fabric around his tail is folded under and glue it right beneath the tail.

22 Wrap the Ankles

Push the pant legs up so the fabric rests just on top of each foot. Put a dot of glue on the back of the pant leg at the ankle, and pinch and fold the edges around it. Cut a 24-inch (61cm) strip of gray cheesecloth about 1" (25mm) wide and wrap around the foot and ankle in a figure-eight pattern. Tack down the end of the strip. Repeat on the other leg. (Later on, for an extra embellishment, I decided to wrap the shirtsleeves at the wrists as well.)

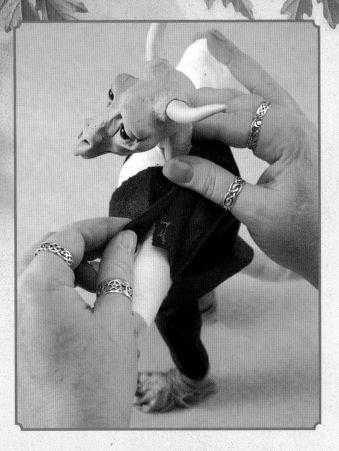

23 Make the Vest and the Sash

Cut a 10" × 5" (25cm × 13cm) piece of microsuede. (See the vest pattern in the appendix.) Fold the fabric in thirds, bringing the short edges in to meet each other in the middle. Cut about halfway down on the fold on either side. Wrap the fabric around the figure, bringing the short edges around to the front. Glue the seams on top of the shoulders.

Cut an 8" × 2" (20cm × 5cm) piece of silk. Lift up the vest in the back, and place a dot of glue on the back waist, then stick down a short edge. Wrap the sash around the front, folding under the top and bottom edges to make it neater, and glue the other end in the back.

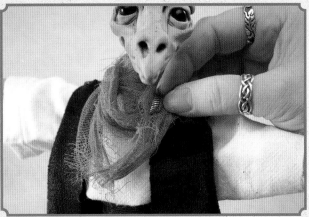

24 Add the Collar and Embellish

Cut a 2" × 5" (5cm × 13cm) piece of gray cheesecloth. Glue one end to the front of his neck, and wrap the strip around, adding twists to create a cowl form and cover up the raw edges of the shirt. Glue down the other end. Glue on a charm, bead or button for embellishment if you like.

25 Wrap the Tail

Cut several long 2-inch (5cm) strips of green cheesecloth. Glue one end at the top of the tail and begin wrapping down the tail, covering all the batting. Glue the end of the strip down at the end of the tail.

26 Attach the Wings

Sew or hot glue the wings to the back of the figure. Put a dot of hot glue on the middle of his back between his shoulder blades. Press the middle bend of the wing wire into the glue. Cut a small triangle of the vest fabric and glue it over the wing wire.

Finished Dragon

Dain shows off his new ensemble!

Try making Dain's wings with thin leather—it's a completely different look. Maybe a silk scarf or cravat? Give him a string of jewels to hold, or a fancy goblet. Since he's a playwright, how about standing him on a piece of parchment with a big feather pen in his hand?

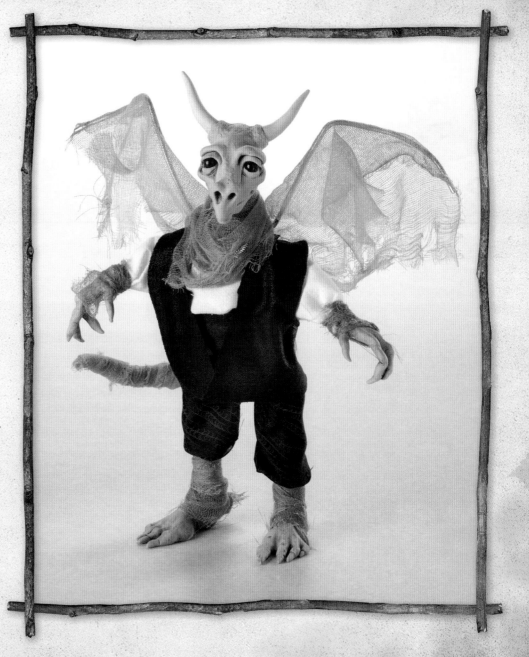

Milse the Bird

An osbick bird flew down and sat
On Emblus Fingby's bowler hat.
It had not done so for a whim,
But meant to come and live with him.

—"The Osbick Bird" by Edward Gorey

One never knows what will turn up in the geraniums. I take my tea with a book on the patio early in the morning, and nothing extraordinary had ever happened until the second Tuesday after the third Monday last month. What happened? That morning I found some eggshells in the geraniums. Picking them up, I wondered where they came from, and, more importantly, what came out of them?

Hearing a chirp from the jade plant, I parted the leaves and came face to face with little Milse. Or would that be face to beak?

Milse was only the first of these little oddbirds (birdfae?) to find their way to our patio. I have no idea where the eggs come from. My only guess is that someone (or something) of faerie leaves them in the night because I always find the broken shells in the morning, and there's a new little friend for Milse. They flutter up to form a line on the railing and chatter and squeak at each other in what must be some kind of fae language; it's like nothing I've ever heard before ... and then they start to sing!

They have sweet little voices to match their sweet little faces, all save Milse—he's a baritone! Altogether I have a birdie barbershop quartet. I'm going to teach them to sing "Sweet Adeline."

MATERIALS

Polymer clay colors: flesh tone of your choice, yellow

Acrylic paint colors: Burnt Umber, Terra Coral

Fabrics and fibers: black microsuede, green four-ounce leather

Sculpting tools: craft knife, manicure stick, needle tool, needlenose pliers, wooden sculpting tool, texture tool (homemade)

Other supplies: aluminum foil, ⅛" (3mm) armature wire (approximately 12 gauge), baby oil, fabric glue, ½" (12mm) floral tape or masking tape, feather pads (2), hot glue gun and glue sticks, knitting needle for pressing fabric into hot glue, nos. 3 and 8 round brushes, ⅓" (8mm) onyx beads (2), paper towels, polyfill for baking, small container of water for burnt fingers, 2" × 3" (51mm × 76mm) Styrofoam egg, super glue

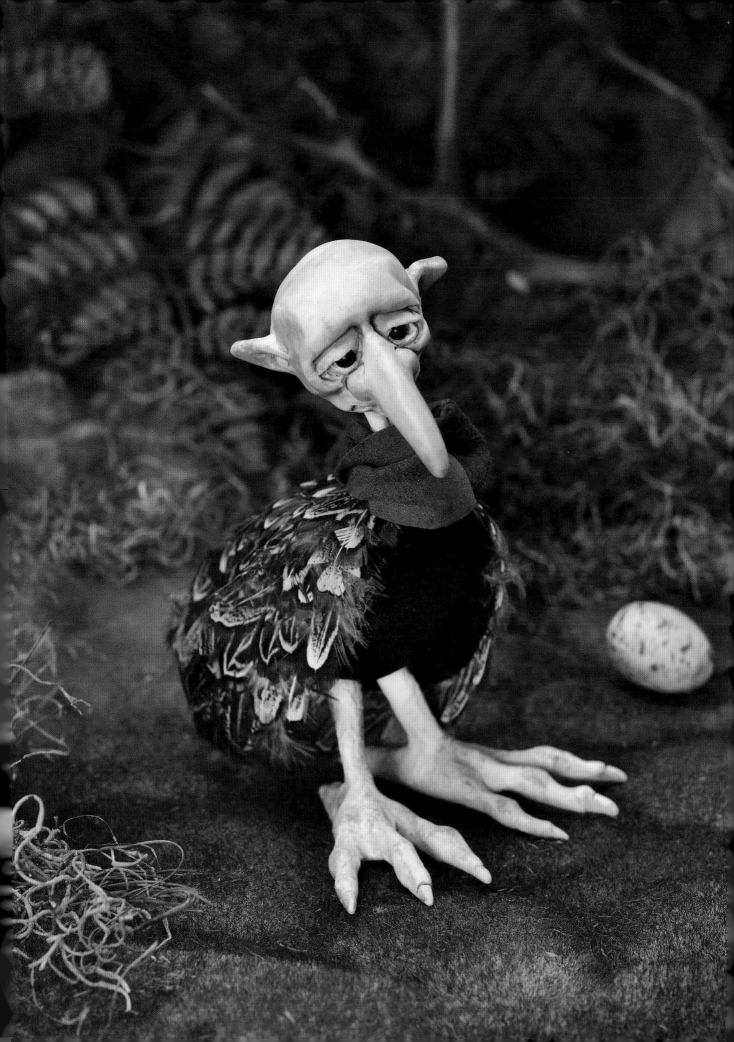

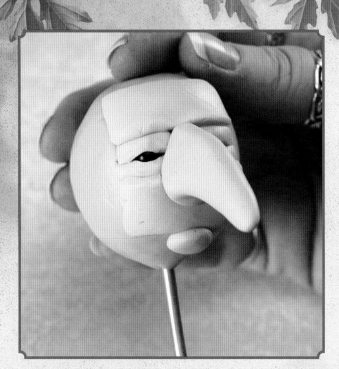

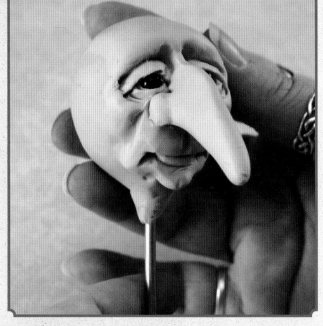

1 Form the Head and Place Clay Shapes to Form the Features

Following the process outlined in step 1 of the Chrainn the Elf demonstration, make the head portion of the armature. (Note: this time leave the non-head end straight.) Cover the ball with a circle of flesh-colored clay, pressing the seams towards the neck wire, and establish the placement of the features.

Make two ½-inch (12mm) balls of flesh-colored clay, flatten them into ½-inch (12mm) circles, and cut each circle in half. Place a half circle over the top and bottom of each eye for the eyelids. Flatten a ⅞-inch (22mm) ball of flesh-colored clay into a 1" × ¾" (25mm × 19mm) rectangle and place it below the eyes, with the longer side horizontal. Form a ⅝-inch (16mm) ball into a 1" × ½" (25mm × 12mm) rectangle, and place it with the long side horizontal above the eyes for the forehead. Form a ¾-inch (19mm) ball of flesh clay into a 2-inch (51mm) cone, and place the cone base between the eyes, securing with your fingers. For the chin, place a ⅜-inch (10mm) ball about ½" (12mm) or so below the nose.

2 Blend and Shape the Features

Use the pointed end of the sculpting tool to blend each side of the nose to better secure it. Use the round end of the manicure stick to tuck the lower eyelids under the upper eyelids, and open the eyes. Then flatten the upper eyelids and blend them into the brow.

Continuing with the rounded end of the manicure stick, blend the brow down into the nose. To define the base of the nose, insert the pointed end of the manicure stick into the place where the nose meets the eyelid. Insert the round end of the manicure stick into the same place and gently pull up to create expression. Use the side of the manicure stick to blend the bottom of the nose into the face, using a rolling motion. Insert the pointed end of the manicure stick under the base of the nose to form the nostrils. Use the rounded end of the manicure stick to help define the nose wings from the outside, being careful not to poke through the clay. Smooth out the cheeks with the round end of the manicure stick, pulling a little clay out from the nose.

Smooth the cheeks with your fingers. Place a thumb on each side of the head behind the eyes, and gently press in. Then press in just behind the cheekbones. Run your fingers over the top of the nose to create a ridge. Smooth the chin in with the side of the manicure stick. Use the needle tool to draw a line for the mouth. Use the pointed end of the sculpting tool to add smile lines at the corners of the mouth. Use the pointed end of the manicure stick to move a little clay from the chin to form a small bottom lip. Use the needle tool to draw a line from the side of the nose towards the chin in a parenthesis shape. Smooth the line out with the round end of the manicure stick, then add wrinkles to the outside corners of the eyes. Use the round end of the sculpting tool to add the philtrum running from beneath the nose to the top of the lower lip (this also defines the upper lip).

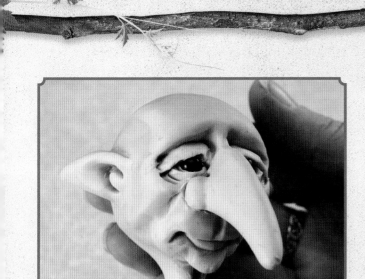

3 Add the Ears and Neck

Roll two ½-inch (12mm) balls of flesh clay into ¾-inch (19mm) teardrops and flatten. Place one on either side of the head, just back from the cheekbone area. Use the square end of the sculpting tool to blend and attach the ears. Rock the pointed end of the sculpting tool across the top of each ear to smooth. Use the round end of the manicure stick to draw a backwards C-shape in the left ear and a regular C-shape in the right ear. Lay the round end of the manicure stick at the top of each C and press an indentation towards the tip of the ear.

Roll a ⅝-inch (16mm) ball into a 1½-inch (38mm) cylinder. Use a craft knife to slit halfway through the cylinder vertically and wrap around the neck wire, blending it into the head. Use your fingers to shape the neck. Pinch a bit below the chin, then skip a space and pinch again to form the Adam's apple. Then use the rounded end of the manicure stick to draw a line from below the chin to the Adam's apple. Use a no. 8 round and a little baby oil to smooth out any fingerprints or indentations. Bake at 275º F (135º C) for 20 minutes or according to package directions. Put batting or a wet paper towel around the nose to help support it and protect it from burning.

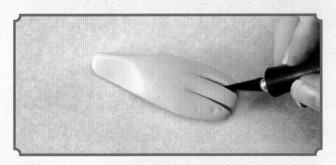

4 Make the Basic Feet Shapes

Roll two 1⅛-inch (28mm) balls of bird's feet yellow clay into fat 2-inch (51mm) cylinders, flattening each cylinder slightly. Pinch one end with your fingers to create a point so it's three-sided. Use a craft knife to cut three long, even toes on the wider end of each foot shape.

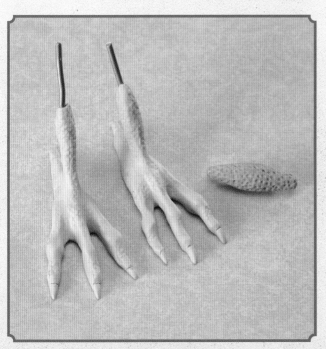

5 Add Knobby Knuckles and Details

Roll the toes, creating a knob for the knuckle and a claw. Press the pointed end of the sculpting tool between each toe, and press it back towards the foot to separate the toes. Use the pointed end of the tool to add detail to the claws. Draw a line across the front of the toe and then roll the part you've segmented off into a point. Then draw a line from the point between each toe back into the foot to create the tendons. Turn each foot around, and roll the heel to create a point, then use the sculpting tool to draw a line where the point meets the foot. Cut two 3½-inch (9cm) pieces of wire, and stick one into the base of each foot (these wires are going to be permanent). Make two ¾-inch (19mm) balls of yellow clay into 1¾-inch (44mm) cylinders. Use a craft knife to cut halfway through each cylinder vertically and wrap one around each leg wire, blending into the feet with your fingers. Roll the homemade texture tool down the top of the foot and up the leg wire. Bake at 275º F (135º C) for 20 minutes or according to package directions.

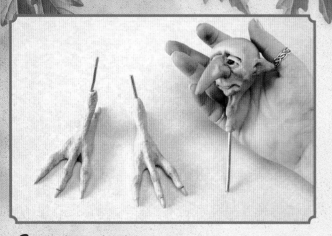

6 Paint the Head and Feet

Use no. 8 round to paint a thin diluted wash of Burnt Umber acrylic paint over the head and feet, then gently wipe off most of the paint with a paper towel. Repeat as needed or use water to remove excess paint. Dab on a thin layer of Terra Coral over the tips of the ears, the forehead, the end of the nose (a little darker here), the lips, the cheeks and the back of the head with a no. 3 round. Add a little coral to the knuckles of his toes (including the back toe!) and the tops of his feet. Pat the edges of the coral areas lightly with your finger so there isn't a sharp line. To remove dry paint, scrape gently with a craft knife.

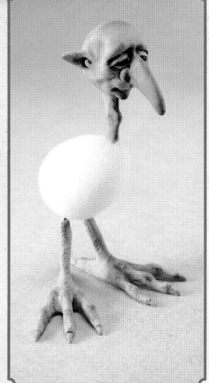

7 Add the Head and Feet to the Styrofoam Body

Bend the leg wires slightly upward with needle-nose pliers and press a 2" × 3" (51mm × 76mm) or larger Styrofoam egg into the wires. Reposition on the feet if needed. Using the pliers, give the head wire a little bend and trim if needed, then press the head into the top of the egg. Secure the head and feet with hot glue (it's OK if the Styrofoam melts a little).

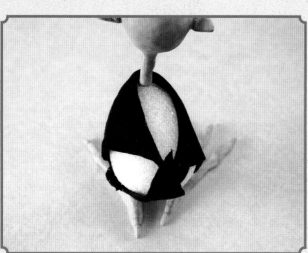

8 Cover the Chest and Underside With Fabric

Cut a triangle of black microsuede with two 7½-inch (19cm) sides and one 7-inch (18cm) side. Use fabric glue to attach the narrower corner of the triangle to the backside. Pull the fabric between the legs, up across the chest and around to the back. Fold the corners over to hide the raw edges and glue to the back. Tug the edges of the fabric around the legs and tack it down with glue. A flap will form on either side of the body. Fold the excess over and glue it down.

9 Attach the Feather Pads

Add a drop of fabric glue just behind the neck, and attach a feather plume pad (see the pattern in the appendix), draping it down the back. Tack down the sides with more glue. Flip another pad of feathers over, and use a sharp craft knife to cut through the center of the fabric backing (don't cut through the feathers). Glue half to each side for the wings. Tack the back edges down, but leave the front edges loose. Flip the figure over, apply glue to the center of the middle feather pad, and pinch together to fold it in half, making a little tail.

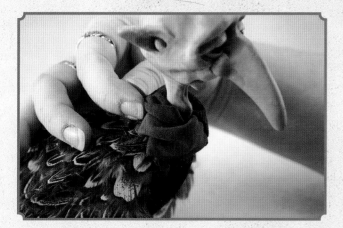

10 Add the Collar

Cut a 2½" × 5" (6cm × 13cm) piece of green four-ounce leather for the collar. Attach one end behind the neck with a dot of fabric glue. Twist and drape the leather around the neck, and secure the other end in the back with more glue.

Finished Birdfae

Milse is looking a little sad because the other birdfae have been poking fun at his big feet, poor birdling!

Birdfae look great with feathers on the head—try a cockatoo-like crest starting just above the beaky nose and running right down the middle, or a fringe of feathers around the back from ear-to-ear, leaving the top of the head bald.

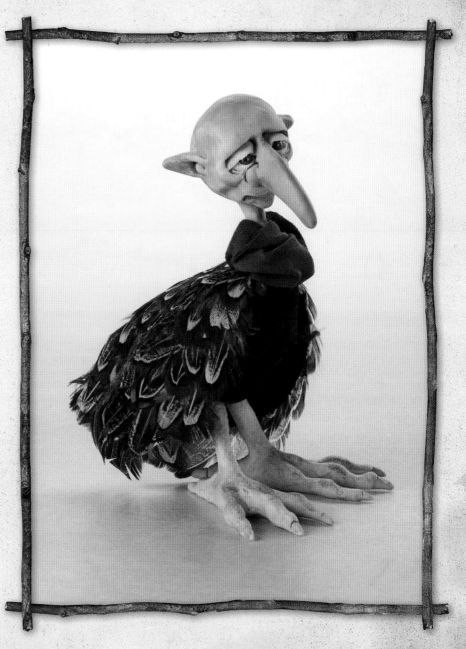

Armature Map

Some of the patterns in this section are too large to show at 100 percent and need to be enlarged. You can use a copier to enlarge the patterns. You can also download and print the patterns at impact-books.com/faemaker.

Enlarge pattern to 111% to bring up to full size

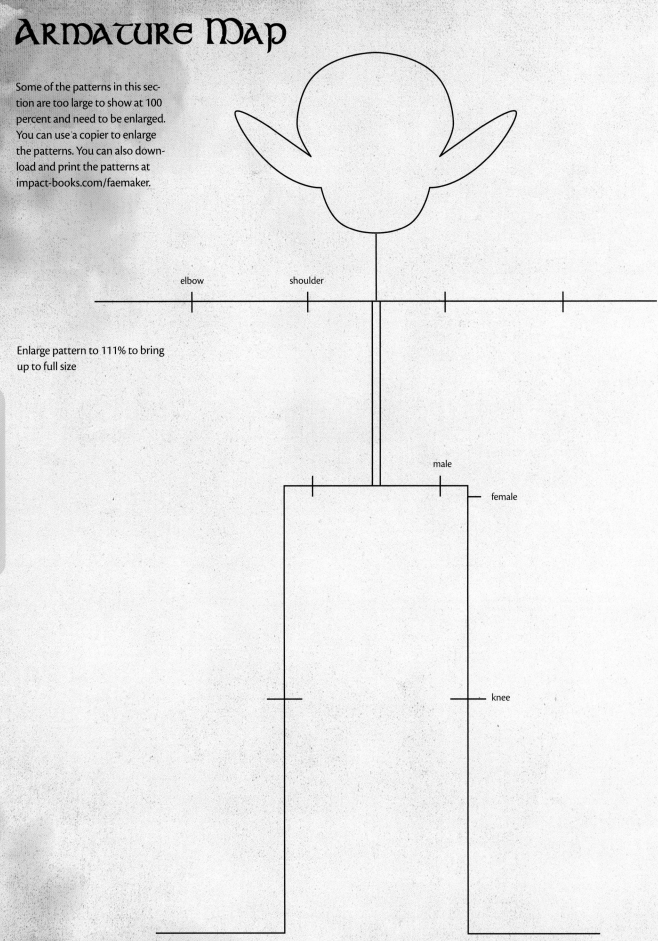

elbow

shoulder

male

female

knee

Appendix

FEATHER PAD PATTERN

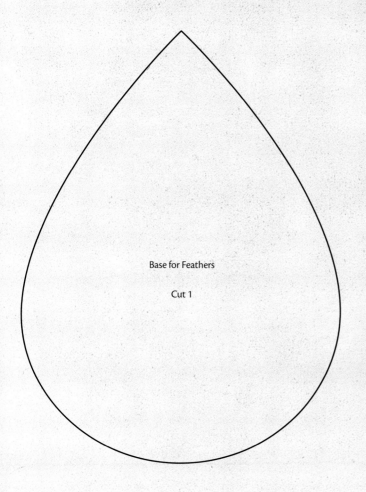

Base for Feathers

Cut 1

Feather Pad Directions

You'll need about fifty feathers to make your own feather pads. Cut one base out of thin, drapy material such as cotton or muslin. Start at the lower middle, and work your way up to the pointed end. Glue the feathers so they extend past the edge of the base. Overlap the feathers like scales or shingles.

If you'd rather purchase your feather pads, they are commercially available at craft shops or online.

Appendix

Pattern shown at actual size

overlap the feathers

extend the feathers past the
edge of the base

Shirt/Blouse Pattern

Shirt/Blouse Directions

Fold the fabric in half lengthwise, bringing the A and B sides together. Put on the character with the opening to the back.

Glue or sew edges from A to C and from B to D.

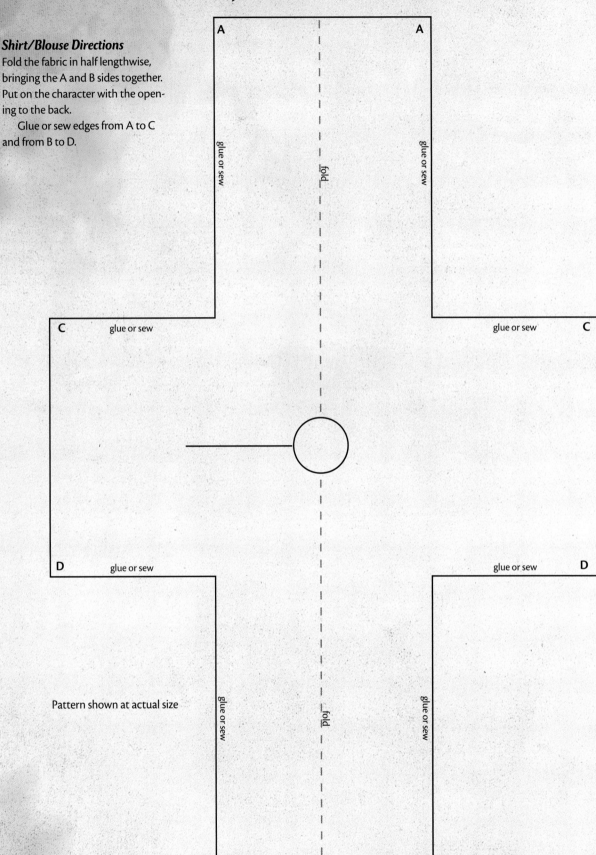

Pattern shown at actual size

Trousers and Vest Patterns

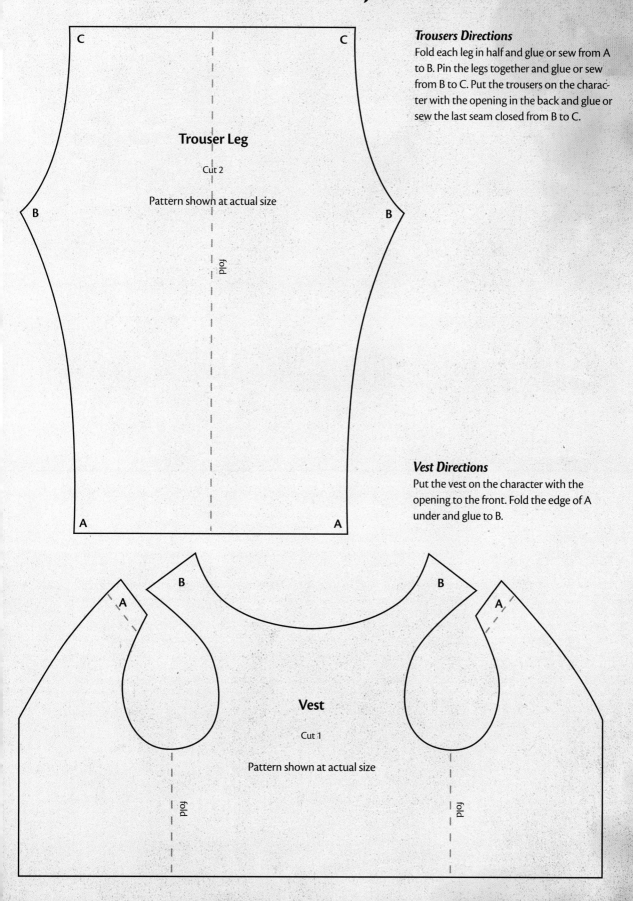

Trousers Directions

Fold each leg in half and glue or sew from A to B. Pin the legs together and glue or sew from B to C. Put the trousers on the character with the opening in the back and glue or sew the last seam closed from B to C.

Trouser Leg

Cut 2

Pattern shown at actual size

fold

C C

B B

A A

Vest Directions

Put the vest on the character with the opening to the front. Fold the edge of A under and glue to B.

A A

B B

Vest

Cut 1

Pattern shown at actual size

fold fold

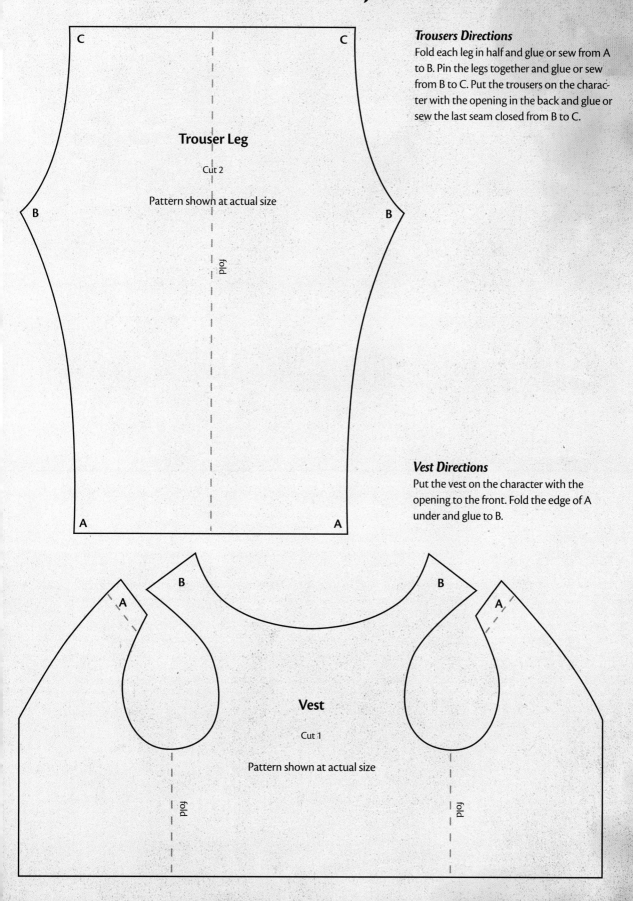

Hat and Shoe Patterns

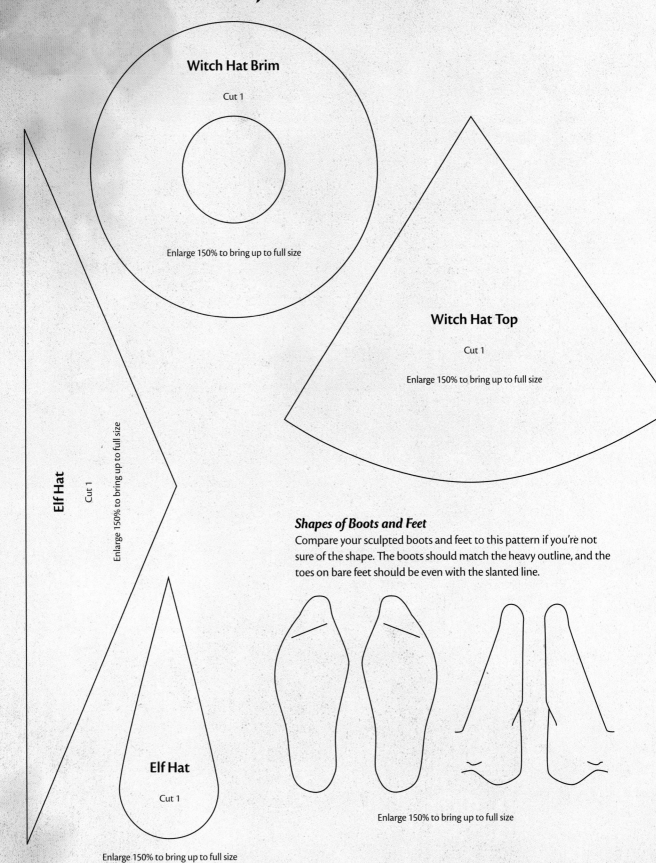

Witch Hat Brim

Cut 1

Enlarge 150% to bring up to full size

Witch Hat Top

Cut 1

Enlarge 150% to bring up to full size

Elf Hat

Cut 1

Enlarge 150% to bring up to full size

Elf Hat

Cut 1

Enlarge 150% to bring up to full size

Shapes of Boots and Feet

Compare your sculpted boots and feet to this pattern if you're not sure of the shape. The boots should match the heavy outline, and the toes on bare feet should be even with the slanted line.

Enlarge 150% to bring up to full size

WING PATTERNS

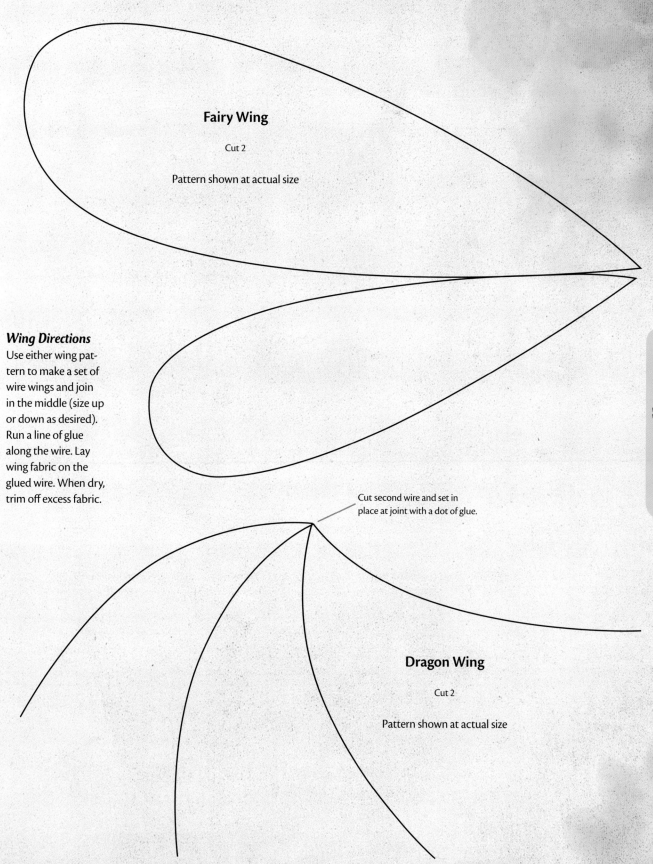

Fairy Wing

Cut 2

Pattern shown at actual size

Wing Directions
Use either wing pattern to make a set of wire wings and join in the middle (size up or down as desired). Run a line of glue along the wire. Lay wing fabric on the glued wire. When dry, trim off excess fabric.

Cut second wire and set in place at joint with a dot of glue.

Dragon Wing

Cut 2

Pattern shown at actual size

Gallery

The pages that follow are a selection of my characters made over the last ten years or so. Some are funny, some are serious, but they all were made using techniques featured in *FaeMaker*.

Phouka
One of my very first oddfae, Phouka is based on the Irish water fairy, but he'd much rather make friends than drown anyone.

Tarbh
What would the Minotaur of Greek legend have been like had he not been thrown into the labyrinth and treated as a monster? If he were born in another place and time? Maybe a hopeless romantic? I've transplanted him to the Highlands of Scotland, where my family originated.

Hermit—McDermit
Hermits are sculpted into real shells and come in all shapes, sizes and temperaments. They turned up here in The Lair (my studio) one fine autumn day in 2005, and are inviting more and more of their friends and relatives to move in! I don't mind as they are usually pretty quiet, but it's getting crowded!

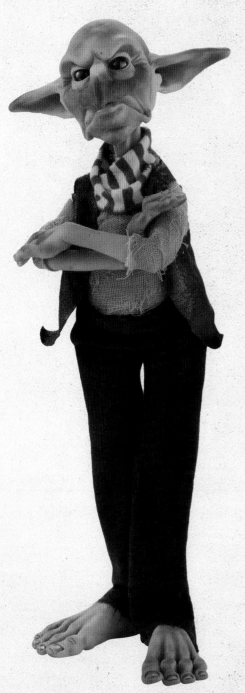

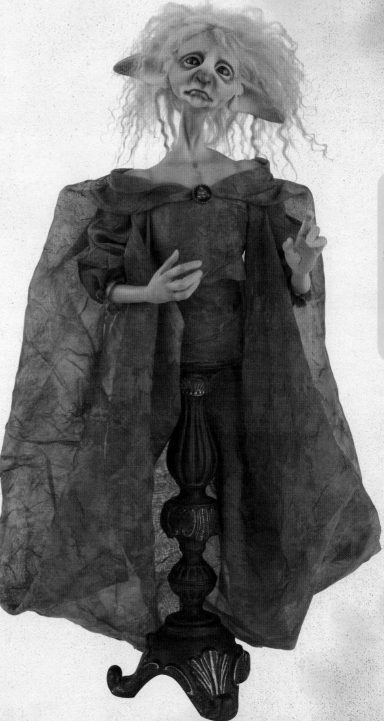

Eshan

Eshan is one of the few pretty oddfae I've made. I just started sculpting with no particular character in mind, and there she was. I had no idea what to do with her until I happened to set the candlestick next to her on my sculpting bench, then she just kind of put herself together.

Cronk

This fella was not happy about being stuffed in a box just to have his picture taken, and I'm *never* going to hear the end of it when he gets home.

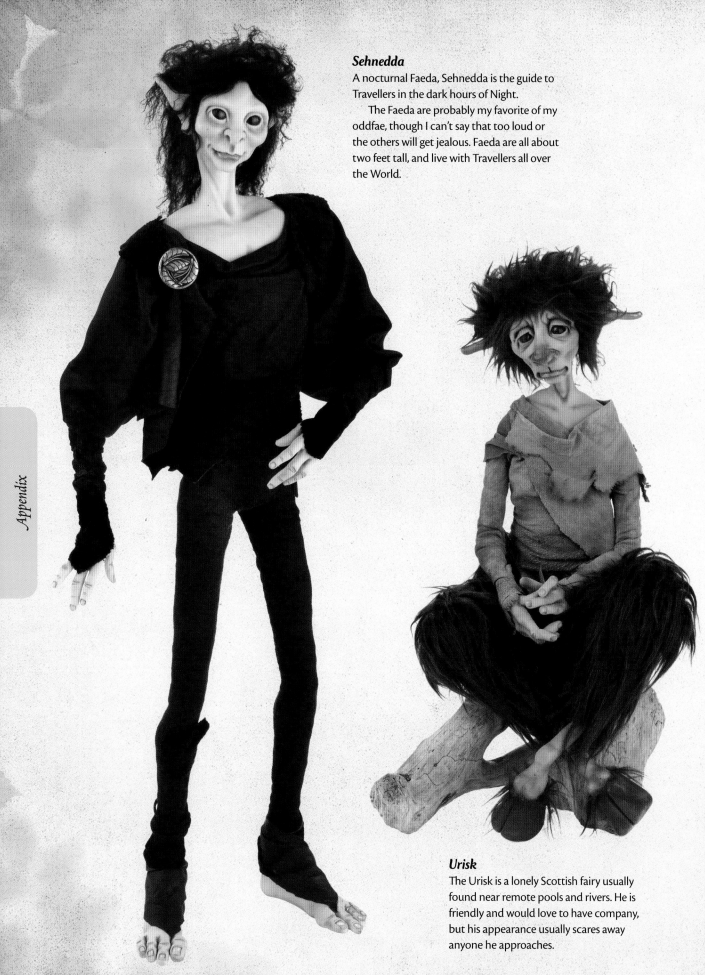

Sehnedda

A nocturnal Faeda, Sehnedda is the guide to Travellers in the dark hours of Night.

The Faeda are probably my favorite of my oddfae, though I can't say that too loud or the others will get jealous. Faeda are all about two feet tall, and live with Travellers all over the World.

Urisk

The Urisk is a lonely Scottish fairy usually found near remote pools and rivers. He is friendly and would love to have company, but his appearance usually scares away anyone he approaches.

Appendix

118

Argh!

Ever have one of those days?

This is a great example of "lemons, lemonade": Argh! was hanging on my husband's belt pouch and got sat on, cracking the pod. So add a few gears spilling out ... who'd ever know he wasn't planned this way?

Pagler

Seidh, pronounced "seed," are a tribe of Other Folk that inhabit the Forest. These tiny fae remove ripe seeds from pods and scatter them so there will be plenty of trees and pods in coming seasons. After their work is done, the Seidh then take up residence in the empty pods, curled up snug and sound for winter.

Arjhaan

The first Faeda.

Faeda are faerie guides, helping beings who are lost (Travellers), either in the Faerie or in the Mundane world, to find their way to the place they truly belong.

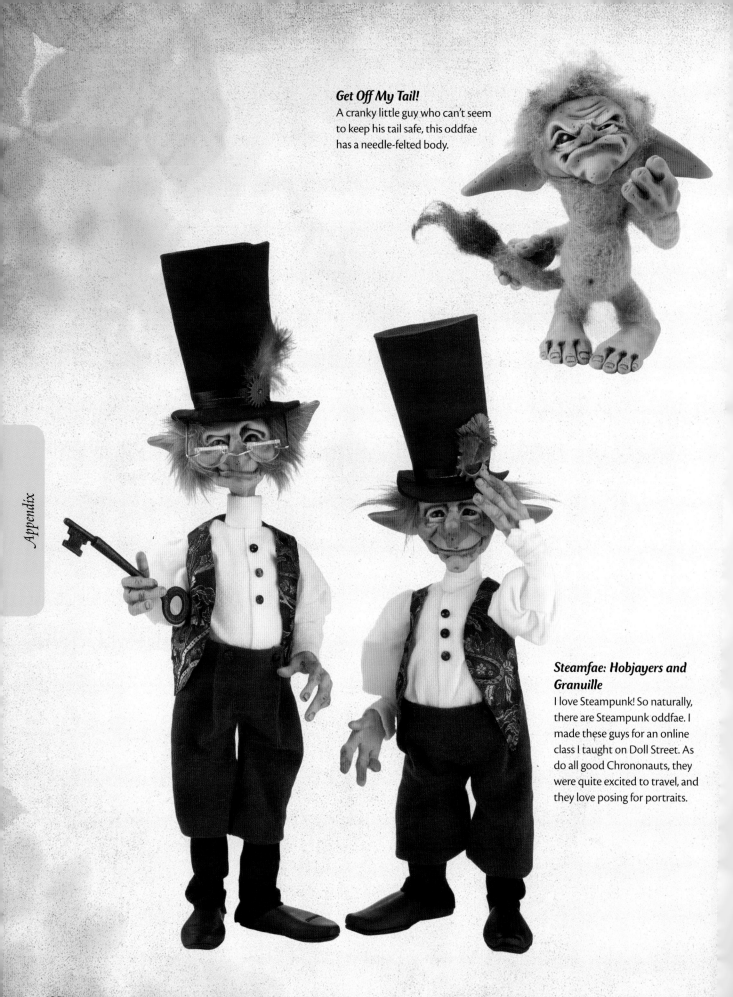

Get Off My Tail!
A cranky little guy who can't seem to keep his tail safe, this oddfae has a needle-felted body.

Steamfae: Hobjayers and Granuille
I love Steampunk! So naturally, there are Steampunk oddfae. I made these guys for an online class I taught on Doll Street. As do all good Chrononauts, they were quite excited to travel, and they love posing for portraits.

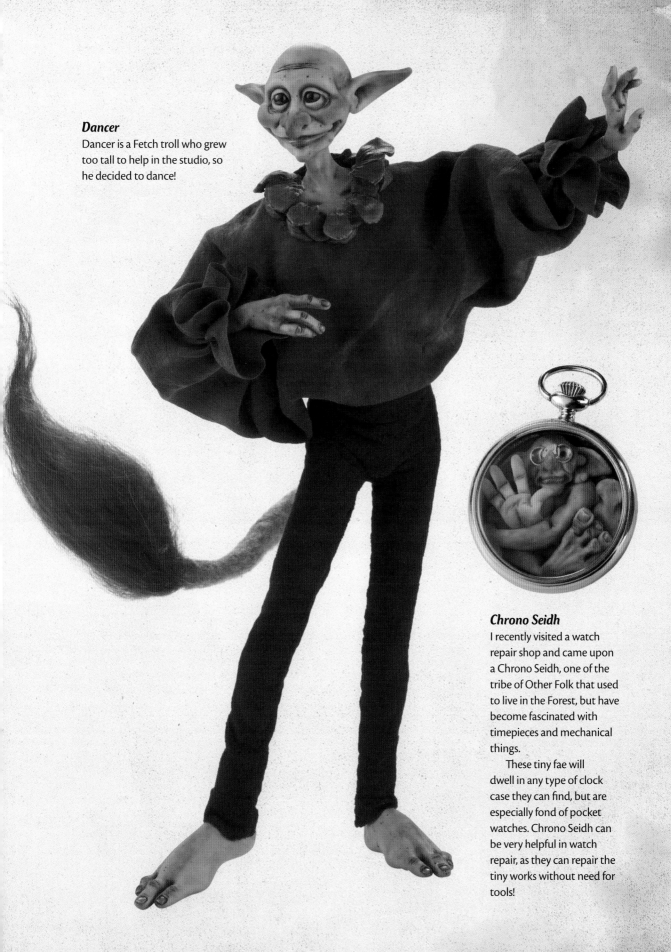

Dancer

Dancer is a Fetch troll who grew too tall to help in the studio, so he decided to dance!

Chrono Seidh

I recently visited a watch repair shop and came upon a Chrono Seidh, one of the tribe of Other Folk that used to live in the Forest, but have become fascinated with timepieces and mechanical things.

These tiny fae will dwell in any type of clock case they can find, but are especially fond of pocket watches. Chrono Seidh can be very helpful in watch repair, as they can repair the tiny works without need for tools!

Find Your Inner Fae

There are as many different kinds of fairies as there are leaves on the trees. The fae who have become my friends just happen to be odd. With the techniques you've learned on your journey to becoming a faemaker, you can make any type of fairy or character you like—pretty, ugly, creepy or whatever.

Remember, practice makes permanent—the more you sculpt, the more skilled you'll become. If you find you love sculpting as much as I do, there are tons of books and DVDs as well as forums and tutorials on the Internet to help you meet all your sculpting goals.

There are innumerable books available covering fairy lore, history of faerie and fairy art for you to use as inspiration—or do what I do and make up your own type of fairy! Take your imagination by the hand, take a deep breath and step into an adventure of creating. One never knows who or what will be waiting when you do.

Send me pictures, ask me questions, share your stories. Come over to Yahoo! Groups and join my Fairly Odd Fae group, where all the oddfaemakers hang out, and we'll make even more characters together.

Thanks for walking with the oddfae and me—stay odd! See you in Faerie.

Cheers,

D

Faemaker@gmail.com

Gehnessa
One of the rare fem Faeda, Gehnessa is a gentle oddfae who is a particular friend of Travellers upon the Sea.

Resources

Clay Suppliers

All the clays used in this book are available at your local art or craft stores, or you can buy clay online.

Supplies

Most of your supplies can be found at your local craft or sewing shop. I've added some URLs for the more hard-to-find items.

Wooden manicure stick, available in the makeup aisle at most department stores or in beauty supply specialty shops.

Wooden sculpting tool, tinyurl.com/8yfjucb. If Colleen doesn't have one listed, convo her and get one custom-made!

Wooden sculpting tool, anatomytools.com. Go to the tools page and purchase P1.

Sculpting tools, armature wire, www.sculpt.com or www.dickblick.com. Almaloy wire is my fave.

Floral tape, craft stores or various online vendors. Do a search for "floral tape."

Realistic glass eyes, www.miniworlddolls.com. If you decide to use plastic eyes, make sure to cover them with a wet paper towel before baking. Unprotected plastic eyes will get cloudy or melt in the oven.

Genesis Oil Colors, FIMO Gloss, polymerclayexpress.com

Ultrasuede®, tinyurl.com/7jx9anc (Ultrasuede® retailers).

Microsuede, tinyurl.com/7uoc7xg (OnlineFabricStore).

Alova Suede, www.syfabrics.com (SyFabrics).

Needle tool, art store or one of the clay suppliers listed earlier.

Embellishments and hair, www.joggles.com.

Tibetan lambskin, ryndaoriginals.com.

Books

Good anatomy books are essential when sculpting figures, even fantasy figures.

Atlas of Human Anatomy for the Artist by Stephen Rogers Peck. My fave!

Portrait Sculpting: Anatomy and Expressions in Clay by Philippe & Charisse Faraut: A bit pricey, but one of the best I've seen.

Facial Expressions by Mark Simon: This one is fun for character dolls—page after page of people making faces!

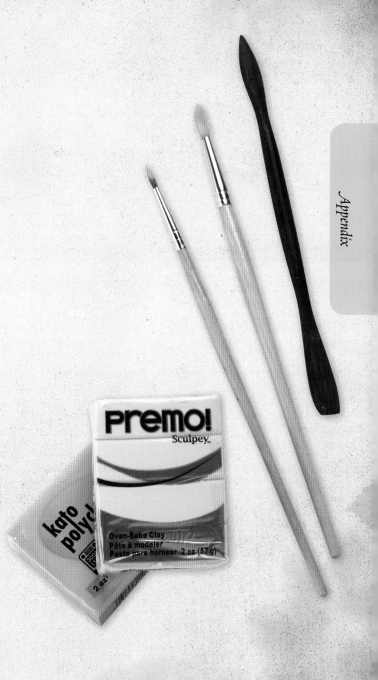

Fetch's Fact: Tiny URLs

We used TinyURL.com to shorten some of the longer Web addresses. It makes unwieldy URLs a bit more manageable!

INDEX

About the Author

Dawn M. Schiller (Dee) is a self-taught artist who is always learning and experimenting. She makes Odd Things. Her motto: "You are what you sculpt."

Photo by Karen Barraza

Her award-winning work is internationally collected and has appeared in shows, galleries, books and magazines, both in the U.S. and worldwide. Dawn exhibits yearly at Comic-Con International in San Diego, and at other pop culture/media-related shows around the US. She also attends art retreats to share her ideas and techniques with other artists, and to learn from them as well.

A self-employed sculptor full-time for fifteen years, Dawn has been teaching online and in-person for seven years. She has recently begun sculpting in leather and fiber in addition to her work with various types of clay—she is fascinated with the anatomy of the human and the fantastic, and will work in any medium that will allow her to illustrate her vision.

Dawn collects Halloween socks and interesting hats, and she loves Faerie, Halloween and Steampunk. She lives in Southern California in a cluttered condo with husband/science teacher/fencer/coach Greg, three kittykids, a red-tail boa, two tarantulas, a gecko, a turtle and any other critters Greg's students happen to find wandering loose.

Dee has sculpted, made dolls or drawn since she was a little kid in the rural Midwest (there really are faeries in the Woods). She's an artist because she can't imagine being or doing anything else — it's BIG FUN! A loft studio, affectionately referred to as "The Lair," is where the oddfae come to life. Greg doesn't like to go up there because there's always someone (or something) staring at him.

Her creepy, strange and lunatic creations—treefolk and witches, merfolk and wizards, werewolves, fugitives from fairy tales, Figments of the Imagination, and the slightly-off-center Oddfae and Autumn Things—can be found online at www.oddfae.com.

Other fine IMPACT Books are available from your favorite bookstore, art supply store or online supplier. Visit our website at fwmedia.com.

16 15 14 13 12 5 4 3 2 1

Distributed in Canada by Fraser Direct
100 Armstrong Avenue
Georgetown, ON, Canada L7G 5S4
Tel: (905) 877-4411

Distributed in the U.K. and Europe
by F&W Media International LTD
Brunel House, Forde Close, Newton Abbot, TQ12 4PU, UK
Tel: (+44) 1626 323200, Fax: (+44) 1626 323319
E-mail: enquiries@fwmedia.com

Distributed in Australia by Capricorn Link
P.O. Box 704, S. Windsor NSW, 2756 Australia
Tel: (02) 4577-3555

Edited by Mary Burzlaff Bostic
Designed by Clare Finney
Production coordinated by Mark Griffin

Metric Conversion Chart

To convert	to	multiply by
Inches	Centimeters	2.54
Centimeters	Inches	0.4
Feet	Centimeters	30.5
Centimeters	Feet	0.03
Yards	Meters	0.9
Meters	Yards	1.1

Acknowledgments

There are so many awesome people who helped me get to the writing of this book; a very special sampling:

My editor Mary Bo Berry, designer Clare, photographers Miss Christine and Ric, and, of course, Pam! Go Team Oddfae—we rock! And thank y'all for my first snow in many years.

Gerry and Esther Schiller—for sushi!

Michael and Susan Jackson, for the first photos of my work that enabled me to publish the earliest incarnation of oddfae.com.

Carole Henning Larson, for the first chance to teach, on Doll Street—hey Mo!

Norm Hood and Leta Davis at Chimera Publishing, who gave the Oddfae their debut at San Diego Comic-Con—smoochies!

Christi Friesen, for handholding.

Kathy Davis, for sharing!

And last but never least—Howard and Marie Segal, for all the years of advice, encouragement and love.

Dedication

Dedicated to Dollmaker Extraordinaire
Imogene Blackwell—thanx Mom . . . and to Greg Schiller,
who's always believed in the oddfae and me.

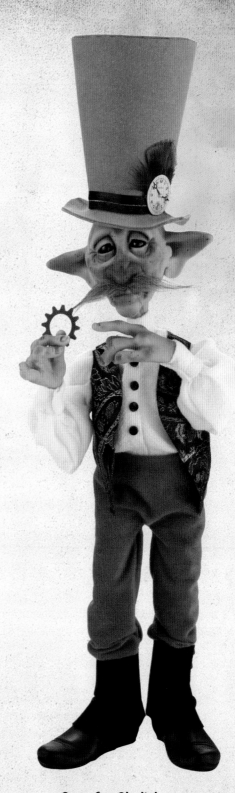

Steamfae: Obediah
Obediah holds a key element of Steampunk—a gear. You are all gears in the clockwork of my heart . . . it wouldn't beat without you!

Fetch's Fact: Get Free Stuff!

Get a free bonus demonstration and download and print the patterns from this book at impact-books.com/faemaker.

IDEAS. INSTRUCTION. INSPIRATION.

Download a FREE bonus demonstration and download and print the patterns from this book at impact-books.com/faemaker.

These and other fine IMPACT products are available at your local art & craft retailer, bookstore or online supplier. Visit our website at impact-books.com.

IMPACT-Books.com

- Connect with your favorite artists
- Get the latest in comic, fantasy and sci-fi art instruction, tips, techniques and information
- Be the first to get special deals on the products you need to improve your art

Follow IMPACT for the latest news, free wallpapers, free demos and chances to win FREE BOOKS!

Scan this code with your smart phone to go directly to the bonus materials webpage.